WORK, LIFE, TOOLS.

WORK, LIFE, TOOLS.

The things we use to do the things we do

Based on an exhibition created by Milton Glaser
and the Steelcase Design Partnership

Foreword by George Beylerian
Introduction by Stanley Abercrombie
Photography by Matthew Klein
Book Design by Milton Glaser

THE MONACELLI PRESS

Steelcase Inc., a world leader in work process understanding and workplace innovation, is the largest manufacturer of office furniture worldwide.

The Steelcase Design Partnership Companies, Brayton International, DesignTex, Details, Metro, Vecta and Wigand are in the forefront of firms developing new concepts of work and space through intense design exploration. Their diverse portfolio is known for striking visual design and exceptional product performance. Together with Steelcase, they provide the most comprehensive offering of products and services in the contract furnishings industry.

CONTENTS

FOREWORD

by George Beylerian

Over the years, the Steelcase Design Partnership has become a source of inspiration for architects and designers. Several exhibitions created by the Steelcase Design Partnership have focused on the company's interest in various aspects of design and architecture, with a certain sensitivity for popular culture.

At the heart of this activity was a commitment to design. We took an eclectic approach hoping in each instance to explore, inspire, educate, and celebrate the many faces of design. Edible Architecture is a fun and frivolous celebration of architecture, where Dreams and Details educated us on architecture through the work and eyes of Paul Rudolph. Mondo Materialis gave us the opportunity to explore the use of materials through the built environment. Industrial Elegance inspired us to stop and recognize the beauty in everyday objects and Women of Design celebrated the contribution of women to the field of architecture and design.

Work, Life, Tools began as yet another way to examine the enduring presence and quality of design in our lives. It resulted in a freeze-frame study of our daily tasks and the tools that help us achieve victories, big and small, personal and professional — a retrospective of work through the things we use to do the things we do. And it provides a springboard for examination and contemplation of our work as we move into the next millennium.

Wouldn't it be interesting, we thought, if we turned the tables? Instead of creating a study and display to illustrate design, design influences, and how and why we create tools, wouldn't it be interesting to let

people tell us how their tools have helped *them*? As we study our lives and the changing nature of work, what might we learn if we ask people to identify the single tool that is most important to their daily lives? What might we learn about work, about life, about the tools of our success?

We all recognize that many aspects of our daily lives and methods of livelihood are changing rapidly. Styles of work, responsibilities and the nature of work itself are major changes affecting our individual lives and lifestyles. Steelcase, as the world's leading resource regarding work and work process has recognized that work and life are inseparable or rather *intertwined*. Stop and think how true this is to your own individual lifestyle — work while you play, and play while you work seems to have become a new lifestyle.

We selected 50 people from many walks of life to participate in *Work, Life, Tools*. It was a fascinating study. In some instances, technological advances revolutionized the way people did their work. In others, tools were amazingly simple, almost archaic, as if there were a lapse between the tools and the state of the arts in general. It was a comforting lesson at times, discovering that a pencil can be as much an instrument of value and efficiency as the latest technologically-laden telecommunicating device.

Over the millennium, tools have evolved from flintstone to the most sophisticated instruments of this century. As humankind invents new tools and processes, the essence of work changes along with it. Discontinuation, obliteration, new techniques, new professions. Workers need to learn new methods, new professions, new ways to perform tasks, new tasks, replacing old habits and lifestyles. Looking back merely a century, I have counted at least 170 occupations or professions completely eliminated through new technology or new process of work. As time gives us change at an exponential rate, we need to be "on our tools" and keep pace with change.

I wish to thank Milton Glaser and Stanley Abercrombie for their passion and dedication to this project.

Words cannot describe the relentless task Matthew Klein undertook on this project by traveling back and forth, coast to coast, trying to capture people, work, life, *and* tools! Whereas back in Grand Rapids, the "nerve center" of the Steelcase Design Partnership, the indefatigable Jill Wilterdink pulled all the strings it took for the production to go on. What organization! What a perfect team!

The key to the success of this project is the distinguished cast of 50 characters (and their assistants in some cases) who took time from their busy schedules to make this project possible. Their generosity and cooperation is greatly appreciated.

Work, Life, Tools, the book and the exhibit, will serve as a time capsule for the generations that follow us. Surely they will be interested in — if not astounded by — the tools we used for the work we did.

INTRODUCTION
by Stanley Abercrombie

1. Tools

As George Beylerian's foreword has explained, the larger part of this book surveys, in an informal way, the work being done today by 50 accomplished professionals and the tools they consider most helpful in that work. This smaller part is an even more informal ramble through some of the thoughts provoked by the survey. As a background for thinking about the role of tools in today's and tomorrow's work and the role of work in today's and tomorrow's life, let us begin with three brief sketches of the roles some tools have played in the past.

VIGNETTE: THE CHINESE CALLIGRAPHER

The artist, putting aside the scholarship that is his main pursuit, takes up his tools for an hour of calligraphy. These "four treasures" include his brushes, his ink, his inkstone, and his paper. Of these, his inkstone is the greatest treasure, made from the finest Duanzhou stone from the province of Guangdong and carved to accentuate the veins and colors of the stone; its flat, slightly slanting plane, where the inkstick will be rubbed with water, leading to the shallow well at its base where the resultant ink will pool. His inkstick, thin and hard, a little over a foot long, is made from the velvety black soot of the pine tree mixed with animal glue, and its tip is encased in lacquer. His brushes are five in number, each varying slightly in length, each different in material, and each used for a different effect. The most frequently used are the two that produce bold, simple strokes; one of these is made of hair from the goat, the other of hair from the sheep,

both with the lengths of hair carefully graded, so that they blend into a fine but pliable point when wet, and glued into the ends of slender bamboo tubes. For coarser, scratchier strokes, with areas of paper visible through the ink, he likes to use a brush made of hog bristle held in a lacquered holder. And for the finest, most delicate passages of all, he has a brush of rabbit hair and another of sable, both of these encased in ivory holders. The unsized paper on which he makes his strokes will, when he is finished, be trimmed with borders of silk brocade and carefully fastened by its edges to a board, burnished on its reverse side with a smooth stone carved to nicely fit the hand, then fastened top and bottom to a wooden stave and a roller. The result is a beautiful scroll.

VIGNETTE: THE JAPANESE TEA MASTER

The host and his four guests approach the tea house through the garden, crossing a small arched bridge and trodding a circuitous path on which a few fallen leaves have been allowed to remain. One by one, stooping slightly — for the door is too small and low for any other means of entry — the party enters the house, a tiny pavilion floored with tatami mats. Taking tea leaves from a lacquered box, the host grinds them with a wooden implement in an earthen jar, which he then covers with an ivory lid. He takes up next an iron kettle, a wide-mouth water jar, and a delicate dipper made of bamboo, with which he transfers water from the jar to the kettle. Nearby is a shallow basket with charcoal for the fire, a pair of bronze tongs for handling the coals, a brush made of feathers for brushing away cinders or ash, and a small box holding incense. When charcoal is lighted in a depression among the floor mats, a piece of incense is added to the fire, and the kettle has begun to warm, he brings from a shelf of the tokonoma niche the pottery bowl in which the tea will be made, and he presents it to his guests, who are seated on the floor. He also produces a bamboo spoon for the powdered tea, a bamboo whisk, a square of silk with which bowl, spoon, and whisk can be wiped, a small bronze rest for the lid of the kettle, a shallow vessel in which the rinsing water for the tea bowl can be discarded, a small circular mat on which the hot kettle will be placed, and, finally, the small cups from which the tea will be drunk. The cups are of rough raku pottery, each individually formed and glazed, each perfect in its intentional imperfection. The tea is delicious.

VIGNETTE: ZELDA AT THE DEUX MAGOTS

Seating herself at one of the small tables, she places her velvet bag in front of her and waits until she hears the waiter asking for her order. With a drink on its way, she takes from the bag a flat rectangular case of glittering silver, opens it with a click just barely audible, peers into it for a moment, breathes in the familiar odor, then selects a cigarette from a dozen that are, after all, identical. Next from the bag comes a long black tube, a cigarette holder that appears to have been carved from onyx but is in reality made of that wonderful new material, Bakelite. The cigarette in the holder, the holder between her scarlet lips, she reaches into the bag yet again and produces her lighter, a delightful object of platinum inset with little diamonds of greenest malachite and a few squares of brilliant blue lapis lazuli. As the smoke from her first inhalation drifts softly from her slender nostrils, she places the lighter atop the silver case and

admires them both, just as — she knows without looking — those at the nearby tables are admiring her.

THE NATURE OF TOOLS

Smoking, of course, is not the innocent pleasure it seemed to Zelda's generation, and the tools she employed to enjoy it to the fullest are threatened with disappearance. Our grandchildren may be as puzzled by a cigarette case, should they ever see one, as we ourselves are puzzled by the calligrapher's inkstone and the tea master's bamboo whisk.

Although the production of tools may be limited in space and time — the whisk is not likely to be made outside the Orient, the cigarette case not beyond the twentieth century — they are still more real and more permanent than some of the things they help to make: the whisk more lasting than the tea ceremony, the cigarette case less ephemeral than smoke. Suzanne Langer has written of the abstraction inherent to both art and science, a background condition against which the tools that help create art and science seem to possess a satisfyingly concrete reality.

In the present selection of 50 tools, that characteristic concreteness exists for all but a few, those few not really proving that some tools are ephemeral but proving instead that the definition of tool can be stretched beyond its normal limits. (One interesting aspect of looking at 50 answers to *any* question, after all, is to see how many different interpretations of the question there can be.) In his original invitation to participants, Steelcase Design Partnership president and CEO Bill Crawford asked for the identification of "the single tool — a physical extension of yourself — that is essential to your worklife." The phrase "extension of yourself" had been meant to preclude the selection of body parts (biceps, fingers, eyes), but some respondents didn't see it that way.

Designer Bran Ferren, for example, has chosen his own brain. I'm assured he is very smart indeed, and no doubt his brain cells have earned the right to be a bit self-congratulatory. (Whether or not it is the best use of those talented cells to be synapsing away in service to the Walt Disney Corporation is a possible question for a quite different essay.) In any case, the choice of a brain is instructive, leading us to ponder that organ's value as a tool. It doesn't take much pondering to realize that such a value is limited, not only in effecting physical change, such as lifting an elevator or propelling a car, but also in purely abstract problem-solving. In the *New York Times* of February 18, 1997, George Johnson wrote about a quite esoteric future possibility, something called quantum computing. "In the never-ending effort to make sense of the universe," Johnson wrote, "the human brain long ago bumped up against its limits. Unchastened, brains learned to amplify themselves with pencils and paper, slide rules, mechanical calculators and electronic computers. And the computers get faster all the time." If the brain is rather circumscribed, therefore, as a tool, we have to agree with Bran Ferren that it is unbeatable and — who knows? — perhaps even boundless as an inventor of tools.

Pamela Miles has interpreted Crawford's ground rules in much the same way as Ferren did by choosing her own breath. "Witnessing a breath," she says, "always connects one with the unfailing flow of life-force within and without." I'm not sure I understand exactly what she means, but she seems to have taken a rather broad view of the ground

rules of this little game, whereas Dr. Will Grossman, who also attends to the fluctuations of breath, chose his stethoscope, a tool in the sense more conventionally understood.

TOOLS VERSUS MACHINES

If Crawford's invitation had been issued without expecting the choice of a brain, it otherwise intentionally put no limit on the respondents' choices, placing no prohibition on machines and making no distinction between machines and tools. We might note here, however, that others have made such distinctions. In my Webster's, one definition of "tool" treats that term as a mere component of the other: "the cutting or shaping part in a machine." And as a synonym for "tool," Webster offers "implement"; but not "machine."

Certainly the two words and what they represent often have different connotations. In *The Education of Henry Adams*, Adams employed two contrasting images, the virgin and the dynamo, the first seen as comforting, the second as threatening. As Lynn White has written, "The Virgin represented all that was distinctly human...; the dynamo pointed to the annihilation of all human values, first by the achievement of a faceless, ant-like society, and then by the victory of impersonal cosmic force over all life." But if the powerful machine is replaced by a tool, if instead of virgin and dynamo we are asked to consider virgin and hoe or virgin and butter churn, the sense of threat turns comic. Similarly, the title of Leo Marx's 1964 book *The Machine in the Garden* well anticipates the subject explained in the subtitle, *Technology and the Pastoral Ideal*, a subject full of potential conflict, whereas *The Tool in the Garden* would have suggested nothing but horticultural pleasantries. And a question often asked, in one form or another, as machines are seen to grow more complex, less understandable, and more self-directing — one thinks of Hal in *2001: A Space Odyssey* — is "Will man continue to be the master of the machine, or will he become its slave?" The same question, asked about a tool, is pretty silly. Similarly, the substitution of one term for the other makes nonsense of this otherwise stirring statement by the Dada artist Tristan Tzara: "No-one can escape from the machine. Only the machine can enable you to escape from destiny."

There are also differences in what we may expect from a tool and from a machine. We habitually think of a tool as something we work *with*, and a machine as something that can work *for* us; the tool is an aid to the workman, but, ideally, the machine is a substitute for the workman. As D. H. Lawrence wrote in *Studies in Classic American Literature* back in 1923, "...the most idealist nations invent most machines. America simply teems with mechanical inventions, because nobody in America ever wants to *do* anything. Let a machine do the thing."

Lewis Mumford, in *Technics and Civilization*, wrote that "The essential difference between a machine and a tool lies in the degree of independence in the operation from the skill and motive power of the operator: the tool lends itself to manipulation, the machine to automatic action. The degree of complexity is unimportant: for, using the tool, the human hand and eye perform complicated actions which are the equivalent, in function, of a well developed machine; while, on the other hand, there are highly effective machines, like the drop hammer, which do very

simple tasks, with the aid of a relatively simple mechanism. The difference between tools and machines lies primarily in the degree of automatism they have reached: the skilled tool-user becomes more accurate and more automatic, in short, more mechanical, as his originally voluntary motions settle down into reflexes, and on the other hand, even in the most completely automatic machine, there must intervene somewhere...the conscious participation of a human agent."

Mumford also imagined a hybrid classification: "Moreover, between the tool and the machine there stands another class of objects, the machine-tool: here, in the lathe or the drill, one has the accuracy of the finest machine coupled with the skilled attendance of the workman. When one adds to this mechanical complex an external source of power, the line of division becomes even more difficult to establish."

How does the machine/tool distinction apply to our 50 objects? In Mumford's hybrid category of machine-tool there are clearly a couple, Ramon Candelario's pipe threader and Philippe Petit's borer. In the category we traditionally think of as tools, there are Craig Morris's trowel, Robert Ebendorf's hammer, all the writing instruments and paper products, scales, erasers, and more. In the machine group are all the computers and perhaps the wheelchair, camera, and microscope as well. To sum up, we have 37 tools, 2 machine-tools, and 11 machines.

Which leads to a speculation about how these figures would have differed if the same question had been asked twenty years ago (without the computers and other electronic gadgets, the number of machines would have been far less) and what they will be if it is asked twenty years hence (wanna guess?).

THE HISTORY OF TOOLS

Our first tool, according to myth, was fire, stolen from the gods by Prometheus. According to archaeology, the first tool was instead a weapon shaped to aid the survival task of hunting. One writer about such early tools, Ludvik Askenazy, follows the example of the present survey in equating tools and machines (or in using the first term to include both): "A piece of stone, the branch of a tree — the first tools in man's hands — like automized factories and cybernetics are really one and the same thing: an idea put into practice, an inspiration, an observation, something which enables man to subjugate nature."

In any case, it seems reasonable to assume that all our early tools were of the most practical sort, intended to support our physical well-being, to supply us with warmth or food or clothing or shelter. That assumption leads to another, that it must have been later that tools began to be developed also for less directly profitable pursuits — for producing calligraphy, for serving tea, for smoking cigarettes, and for all the arts.

Some, however, think that attention to art (or at least to the symbolism with which much art operates) preceded useful tools, and who can be certain that the symbols of horses, deer, aurochs, and rhinoceroses on the walls of the Chauvet caves were not painted before arrowheads were fashioned to kill those same beasts? Lewis Mumford, in a later book, *Art and Technics*, mused that "Orpheus, not Prometheus, was man's first teacher and benefactor; ...man became human, not because he made fire his servant, but because he found it possible, by means of his symbols, to

express fellowship and love, to enrich his present life with vivid memories of the past and formative impulses toward the future, to expand and intensify those moments of life that had value and significance for him…Man was perhaps an image maker and a language maker, a dreamer and an artist, even before he was a toolmaker."

These distinctions, however — between symbols and tools, between Orpheus and Prometheus, between art and work — become, for us, less and less interesting, less and less meaningful, as these elements grow more closely together and their boundaries blur. Both art and work depend on tools for their execution, and, no matter which came first, both art and work are necessary for life. The new realization of such blurred boundaries is really a return, after a long absence, to a time before such distinctions were made. For Plato, the "arts" included catering, shoemaking, and medicine, and the classical roots of the word "art" — the Greek *harmos*, meaning joint, and the Latin *ars*, meaning skill — suggest the original notion of artistic activity as being primarily one of joining or fitting together harmoniously, an activity common to both art and work and one greatly facilitated by the use of tools.

If the origin and early history of tools lie beyond the horizon of our knowledge, the later history of tools is fundamental to the history of manufacturing, commerce, warfare, welfare — to the history, indeed, of all civilization. It was stone tools that were in use as our history began to be written; axes, adzes, awls, hammers, and even saws were made of stone, the tools themselves evidence of what fine workmanship could be produced without metal.

The development of stone tools was slow. As Lewis Mumford has described, "During a great span of primitive life the slow perfection of stone tools was one of the principal marks of its advancing civilization and its control over the environment: this reached perhaps its highest point in the Big Stone culture, with its capacity for cooperative industrial effort, as shown in the transportation of the great stones of its outdoor temples and astronomical observatories, and in its relatively high degree of exact scientific knowledge." But this slow process soon picked up speed and, in our own time, continues to evolve at an exponential rate: the stone tools were translated into metal; the metal tools came to be operated by machines; the machines came to be power-driven; the power became electric; the control of power became electronic.

Details of this general history of tools (which Mumford characterizes as "from utensils to utilities") could fill a library; somewhere, on the campus of some Institute of Technology, they undoubtedly do. But it may be more immediately instructive (and less tiring) to focus our historical investigations on a few of the 50 specific tools chosen for this book.

THE TOOLS AT HAND

The largest group of objects chosen by our 50 respondents is that made of paper, a tool with a very long history. Paper is the basic material of eight of our 50 items (nine, if you count Tina Afendoulis's Kleenex tissue). Although the ancient Egyptians had made a paper-like substance from papyrus, the invention of paper is generally credited to the Chinese (specifically, to the eunuch Cai Lun) in the early part of the second century A.D. There it was made from a mash of plant fibers (sometimes with

the addition of tree bark and old fishing nets) spread onto a fine sieve; after drying, it was peeled off and plastered on a sunny wall for further drying and hardening. By the 13th century in Europe, it was being made from the pulp of linen rags, and today it is primarily a wood product.

The second largest group of tools chosen, numbering seven, is that of equipment related to the computer, that object that was once expected to make paper obsolete. The recent history of the computer is evolving too fast to record: in the time it takes to type this paragraph (on a computer keyboard, naturally), a thousand people are buying their first computers, a hundred newcomers are joining the internet, a dozen inventors are devising wondrous new advances. But the earlier history of the computer is one of the most important and intriguing stories of our time.

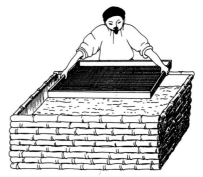

Papermaking in ancient China using a sieve and a vat of plant fibers.

In capsule: The forerunner of today's digital computer was the calculating machine. An early landmark in its development was the first such machine with geared wheels, built by Blaise Pascal in 1642, and later milestones included early-19th-century models with stepped drums, the not-yet-quite-buildable "analytical engine" of Charles Babbage in 1834, and the 1888 patent of W. S. Burroughs for a key-driven adding machine with a crank. A giant step, conceptually, was Alan Turing's 1937 paper, "On Computable Numbers," leading to a theoretical device called the Turing Machine. Something called, in those simpler days, the Complex Computer, was built in 1940 on the principle of the telephone switchboard. But the first device to use electronic tubes for calculating was built in 1946, the Electronic Numerical Integrator and Calculator, or ENIAC. From then until now, the story of computing has been a busy one, offering continuously increasing power within containers of continuously decreasing volume. The end of the story is nowhere in sight.

Contrasting with this rather startling development is a group of objects — comprising six of our 50 — that has remained virtually unchanged for generations: pens and pencils. The pencil with which Richard Meier sketches those elegant and lyrical white forms is virtually the same as the black-lead pencils that have been manufactured in England since 1565 and at the Staedtler factory in Nuremberg since 1660. The fountain pen, surprisingly, is almost as venerable, first appearing in Paris in 1657, although it became truly popular only in the first decade of the 20th century.

Guggenheim Museum director Thomas Krens named as his favorite tool a binder clip, a rather specialized substitute for a more generic item that we all use: the paper clip. The paper clip is often said to have been invented in 1899 by a Norwegian named Johan Vaaler, although similar devices were common in the preceding quarter century and, according to Henry Petroski's *The Evolution of Useful Things*, a Pennsylvanian named Matthew Schooley filed a patent application for such an object in 1896 and was granted the patent in 1898.

The electronic Rolodex, tool of choice for Gwendolyn Calvert Baker, is a much more recent invention, of course, but is simply a smarter version of the 1950 invention of a Brooklyn engineer named Arnold Neustadter. His earliest inspirations, according to Bruce Handy in *The New York Times Magazine*, December 29, 1996, had been decidedly less successful, including the Swivodex, a swiveling spill-proof inkwell, and the Clipodex, a tablet for dictation that clipped onto secretaries' knees.

More useful was the Autodex (an object still manufactured), an address book that flips open at a chosen letter of the alphabet. Both the Autodex and the manual Rolodex may soon, however, be as dead as the Dododex, not because of the competition from alternate systems such as File-O-Fax, but because of competition from electronic versions like Baker's.

Other chosen tools have their own stories. The ancestry of Blake Westman's optical gauging microscope dates back, some would say, to a Dutch spectacle-maker named Zacharias Janssen, who may have built the first microscope around 1590, or, others say, to Galileo, who certainly built one in 1610. Judy Carmichael's Steinway piano has a heritage dating to 1853, when Henry Steinway (born Heinrich Steinweg) and his three sons opened their piano factory in New York, although there were, of course, pianos before Steinway. And the key forerunner of Duane Michals's camera was George Eastman's "Kodak" box camera of 1888, sold in great numbers with Eastman's famous slogan, "You press the button — we do the rest."

OLD TOOLS, NEW TOOLS

Considering the history of a few of our chosen tools may make us wonder how many of them *have* a history. It is interesting to ask — but difficult to answer — how many of our 50 respondents chose new tools, how many old ones. Difficult, because, as we have seen, many of the specified objects have long histories, yet have changed greatly during those histories. In those cases that are ambiguous (and there are many) some judgment calls are necessary. We would consider Judy Carmichael's Steinway piano an old tool, for example, because it is fundamentally the same instrument that Henry Steinway built in 1853, but we would consider Duane Michals's camera a new one, for it differs so radically from George Eastman's.

Making such assumptions, and making another that specifies twenty years ago as the dividing line between old and new, we get the very rough ratio of 27 old tools to 23 new ones. If, just as arbitrarily, we say that an old tool is one that is at least ten years old, we get the equally rough figures of 33 old, 17 new. And if we say that anything older than five years is an old tool, we can count 40 old ones and 10 new.

NAMELESS TOOLS, BRAND NAME TOOLS, DESIGNER NAME TOOLS

Another standard by which to examine our 50 tools is their degree of anonymity: which are generic, and which others carry the label of a noted designer or proud manufacturer? Although the fashion for designer labels seems to be on the march (a recent cartoon having shown a waiter recommending such fare as the Chanel salad, the Valentino minestrone, and the Versace rack of lamb), such labels seem to hold no allure for our 50 achievers. Perhaps the only name that could be identified as a designer is Steinway, and even he fits more comfortably into the category of manufacturer.

Looking, then, at the category of brand-name items (those names denoting manufacturer, product line, or distributor, and most of them copyrighted) versus the category of items without such identification, we find our 50 tools divided into 18 with names and 32 without. Our group is not guilty of name dropping.

BEAUTIFUL TOOLS, UGLY TOOLS

If our group has not chosen objects based on their designer credentials, it is also true that they appear not to have chosen objects based on their appearance. To assess which of any group of 50 objects are attractive, which not, must be one of the most arbitrary tasks imaginable, and each assessor will have a personal opinion. My own is that there are only a handful among the 50 that can be considered really beautiful.

Victor Papanek is the only respondent who wrote explicitly about a "near-perfect configuration" and consequent "great beauty," (although Philippe Petit did claim that his borer was "pleasing to the eye"), and Papanek's Norwegian wood whittling knife is (for me, unarguably) the most handsome item of the lot. Others that seem to me to possess genuine beauty are: Robert Ebendorf's hammer, Will Grossman's stethoscope, Craig Morris's trowel, and Judy Carmichael's Steinway piano. Five beauties out of 50 is not a great many. Admittedly, a large numbers of others are what we might call aesthetically neutral; all the cards and pads, all the pens and pencils, the calendars, the erasers, the office walls, the Kleenex tissue— these are not ugly, certainly, but they are hardly beautiful. We must not be fooled by the crisp photographs of Matthew Klein or the artful layouts of Milton Glaser; our 50 objects are not, on the whole, a great-looking bunch.

Is that beside the point? Of no consequence? To be expected? Our respondents were never asked to select tools on the basis of their appearance. Furthermore, we don't expect work to be pretty, after all; we expect it to be plain. One thinks of Fowler's distinction, in *A Dictionary of Modern English Usage*, between working words and stylish words, the last term having, in Fowler's opinion, a quite pejorative sense: "The motorist before the magistrate does not improve his chances of acquittal by saying *I observed that I should not impede her progress* when he means *I saw that I should not get in her way.*"

On the other hand, we do expect tools to be pretty, not because of the application of ornament or any other attempts at prettification, but because of an inherent fitness to purpose that, we have learned to expect, results in beauty. This expectation of beauty, and the reasons for it, may themselves be worth some attention.

The identification of function with beauty has a long history, a history wonderfully summarized in Edward Robert De Zurko's *Origins of Functionalist Theory*. De Zurko finds such theory operating in the classical world of Greece and Rome, in medieval times, in the Renaissance, in 18th-century France and in Victorian England, among other cultures, but it really blossoms with the modern architecture of the 20th century. The German architect Bruno Taut (1880-1938), one of the many sources quoted by De Zurko, offered one of the most succinct expressions of functionalist theory. "The aim of Architecture," he said, "is the creation of the perfect, and therefore also beautiful, efficiency."

Another expression, from a quite different source, is embedded in theater critic Kenneth Tynan's famous 1959 rave review of Jule Styne and Stephen Sondheim's *Gypsy*. Tynan described seeing the musical as "like being present at the triumphant solution of some harsh architectural problem; stone after massive stone is nudged and juggled into place, with a balance so nice that the finished structure seems as light as an exhalation,

though in fact it is earthquake-proof. I have heard of mathematicians who broke down and wept at the sight of certain immaculately poised equations, and I have actually seen a motoring fanatic overcome with feeling when confronted by a vintage Rolls-Royce engine...With no strain or dissonance, a machine has been assembled that is ideally fitted to perform this task and no other. Since the task is worthwhile, the result is art." Or, as my grandmother used to say, "Pretty is as pretty does."

If our 50 tools are possessed of something close to Taut's "perfect efficiency," why are not more of them "therefore also beautiful"? And, if like Tynan's view of *Gypsy*, our 50 are "ideally fitted to perform" tasks that are "worthwhile," why are so few of the results art?

One general reason, we might suppose, is that a large number of them are machines, not tools. But, in addition to our tradition of ascribing beauty to a perfectly functional tool, there is another tradition ascribing beauty also to a well-designed machine. This second tradition is admittedly shorter-lived, but it predates by far Le Corbusier's dicta in the 1930s praising ocean liners, locomotives, and automobiles and calling the house "a machine for living in." It can be traced back at least to the American sculptor Horatio Greenough, born in 1805, whose writings similarly praised the construction of ships and bridges. In architecture, Greenough made a distinction between the ceremonial, monumental structures traditionally held to possess beauty and the more practical, workaday structures in which he also found a sort of beauty. These last buildings, he said, "may be classed as organic, formed to meet the wants of their occupants," and in them "the laws of structure and apportionment, depending on definite wants, obey a demonstrable rule. *They may be called machines.*" And to Greenough we owe one of the tersest statements of functionalism and one of the sweetest definitions of beauty: "Beauty is the promise of Function."

What we have come to believe today, a belief that can be considered a corollary of Greenough's dictum, is that function is the promise of beauty. When a tool (or, for that matter, a bowl or a spoon or a chair or a ski) is formed so that it perfectly fulfills the function required of it, it is our expectation that beauty will be a happy by-product. Sometimes this expectation is met, sometimes not.

And one more specific reason our 50 objects are less than outstanding in appearance is that quite a few are computers or other types of electronic equipment, a product category that is notoriously deficient of examples of good design. One exception, a few years back, was a product by Grid, housing computer and monitor in a black box with crisp, square edges. Almost all others, before and since, have been bulbous almond-colored lumps, some of them tricked out with feeble attempts at "streamlining," a pointless curve here, a needless angle there. A fervent plea: Isn't there someone out there who can take this object, with which we spend an increasingly large amount of our time, and make it look good?

But enough carping. Tools, beautiful or not, are with us not to be admired, but to perform. How do tools in general — and our 50 in particular — affect our work?

2. Work

"Accomplished labors are pleasant," Marcus Tullius Cicero said. Tools help make our work more accomplished and therefore, presumably, more pleasant. They also make our work more efficient, therefore making our lives more pleasant by altering the mix of work and leisure. These pleasure-giving processes give rise to a few questions, however. First, is there a distinction to be made between work and labor? Second, whatever the distinctions may be, what roles do work and labor play in our lives? And third, if the nature of our work is changing (and it clearly is), is the nature of our leisure changing too?

WORK VERSUS LABOR

Hannah Arendt, in her important 1958 book *The Human Condition*, designates three fundamental human activities — labor, work, and action — thus making a distinction between labor and work. Labor, she says, "is the human activity which corresponds to the biological process of the human body, whose spontaneous growth, metabolism, and eventual decay are bound to the vital necessities produced and fed into the life process by labor. The human condition of labor is life itself." And work, according to Arendt, is "the activity which corresponds to the unnaturalness of human existence, which is not imbedded in, and whose mortality is not compensated by, the species' ever-recurring life cycle. Work provides an 'artificial' world of things, distinctly different from all natural surroundings. Within its borders each individual life is housed, while this world itself is

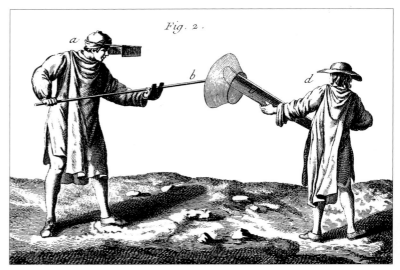

meant to outlast and transcend them all. The human condition of work is worldliness." The blurb on the dust jacket simplifies these definitions, as blurbs do, and tells us that labor is our "efforts to continue the biological processes of life," and that work is our "acts of fabrication beyond the needs of life." To simplify even further: labor is natural; work isn't; tools can be used for both.

Webster takes a somewhat different tack, distinguishing the two terms by specifying that work involves the relatively mild activity of "expending effort," but that labor involves "great and often strenuous exertion." And, if you think labor sounds hard, you should see the definitions of travail, toil, drudgery, and grind.

Another way in which we could apply these terms is to give labor the meaning of effort that directly results in some form of life sustenance — planting a crop, say, then harvesting it, and then eating it — and work the meaning of effort that is a step removed from such primitive activity and — perhaps the most interesting distinction — driven by aims that are more complex and more elevated than the immediate satisfaction of need. This sort of work is also dependent on a more complex social organization than is simple labor: work is no longer each man for himself. The laborer's end product is food or clothing or shelter, but the worker's end product is money for the marketplace. One measure of the sophistication of a civilization could then be what percentage of its citizens are still laborers, and what percentage have advanced to the status of workers.

By this measure, the little band interviewed for this book is thoroughly sophisticated. Even though restaurateur Drew Nieporent might conceivably sustain himself from the contents of his chosen Teflon pan, he bought those contents with the profit accruing with the work — not labor — his employees do with that and other pans. Like all our other forty-nine respondents , he is a worker, not a laborer.

THE ROLE OF WORK

Over the centuries, some people have apparently liked work. Others, it seems, have helped themselves and their colleagues put a cheerful face on the inevitable by pretending they liked it. Thomas Carlyle, for example,

with what degree of sincerity we cannot know, wrote in his 1843 *Past and Present* that "Blessed is he who has found his work; let him ask no other blessedness." At just about the same time, in *A Glance Behind the Curtain*, James Russell Lowell was expressing just about the same sentiment:

"No man is born into the world, whose work
Is not born with him; there is always work,
And tools to work withal, for those who will:
And blessèd are the horny hands of toil!"

But there were others, even in those pious times, who, in a more contemporary frame of mind, seem to have thought that those horny hands were not so blessed as all that. Charles Lamb, writing to his friend Bernard Barton in 1822, asked the question:

"Who first invented Work — and tied the free
And holy-day rejoicing spirit down
To the ever-haunting importunity
Of business in the green fields, and the town —
To plough — loom — anvil — spade — and, oh, most sad,
To this dry drudgery of the desk's dead wood?"

Today, even for those of us fortunate enough to have found work we sincerely enjoy — and that, we assume, must include most of our 50 capable respondents who surely get personal satisfaction from their creative efforts — even for those, the Friday night drive to the country is a more cheerful event than the Sunday night drive back to the city. This last observation, however, thoroughly dates me, for both what we do as a break from work and when we do it are rapidly changing.

THE EVOLUTION OF LEISURE

Witold Rybczynski, a best-selling author (*Home* and *The Most Beautiful House in the World*) and now a professor of architecture at the University of Pennsylvania, recently turned his attention to the subject of leisure in a book called *Waiting for the Weekend*. One of the observers he quotes there is the portly author and illustrator G. K. Chesterton (1874-1936), who wrote that the term "leisure" had three different meanings: "The first is being allowed to do something. The second is being allowed to do anything. And the third (and perhaps most rare and precious) is being allowed to do nothing." In a similar vein, it was Chesterton, you'll remember, who also observed that "If a thing is worth doing at all, it is worth doing badly."

There is a definite trend towards disagreeing with the old gentleman. Doing nothing with our leisure time, if not exactly disallowed, would today be quite suspect, and when we do something with our leisure — cooking, gardening, sailing, jogging, whatever — we certainly don't enjoy doing it badly. Our sports and hobbies demand the latest in equipment and the utmost in ability. As Rybczynski puts it, our current use of leisure time "reflects a concern for status and consumption, but it also suggests an attitude to play that is different from what it was in the past. Most outdoor sports, once simply muddled through, are now undertaken with a high degree of seriousness. 'Professional' used to be a word that distinguished someone who was paid for performing an activity from the sportsman; today the word has increasingly come to denote anyone with a high degree of proficiency; 'professional-quality' equipment is available to —

and desired by — all. Conversely, 'amateur,' a wonderful word literally meaning 'lover,' has been degraded to mean a rank beginner, or anyone without a certain level of skill. 'Just an amateur,' we say; it is not, as it once was, a compliment."

And so a morning of leisure these days is less likely to be spent in a friendly tennis match than in a grueling session of practice to perfect our backhand. For our friend Chesterton this would certainly have seemed more like work than play. As the nature of our work — in the locations in which it can take place, in the times at which it can take place, and in the character of what we do — is becoming more like leisure, it seems to be also true that the nature of our leisure is becoming more like work. Perhaps this is a fair exchange, one of the many transformations that distinguish our future from our past.

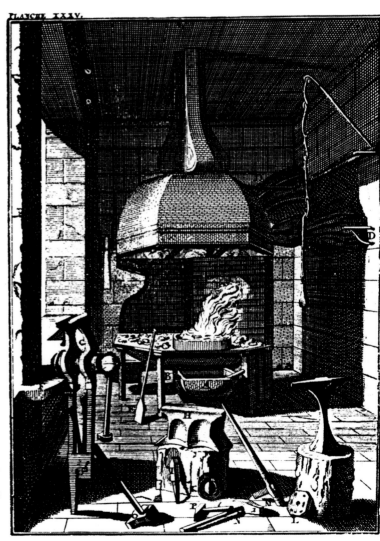

A 17th-century blacksmith's workshop. (From André Felibien's Des Principes de l'Architecture, 1699)

3. Changes

Obviously the three nouns in the title of this book (and of the exhibition on which it is based) are locked together in an unbreakable triangle of mutual dependency. Alter one of the three factors and the other two are affected as well. Not one of them can evolve independently, nor is any one of them dispensable: we cannot, it seems, have life without work, and we cannot have work without tools. But let us look at some of the ways our unbreakable triangle can be twisted, tweaked, and stretched.

TOOLS CHANGE WORK

Some tools are born of specific needs and wants. (Orville and Wilbur Wright wanted to fly, for example.) Some are created for the solution of one problem, but are then adapted to solve others. (Victor Papanek uses that Norwegian wood whittling knife for more than whittling wood.) And some come to exist without our really wanting them or knowing, at first, what to do with them.

In this last group — and it's a large one — are the modern wonders driven into being by the simple fact of their having become possible. The *New York Times* this morning carries an essay titled "Ban Cloning? Not a Chance"; it is written by Kirkpatrick Sale, the author of *Rebels against the Future: The Luddites and their War on the Industrial Revolution: Lessons for the Computer Age.* This morning, Sale is responding to the alarm that has greeted the news of the cloning of Dolly the sheep and to the fear, probably well founded, that it is but a short step from cloning ewes to

cloning, as we say in Brooklyn, youse. Sale refers to "the technological imperative that is inevitable in a culture built on the myth of human power and the cult of progress," and he quotes two of the men who created the first atomic bomb: "'When you see something that is technically sweet, you go ahead and do it,' said Robert Oppenheimer. 'Technical possibilities are irresistible to man,' said John von Neumann. 'If man can go to the moon, he will. If he can control the climate, he will.' These men were creating a weapon they knew could obliterate the earth. They couldn't stop."

And Sale's piece concludes, "The history of science is the history of the dominance of technology, establishing its own definitions and boundaries, over settled human societies and ordered human perceptions.... It will be a chaotic future. Better get used to it." This apocalyptic view is, of course, quite at odds with the sanguine one that arises from the contemplation of our 50 chosen tools; the atomic bomb, it turns out, is nobody's favorite. Still, it is healthy to be reminded that all our tools are not answers to our prayers, but that some of them come to us quite unbidden.

If the manifestation of technological possibilities is indeed irresistible, does it not follow that the implementation of new technology is also irresistible? Will we not use our new tools to do everything they are capable of doing? The answer, thank heavens, is no, and one important piece of evidence is the earth itself. Although, as Sale suggests, we have for quite a while now been capable of obliterating it, it still spins habitably along.

The quality and character of our habitation, of course, is greatly influenced by the infusion of tools, whether or not we avoid their most destructive potentials. To consider a level of activity less dramatic than atomic fission and embryo cloning, the work environments of our 50 respondents have all been shaped by tools; the invention of electric light, for just one example, has touched them all.

The greatest changes in the workplace of our own time, however, have their source in the growing presence of new electronic tools. For the fundamental workplace requirement — space itself — these changes, if greatly oversimplified, could be represented by two opposing tendencies. The first is that the increase in quantity of electronic equipment — scanners, fax machines, docking stations, printers, modem and infrared linkages, cellular phones, speakerphones, larger and larger CRTs — brings a demand for an increase of space. The second trend — the miniaturization of much of this same equipment — promises both a need for less space and an unprecedented mobility. The proper response to both trends is a balancing act that requires constant adjustment.

One group of workplace tools that may soon come to demand greater design attention is the group that talks out loud. Speakerphones are not alone here, but are increasingly joined by office machines with voice recognition and voice synthesizing capabilities. Indeed, for more than 30 years now, computers at the New York Stock Exchange have been giving verbal replies to telephone inquiries. It is clear that when we and our machines begin to interact verbally on a frequent basis, the need for acoustic control in our workspaces will be radically different.

In many cases, of course, the effect of tools is much less direct. New tools change the way we design; new design changes our workplace; and then a new workplace changes our work. For most of us, Carlyle's "dry drudgery of the desk's dead wood" is no longer a given — not liter-

ally, in any case — for our work surface is not a wood desk but a brightly hued plastic laminate computer stand, a portable keyboard, the back seat of a taxi, or the tray table folding down from an airplane seat.

TOOLS CHANGE DESIGN

Frank Lloyd Wright delivered a lecture at Chicago's Hull House in 1901, a year when the English Arts and Crafts movement, glorifying handicraft, was having an influence in America. Wright's lecture, *The Art and Craft of the Machine*, derided handicraft as anachronistic and proposed instead an art based on the machine: "Is it not more likely that the medium of artistic expression itself has broadened and changed until a new definition and new direction must be given the art-activity of the future, and that the Machine has finally made for the artist, whether he will yet own it or not, a splendid distinction between the Art of old and the Art to come? A distinction made by the tool which frees human labor, lengthens and broadens the life of the simplest man, thereby the basis of the Democracy upon which we insist...Now let us learn from the Machine."

Since 1901, we have indeed learned from the machine, some of its lessons having been much more congenial than others. As Wright's lecture nears its centennial, we find ourselves in a world in which almost every aspect is dominated by the machine, one prominent exception being the very area Wright advocated: the marriage of our machines with our art.

Victor Papanek, one of our 50 respondents, has not only been a distinguished industrial designer, but has also written eloquently about the relationship of technology to design. In his seminal book, *Design for the Real World: Human Ecology and Social Change*, he described how recent technology, in being unable to replace the artist or the designer but in being quite capable of replacing other traditional categories of workers, has increased the value of design: "In a world in which much work increasingly will be done through automation and in which most routine supervision, quality control, and computation are performed by word and data processors, the work of the design team (research, social planning, creative innovation) *is one of the few meaningful and crucial activities left to man.* Inescapably, designers will be needed to help set goals for all of society."

TOOLS CHANGE THE WORKPLACE

The present computer revolution is not the first instance of radical technology-driven change in the way we work. At the beginning of the modern era, of course, there was the Industrial Revolution (to use a term made popular by Arnold Toynbee), but that phenomenon was more truly an evolution, taking place gradually from the last decades of the 18th century until the last decades of the 19th. Within the broad sweep of the Industrial Revolution, however, there occurred a quick succession of inventions that constituted a true revolution, one that specifically affected the office and that in many ways must have been even more dramatic than our own experience: In 1844, Samuel F. B. Morse's telegraph was used for the first time between Baltimore and Washington; in 1860, American inventor Christopher Latham Sholes devised the first typewriter; and in 1876, Alexander Graham Bell invented the telephone. With this combination of tools, the office as a center of communications was born. And with Elisha Gray Otis's safety elevator of 1857, combined with

the development of the skeleton iron frame, first employed by William Le Baron Jenney in Chicago's Home Insurance Building, 1885, such offices could be stacked almost infinitely to create both the modern business building and the modern business district.

Compared to those times, our own computer revolution is a rather quiet one, affecting us in ways no less profound but not as outwardly obvious. In one sense it even reverses the previous revolution, scattering us to our homes rather than clustering us in downtowns of unprecedented density. We are dispersing because the great magnet that previously drew us together — the office, place of work for the great majority of us — is changing before our eyes.

THE OFFICE, OUR MOST COMPLEX TOOL

A few years ago the word "office" meant a specific geographic site, like the factory, that held a number of work-related tools. Today the emphasis on geography has evaporated. An office can now be in a traditional office building, in an apartment, in a beach house, or in a suitcase traveling from one site to another. Even within some offices that remain geographically fixed, there are now workspace components that can be wheeled around from place to place. And no matter where their offices may be, many of today's workers are often elsewhere — calling on clients, on the job site, on the road, "telecommuting" from home. Now that it has the option of being portable, we can think of the office itself as a tool, although a highly complex and variable one, incorporating different equipment for different workers and different tasks. Although none of our respondents actually chose the office as a favorite tool, someone could have (as plausibly as choosing a courtroom, as attorney Martin Garbus did), and more than two-thirds of the objects chosen are office components. It is time to look more specifically at some of the changes going on within the office, that institution that is at once our most frequent workplace and our most employed tool.

Steelcase, the world's largest designer and manufacturer of office furniture (and parent of the Steelcase Design Partnership that sponsored the exhibition on which this book is based), in an effort we might characterize as enlightened self-interest, has undertaken a thorough study of different aspects of the new workplace. Among the rather voluminous literature that study has produced is a succinct seven-item list of characteristics of that new workplace. They are:

"1. When it comes to the working environment, what you do is more important than who you are.

2. You don't have to 'go to work' to work. For many people, technology has made being there optional.

3. If and when you do go to work, chances are you won't sit in one place for very long.

4. There is an evolution toward:

— one person occupying several chairs as he or she moves from task to task throughout the day

— several people sharing one chair, as in settings used over the course of a day or week by people who work outside the office as much (or more) than they do inside.

5. Group and team settings are becoming increasingly important...

6. There is no one model for what the working environment should be.

7. We're moving from a focus on efficiency (getting work done quickly and cheaply) to a focus on effectiveness (achieving the outcomes required to meet business objectives). To remain competitive, we've got to do both. But effectiveness must come first."

To these seven we might append a couple more. One is that the multidisciplinary team, rather than the individual or the department, is increasingly seen as the key production unit. And the other is that we seem to be moving from an emphasis on the production of physical goods to an emphasis on the processing of information, or — to put it another way — from the real to the abstract.

The trends on our little list have already had a powerful effect on the workplace, as well as on the vocabulary we use to describe the workplace. The very process of making changes, for example, has been called by a number of terms: "process innovation," "core process redesign," and "reengineering." Take your pick. The physical redistribution of office work, now progressed far beyond the older concept of "satellite offices," now goes by one inclusive name, "alternative officing" and by several more particular terms, "hoteling" (sometimes spelled "hotelling"), "free address," "teleworking," and "the virtual office." Within that new office, space is allocated in new ways with their own new identifications, such as "communities of practice," "caves and commons," "team co-locations," and the divisions "project areas, quiet areas, and guest areas." Finally, in a great rash of hyphenization, the new office has been called:

"high-performance,"
"high-involvement,"
"self-directing,"
"self-managing,"
"worker-centered,"
"non-territorial,"
"post-hierarchical,"

and probably a lot of other names as well. Armed with this whole new vocabulary, let us look more closely at a few of the changes that characterize the new workplace.

THE CHANGE FROM PRODUCTIVITY TO PERFORMANCE

Having written repeatedly in articles and editorials that workplace design can materially affect workplace productivity, and having not only written that but sincerely believed it, I am nevertheless aware that my conviction is based more on intuition than on documentation. Documentation is needed, with the best results probably coming from a company documenting its own experience. Like the office itself, however, methods of measuring what's done in the office are changing, and what's being measured is changing, too.

One element of Steelcase's study of the workplace focuses on the measurement of its output. It notes a change from the measurement of productivity to the measurement of performance. Realizing that the difference between the two terms needs a bit of explanation, Steelcase provides this definition of performance: "a holistic focus on outcome, distinguished from productivity, which focuses more on tactical output." The shift of focus, therefore, is from tactics to strategy, from small-scale effects

to large-scale ones, from individual departments to the whole organization.

This is a shift completely consistent with changes in work patterns, in which the whole notion of separate departments is evaporating. Thomas A. Stewart, in *Fortune*, has written of a company where "mortgage loan officer, title searcher, and credit checker sit and work together, not in series," this cross-departmental teamwork having the result that "information moves straight to where it's needed, unfiltered by a hierarchy. If you have a problem with people upstream from you, you deal with them directly, rather than asking your boss to talk to theirs."

Another of Stewart's examples is the greeting card giant Hallmark, which once shuffled new designs tediously from one department to another — the domains of writers, artists, lithographers, merchandisers, accountants, etc. — but now assembles representatives from all departments into teams — the Mother's Day team, for example — thereby cutting cycle time roughly in half. "Hallmark hasn't eradicated departments," Stewart says. "There will be 'centers of excellence' to which workers return between projects for training and brief, special stints, a bit like homerooms in high school."

In other companies, departments are only a memory, replaced by teams or other sorts of horizontal organization. These units may have names as new as the concept — "microenterprise units," for example, or — in the black-and-white film division of Kodak — simply "the flow." By whatever name, the flow is with us.

THE CHANGE FROM ORGANIZATIONAL CONTROL TO PERSONAL CONTROL

Business Insurance has reported that "According to a 1993 survey of 480 large employers by Coopers & Lybrand, 71 percent allow employees to begin and end work at hours other than the traditional 9-to-5 schedule." By now, that percentage has probably increased. This new freedom to name our own hours (within limits) is popularly known as "flex time" and has done a lot to alter the way we work and the way we think about work.

A similar innovation is one that might be called "flex space," permitting workers to choose where their work will be done at particular times of the day, week, or month — deciding for themselves whether to be in the office or not, and, once there, deciding where to sit.

A contribution to personal control of our workspace that has been recently considered but not yet fully implemented is the provision of creature comforts. Under the rather vague rubric of "designing from the inside out," some architects and designers have begun to imagine the same individualized control over our heating, air conditioning, and lighting in our offices that we expect in our automobiles or even, when things work properly, in an airplane seat.

Another ideal not yet fully reached is the tailoring of the office to particular tasks and even to particular personalities. Within the modern office, efforts in this direction can be dated to ideas hatched around the middle of the century in the Hamburg suburb of Quickborn by two management consultants, brothers Wolgang and Eberhard Schnelle. It was the notion of the so-called Quickborner team that the distribution of workplaces should be based on the patterns of communication between workers and between teams of workers, rather than on company organizational

charts. The team's invention of *Bürolandschaft* (office landscape), first tried in Germany in the early 1960s, then in the United States in 1967 (for the Freon division of E. I. duPont de Nemours in Wilmington) and 1968 (for Kodak in Rochester) was a successful test of the value of the apportionment and placement of territory based on the demands of work, not the circumstances of rank.

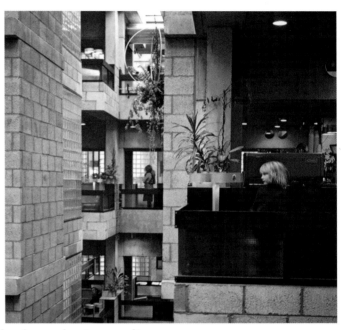

The principle of territorial particularity was given more complete architectural expression in Herman Hertzberger's Centraal Beheer office building in Apeldoorn, east of Amsterdam, in the 1970s, a monument of liberal philosophy and human scale (yet one that, having never been replicated, can hardly be said to have been influential). Talking of his building, Hertzberger said that "The pretension inherent in an office building that has a distinct form...must justify itself by improving the work situation of the people who work there or rather by offering them a helping hand to improve their own conditions by themselves."

Continuing in this tradition, Cecil Williams, David Armstrong, and Clark Malcolm, in their 1985 book *The Negotiable Environment*, postulated different types of office space for each of four Jungian archetypes — the catalyst, the cooperator, the stabilizer, and the visionary — but office design that truly takes workers' personality traits into account will need many more than four types of space. If Marcel Proust were to sign on as an employee today, would he be given the cork-lined study he thinks he needs? Not likely. If it is hard to imagine such a thorough degree of personalization occurring effectively in any collective office of the traditional sort, however, it is easy to imagine its occurring in every home office.

Interior of Herman Hertzberger's Centraal Beheer office building near Amsterdam, a 1970s attempt at providing workspaces with territorial particularity.

Here personal control reigns supreme. Work with your shoes off, if you like; work with your own teapot at your elbow; work while the casserole is in the oven; work with Sutherland and Horne singing duets from *Norma*; work nude. The choices are close to infinite.

THE CHANGE FROM VERTICAL TO HORIZONTAL STRUCTURE

If a company has a horizontal structure, does it mean everyone lies down on the job? On the contrary, such a company apparently does more work with fewer people. New incentives, new opportunities and new freedoms become the motivating factors, rather than the carrots and sticks of middle management. The organizational chart resembling the Great Pyramid of Cheops is on its way out.

Gone already, for the most part, is the supervision — in some cases, surveillance would have been the proper word — coming from the old executive suite, and gone with it the practices and personnel that were its instruments, the tyrannies of the "efficiency expert" or the "time study man" or, as in Aldous Huxley's *Brave New World*, the "Human Element

Manager." These tyrannies stemmed from the popular doctrine of "Industrial Management," which was given authoritative form in Frederick Winslow Taylor's 1911 book, *Principles of Scientific Management*.

In 1925, W. H. Leffingwell, one of Taylor's admirers (a group that also included Henry Ford and Adolf Hitler), wrote a treatise called *Office Management, Principles and Practice*, which included such advice as this about having employees keep their desk contents in order: "Desk system should be taught to all clerks, and close watch kept until they have thoroughly learned it. To ascertain how well they are proceeding, suddenly ask for an eraser or ruler, or some other item not in constant use, and see how long it takes to locate it. If it cannot be located at once, the lesson has not been learned."

It is hard to imagine today's employees tolerating such a drill as Leffingwell's. Yet as recently as 1993, Dr. Francis Duffy, founder and chairman of the British architecture practice DEGW Group Ltd. and an astute observer of workplace design, could write that "Taylor's ideas of the mechanical, top-down, inhuman, status-rich, invention-poor, alienated workplace live on, manifested in every workstation, ceiling tile and light fitting." Today that view seems wildly pessimistic, for Taylor's ideas, not a minute too soon, are out the window.

Duffy was well aware that ideas had changed. In the same article, he reviewed a number of new theories and theorists of the workplace, including "Michael Hammer, who uses the term *reengineering* to advocate the radical redesign of work; ...David Nadler, who ironically enough uses the term *organizational architecture* to describe a new form of organization evolved around 'autonomous work teams' in 'high-performance work systems'; and Peter Senge, who talks about 'the learning organization' as director of the Massachusetts Institute of Technology's Systems Thinking and Organizational Learning Program." Taken together, Duffy said, these ideas comprised what was "little short of a new intellectual industrial revolution."

Duffy's pessimism was based not on a lack of ideas but on a discrepancy between the ideas and their implementation in actual workplaces. "The new gurus," he complained, "talk about the redesign of work but very little about office design." Indeed, he felt, "Never has organization theory been so rich and inventive as in the 1990s. Never has innovation in office planning fallen so far behind. Never has the contradiction between managerial aspirations and physical reality been so sharp."

There are real signs now that things have changed for the better, that physical reality is catching up with those managerial aspirations. A majority of office facilities in the United States have now begun to employ some kind of "alternative officing" practice. Even better news, perhaps, is that most of them report that the new practices have resulted in cost reductions, for there is nothing like the prospect of cost reductions to insure that alternative officing practices will receive further application.

THE END OF FORMALITY, THE NEW FLEXIBILITY, AND THE NEW FREEDOM

A new informality results naturally from the introduction of flex hours and flex spaces, and it is also a consequence of less vertical, more horizontal organizational structure. Such policies as "Dress-Down Fridays," when

the suit and tie (or the suit and scarf) are traded for jeans and sweat shirts, have proved to be more than just cosmetic changes. They have done much to make us feel more comfortable at our work than ever before, and, perhaps surprisingly, by eliminating the distraction of "power dressing," have helped focus our attention where it properly belongs: on our work. And who can doubt that the "Dress-Down Friday" will eventually lead to the "Dress-Down Week," when white button-down shirts will come to be considered as quaint as spats and moustache cups?

In addition to these new benefits for the worker, the type of organization coming into being has benefits for its own operation. Organization consultant Douglas Smith of McKinsey & Co., quoted in Stewart's *Fortune* article, compares the newly ordered, unprecedentedly flexible company to the metal monster faced by Arnold Schwarzenegger in *Terminator II*, a monster that can quickly melt itself down and solidify in a new form, changing from a man to a machine to a knife: "Says Smith: 'I call it the *Terminator II* company. How'd you like to have to compete with one of those?'"

So the dominant word is change. In that unbreakable triangle we noted before, tools change our life, then life changes our work; or, alternately, tools change our work, then work changes our life; or, sometimes, life requires a new way of working, then the new work requires new tools. In whatever order they come, the changes in our lives, the transformations in our overall views of what the world should be and how we should conduct ourselves in it, these are the fundamental things that affect and are affected by — the nature of our work.

Admittedly, the work habits of a few of our 50 respondents are not substantially affected by these overall tendencies. Judy Carmichael's Steinway piano and what she does with it are apparently immune to the changes swirling past. And the act of taking pen (or pencil) to paper may have a future as long as its past. But even these islands of stability may be affected in unforeseeable ways. New attitudes towards home and towards downtown and new audio equipment both at home and in the concert hall may somehow alter the current artist/audience relationship. Although Richard Meier may continue to sketch with his beloved Berol #314, the buildings and spaces he creates for the future may be quite different from those he creates today. And Sara Little Turnbull, continuing to constructively daydream on her workplace sofa, will undoubtedly see a new vision.

Even so, standing in the wings of this deservedly spotlit theater of change, are there not some constants?

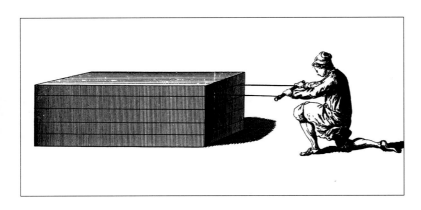

A soapmaker slices soap into small cakes by drawing a loop of wire through it. (From Diderot's Encyclopedia)

4. Conclusion:
Some Constants

Our lives are different from our parents' lives; our children's lives will be more different still. What is most constant in our general culture is change — labor becoming work, tools becoming machines, machines becoming computers, offices becoming tools. What must therefore become constants in our individual lives are vigilant observation of these changes and serious consideration of their implications, for all that we know of the past history of our work, life, and tools teaches us that the history to come will hold some surprises. They may be pleasant surprises, most of them, but even changes from worse to better are not accomplished without the temporary inconveniences of learning new ways.

Obviously, to say that change is constant hardly justifies, by itself, a heading called "Constants" or any feeling of security or optimism. Yet, if change is constant, it is not all-pervading, and many aspects of the workplace of the past will surely continue into whatever future we can imagine. Appealing as the wonders of "virtual reality" may be, they still must take place within real time and in a real space, inhabited also by our persistently corporeal selves and our quite physical tools.

Another constant to be mentioned in this brief conclusion is the goal we hope we are approaching. We must not think that the changes we note are random events, some steps forward and just as many backward. We believe instead that they, like the steps in our own evolution from fish

to amphibian to ape to man, however many aberrations they may include, are in the main purposeful, sequential, and cumulative, being only the most obvious — or perhaps the most strenuous — steps along a single path, an evolution towards a future state in which our work will be more effective, our tools more efficient, our lives more satisfying. If we review the recent changes mentioned above, we will see that the features that have been discarded or have become outmoded — fixed geography, vertical structure, organizational tyranny, and formality — are features we will be more than happy to live without, once some initial adjustments are made. Once thought desirable, they are now seen as obstacles to the goal that lies ahead. The nature of that goal is not yet fully visible, but as we approach it, if we remain alert, it becomes clearer, and an occasional glance at the tools with which we're working gives us some useful clues about where we're headed.

Hannah Arendt, whose book *The Human Condition* has been quoted here several times and has been a standard of sense and sensibility even when not being quoted, introduced her study by saying that "What I propose ... is very simple: it is nothing more than to think what we are doing." I believe that the exhibition *Work, Life, Tools* — and I hope that this accompanying book — will also, in a much less scholarly, more pictorial and more anecdotal way, help us think what we are doing and what, in the near future, we may do differently.

THE PEOPLE AND THEIR TOOLS

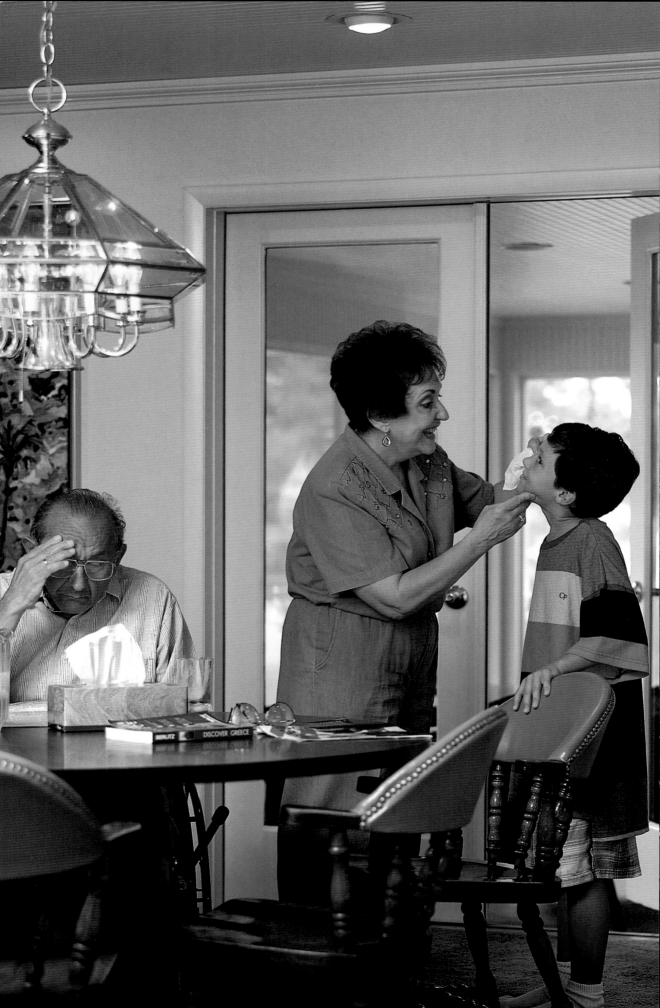

Tina Afendoulis
Mother, Grandmother, Caregiver

Tina Afendoulis has had a diverse career, including a position in human resources with the Dayton Hudson Corporation and involvement in the management of a family-owned business. She has also held a number of volunteer and leadership roles in church, community, and arts organizations. But the majority of her adult life has been dedicated to the role of caregiver. For 19 years, she worked at home raising her four children. Since 1986, she has provided child care for her grandsons, Nicholas and Philip. Afendoulis also cares for Sam, her husband of 40 years who was severely disabled by a stroke in 1994. She lives with her daughter, son-in-law, and grandsons. In addition to her daily role as mother, grandmother, and wife, Afendoulis is responsible for the management of their household, which includes her favorite pastime, cooking.

TISSUE: *"Tissue performs all the basics — it wipes a runny nose, dries a tear, and soothes a cut."*

In my many years of caring for my children, grandchildren, and now my disabled husband, there has not been a single day that I have not relied on Kleenex tissue for so many reasons, above and beyond its intended uses!

Tissue performs all the basics — it wipes a runny nose, dries a tear, and soothes a cut. It is also handy for unexpected spills, or to dispose of a piece of chewed gum. When a shoe is too big, you can stuff tissue in the toe. It can even be used for play time. A toddler can have fun shredding a tissue without causing any damage, and tissues are a ready resource for arts and crafts projects. Tissue helps me take care of myself, too. It's part of my daily routine of applying and removing my make-up, and it's an absolute must for blotting my lipstick.

Kleenex tissue is durable and strong, yet soft and comforting. It's packaged for easy use at home and on the road, and you can find it almost everywhere you go. Unused supplies will last forever — a spare tissue found in the pocket of your coat can be a lifesaver. Tissue is reliable and consistent, like a good friend.

When I was a young woman, my grandmother gave me two handkerchiefs as a gift. She must have known they would be useful to me over the years. Now we have tissue, which has replaced the widespread use of handkerchiefs, but I often think of my grandmother when I reach for a Kleenex tissue.

TOOL:
Tissue. A soft, absorbent paper product that serves as a disposable handkerchief. A main ingredient in facial tissues is cellulose, which is obtained primarily from wood pulp. Tissues, which are usually about eight inches square, were originally developed by Ernst Mahler and were introduced to the market in 1924.

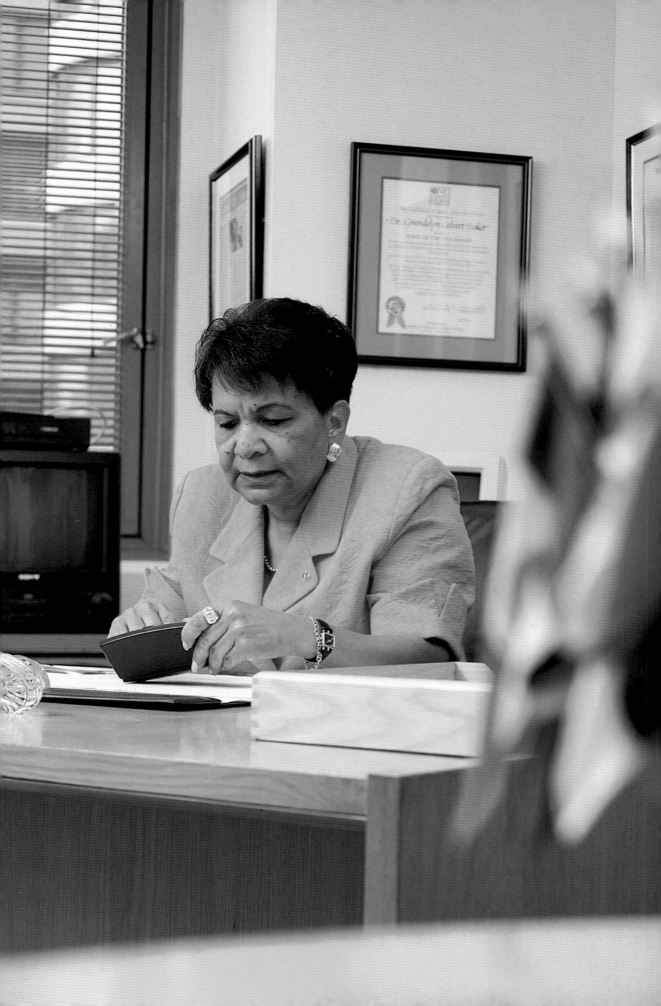

Gwendolyn Calvert Baker

Educator, Activist

A native of Ann Arbor, Michigan, Gwendolyn Baker earned three degrees in education and educational administration from the University of Michigan. Baker began her career in Ann Arbor as an elementary school teacher and later served as an assistant to the president of the University of Michigan as director of affirmative action programs and also as a tenured professor of education there. From 1993 to 1996, Baker served as president and CEO of the United States Committee for UNICEF, the oldest and largest of 38 national committees that mobilize support around the globe for the United Nations Children's Fund. In that position, she has traveled the world. A frequent speaker in the United States and abroad, Baker is the author of many articles, research studies, and two books on multicultural education.

ELECTRONIC ORGANIZER: "My Rolodex organizer helps me to remain current by erasing old information and replacing it with new."

My electronic organizer is the most useful tool I have — I depend on it for 50 to 70 percent of my work. Networking is essential in my line of work, and it helps me to keep in touch with board members, volunteers, staff, and donors.

For years I relied on the large, clumsy, "old-fashioned" Rolodex organizer with paper cards. It wasn't at all portable so I had to have all of my phone numbers in several places. Every time I needed to change a number or update a card I had to cross out old information or just throw the whole card away and start over. I am really pleased with the electronic organizer. It is very compact, so I can carry it in my briefcase or purse — it's with me wherever I go. Making changes is simple. I just erase old information and replace it with new. My staff can even update the phone numbers and addresses in it for me.

Ultimately, the Rolodex organizer makes me more efficient, assuring that my records are accurate and helping me in my networking efforts across the country and the world. Phone numbers and addresses are always at my fingertips.

TOOL:
Electronic Organizer. A small computer that generally features a business card file, a notes file, a calendar, and a calculator. It uses memory to hold thousands of records, and it displays information on a small screen, using characters.

43

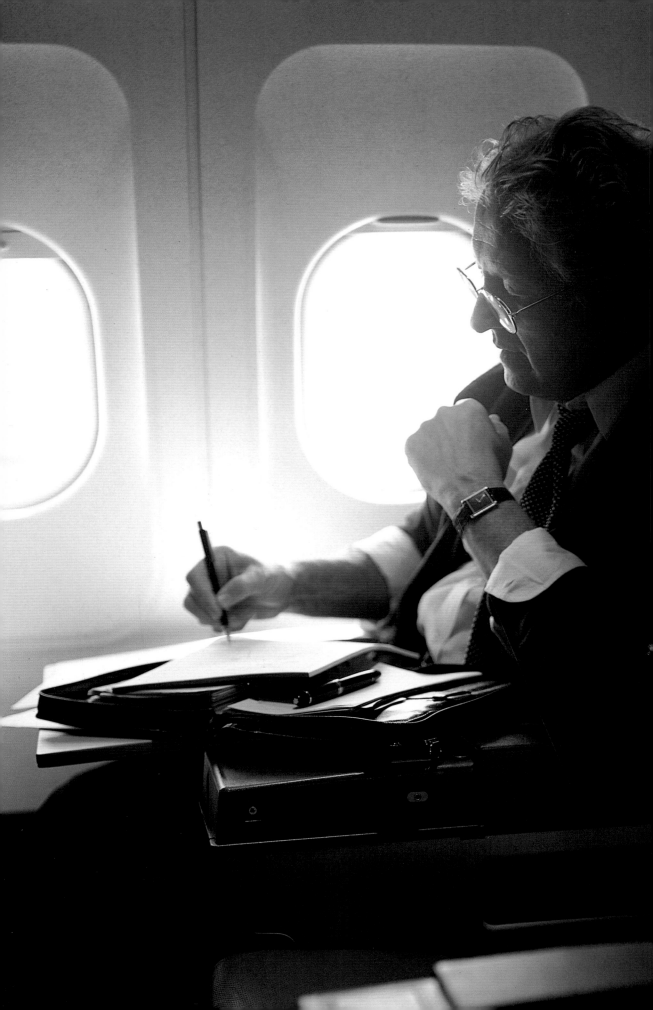

Michael Bedner
President, Hirsch Bedner Associates

Michael Bedner is credited with revolutionizing the field of hotel design, together with his partner Howard Hirsch. The formation of their firm in 1964 marked the beginning of hotel interior design as a separate and distinct discipline. Since that time, their vision and creative energy have provided inspiration to the entire industry. Bedner's design influence can be seen in hundreds of hotels throughout the world. Hirsch Bedner Associates has established offices in Los Angeles, Hong Kong, Atlanta, London, Singapore, and San Francisco.

QUAD PAD: "My quad pad is portable and transcends language barriers."

My quad pad gives structure to the unstructured. It helps me organize my ideas and time, and to communicate an idea or a concept in the quickest way possible. I can plan, sketch, schedule, emote, create, detail, and duplicate, and organize thoughts, projects, and emotions with this aid. It's portable and transcends language barriers. The pad reminds me of a celestial navigation chart that brought me to this life and serves as a tool for taking me through it.

I use the pad ten to twenty times a day, sometimes for ten hours at a time depending on the flight time on any trip. When I travel, the pad in effect becomes my drawing board, my explorer of ideas, my communication medium, and my dream pad. It allows me to refine, structure and schedule projects, regardless of where I am.

If I could improve on the quad pad's design, I would have it computerized with the computer and screen being the size of my current pad and with the ability to use a stylus and voice recognition for the dictation of notes and directives. I would arrange to retrieve drawings and information from whatever office necessary via modem or e-mail, and to use the Internet for information and to communicate in real time, globally.

TOOL:
Quad Pad.
A quad pad consists of medium weight white paper, 8½" x 11" in size. Light blue lines form a grid on the paper, with ¼" squares forming more strongly defined 1" squares. There are 50 sheets of paper in each pad.

47

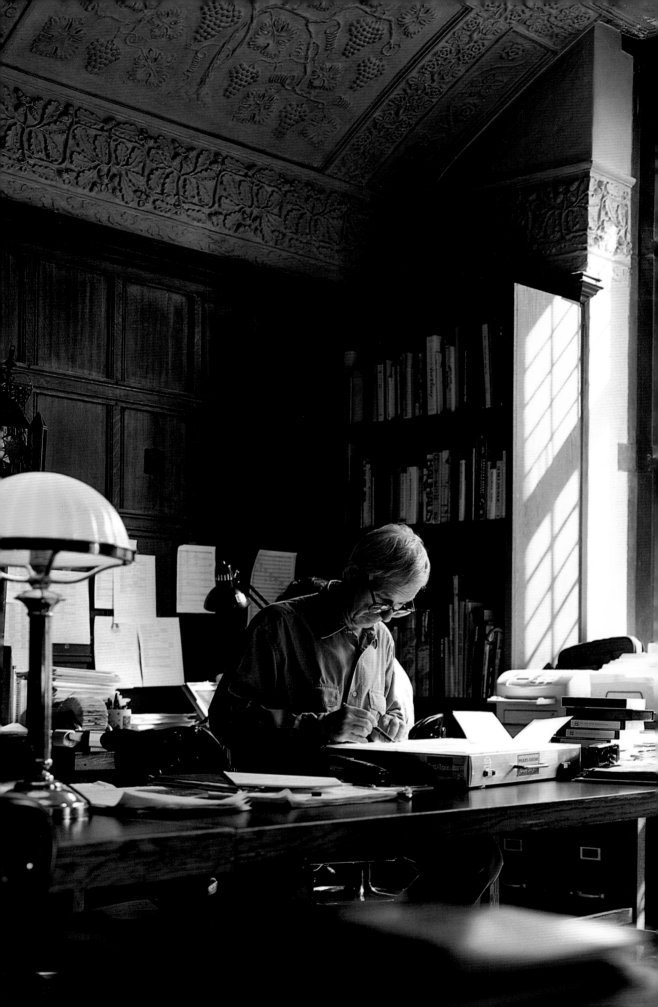

R. O. Blechman
Illustrator, Animated Filmmaker, The Ink Tank

Born in 1930, R. O. Blechman graduated from Oberlin College in 1952. Only a year later, his first book, *The Juggler of Our Lady,* was published. It was selected as one of the A.I.G.A. "Fifty Books of the Year." For the past forty years Blechman has been a major force in the field of illustration. Twenty years ago he branched into animation and now pursues a dual career as illustrator and director of the New York-based animation studio, The Ink Tank. His illustrations have appeared on covers of *The New Yorker* and *The Atlantic* and he has had one-man exhibits in New York, Paris, and Munich. His animated commercials for clients — including Hershey's, Perrier, 7-Up, and MTV — have won many honors and awards, including a Gold Medal from the Cannes Film Festival and a Silver Lion from the Venice Film Festival.

LIGHTBOX: "My lightbox has probably become a kind of electric security blanket."

The most important tool in my work is my lightbox. My first sketches usually have just the right spontaneity, but there is invariably something wrong with a detail or two. If I were to start over, I would lose the spontaneity and intuitive feeling of the sketch. With the lightbox, I can put a clean piece of paper over my initial drawing and still see the original marks I made. Refinements can be made without losing anything.

The lightbox allows me to use each drawing as the basis for subsequent drawings. As a result I don't have the bother or the anxiety of starting drawings from scratch — the lightbox frees me to concentrate on finessing the work.

I use my lightbox all the time. It is as much a fixture on my worktable as a lamp and has a very comforting glow. After so many years of use, it's probably become a kind of electric security blanket.

TOOL:
Lightbox. The light-box is made up of a 24" x 18" stainless steel and plastic frame with a trans-lucent top. The frame houses a lightbulb which illu-minates drawings or transparencies from beneath. The hard, flat top allows a per-son to trace or draw while seeing an image clearly.

Mary Beth Blegen
1996 National Teacher of the Year

For over thirty years, Mary Beth Blegen has enriched the educational environment of Worthington, a small rural community in Southwestern Minnesota. On April 23, 1996, she was named the 1996 National Teacher of the Year and was honored by President Bill Clinton in a ceremony at the White House. Blegen's childhood in Chamberlain, South Dakota was blessed with teachers who helped her identify and develop her abilities. Following her graduation from Augustana College in Sioux Falls, South Dakota, Blegen began to share that love of learning with her first class of students in Worthington. Several years into her career she took time out for marriage and family but soon returned to the classroom and students she loves. She teaches English, humanities, and writing at Worthington High School.

ANY SMOOTH WRITING PEN: "A good pen has been important to me since grade school, when I discovered that I liked to write."

The most important tool in my life is a wonderfully smooth writing pen. A good pen has been important to me since grade school, when I discovered that I liked to write. I had teachers who encouraged me and made a difference because they saw something in me that I did not yet see in myself. I came to love learning, too, and wanted to share that love with kids.

So now I teach and I write. Both activities require a constant, changing thought process. I use a pen of one sort or another probably hundreds of times in a week, writing notes to myself for my classes and jotting down ideas for my weekly columns.

Every time I plan a lesson for one of my classes or do some brainstorming for my writing efforts, I become very much aware of the pen that I will be using. I look almost daily for the perfect pen for my purposes. I frequently go through my junk drawer until I find exactly the right one — I like my pens smooth-flowing and comfortable to hold.

I like pens because they are accessible and easy to use anywhere, any time. A pen is easy to carry along in my pocket or purse, so I always have one when I need something to help me express my ideas immediately, in my way.

TOOL:
Any Smooth Writing
Pen. A hand-held,
cylinder-shaped
instrument contain-
ing ink which can
be transferred
through a tip to
a writing surface.
The quill pen was
the most common-
ly-used writing tool
for nearly 14 cen-
turies. The first
patent for a ball-
point writing tip
was issued in
1888 to American
John H. Loud.

55

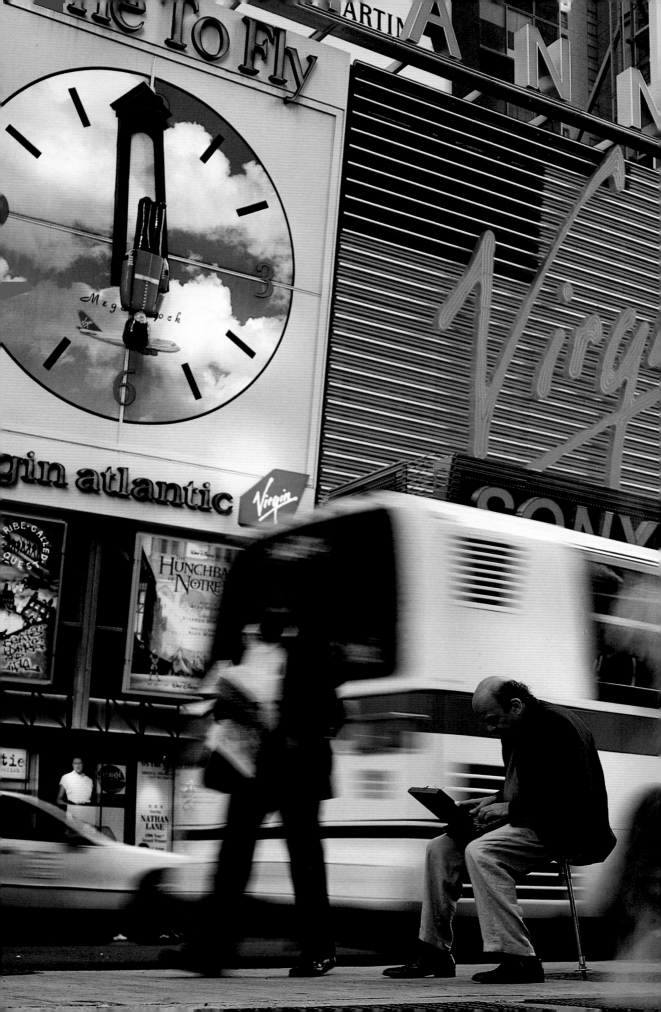

Marshall Blonsky
Cultural Critic, Author

Marshall Blonsky, whose doctorate is in comparative literature from Columbia University with the participation of Yale University under the direction of Paul de Man, is a writer and professor. His authorial credits include "American Mythologies," "Private Property" (with Helmut Newton) and "On Signs." He is a fellow of the Wolfson Center of New York's New School and a professor of communications at New York University. He has written for such publications as the *Washington Post*, the *New York Times Magazine*, *Telèma*, *Folha de São Paulo*, etc. In 1973 he introduced the field of "semiology" to New York City at the New School. His next book is on the travails of Apple Computer.

PORTABLE COMPUTER: "I use the Macintosh PowerBook 180 computer when I want to be myself. I use it when I want to be, very simply, nice."

The most important tool in my work is my Macintosh PowerBook 180 computer. It sits on my desk, the father (or mother) of all subsequent PowerBook computers I have bought — its progeny.

The 180 computer comes from the glory days of Apple when upon launch in 1991 it announced the beginning of personal communications devices. Writing on it today, I memorialize Apple and John Sculley. On my desk I also have some of the 180 computer's sleeker progeny, including the troubled 5300 computer. Writing on it (when it works), I am slick; writing on its successor, the 3400 computer, I shall be slick; writing on the 180 computer, I approach sincerity.

I use my antique 180 computer when I'm not on a deadline, showing off — when I'm happily free of the need to be pyrotechnical, or the need to prove to someone that I can make writing into something like a film full of effects. I use the 180 computer when I want to be myself. I use it when I want to be, very simply, nice. (While I wrote most of this on the 5300 computer, I am writing this last paragraph on the 180 computer.)

TOOL:
Portable Computer. A portable, programmable electronic machine that assembles, stores, correlates, or otherwise processes information. (Blonsky's choice is the Macintosh PowerBook 180 computer, which was state of the art in 1993 when he bought one. The 180 computer is dated by its black and white screen and tracking ball.)

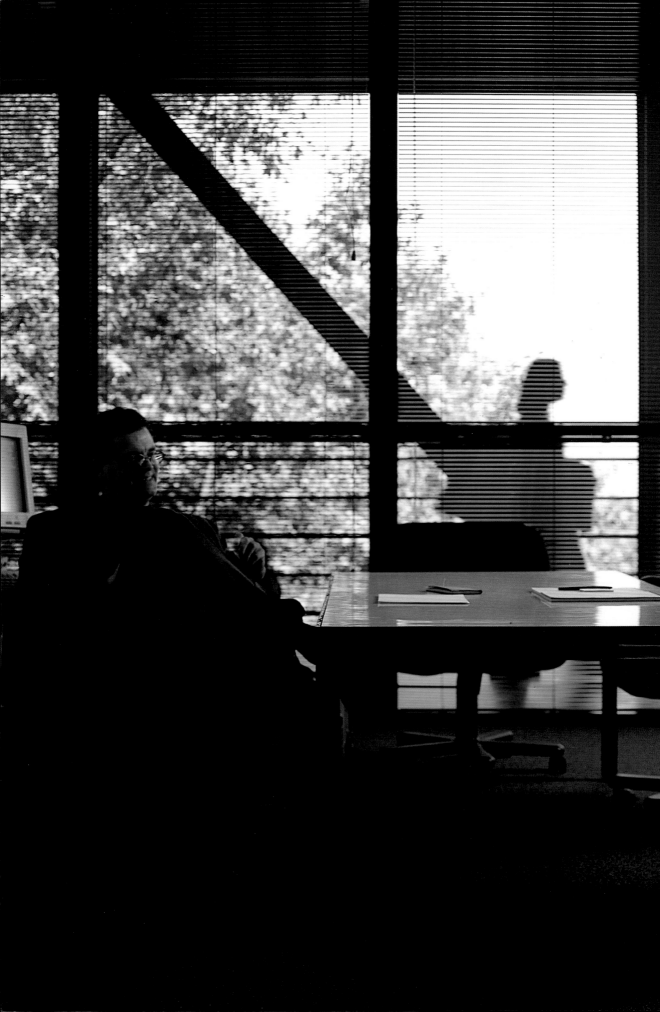

David Brown
President, Director & CEO,
Art Center College of Design

David R. Brown is president, director, and chief executive officer of Art Center College of Design in Pasadena, California. Prior to leaving the East Coast for Art Center in 1986, Brown served seven years at Champion International Corporation (Stamford, CT), one of the country's larger paper and forest products companies. As vice president and creative director, his responsibilities included all corporate and marketing communications, advertising, design, press relations, and public affairs. Brown holds a "double" Master of Arts degree from Trinity College and a Bachelor of Arts degree from Dartmouth College. He and his wife Judy have two daughters and a son.

POCKET CALENDAR: "My pocket calendar helps me plan, remember, organize, commit, avoid, and wonder about the meaning of time, and how we perceive and experience its passage."

I first came across a Letts of London pocket calendar in a department store in Tokyo. It's a Model 33S calendar, with a horizontal page layout format and a black leather cover. Since buying my first one, I have used my calendar constantly — several times an hour. It's always with me — on my desk, in my briefcase, or in my pocket.

I chose this tool because the way I spend my time is the only thing over which I have absolute control, and for which I must take full responsibility. This calendar serves my professional ends as well as my emotional, physical, and psychological needs. It helps me plan, remember, organize, commit, avoid, and wonder about the meaning of time and how we perceive and experience its passage.

My calendar is a study in efficiency. The calendar shows time by the week and by the day, in hourly increments. Other sections show the year at hand and the two years ahead. Because of its scale, it reminds me of how much can be fitted into a year, a month, a week, a day, an hour. It suggests time, that which has been and is yet to come, and gives me an analog metaphor for time — my time, as well as that of others. As the president of a college, I really have only two ways to influence things: by my choice of people and by the allocation of resources — the college's cash and my own time. The calendar helps me be efficient.

9 September

Monday

8 am

9 FALL
10 TERM
11 BEGINS

12 noon

1 pm

2

3

4

5

6

7

8

12 September

TOOL:
Pocket Calendar.
A small booklet,
with leather or vinyl
covers, indicating all
the days of the year
and spaces in which
to record meetings,
appointments, birth-
days, to-do lists,
and other time-sen-
sitive information.
Unlike desk or
wall calendars,
pocket calendars
are designed to be
portable, and are
often with a person
at all times — in
a pocket, briefcase,
or purse. The
thought of losing
one's pocket calen-
dar can evoke fear
and panic in most
professionals.

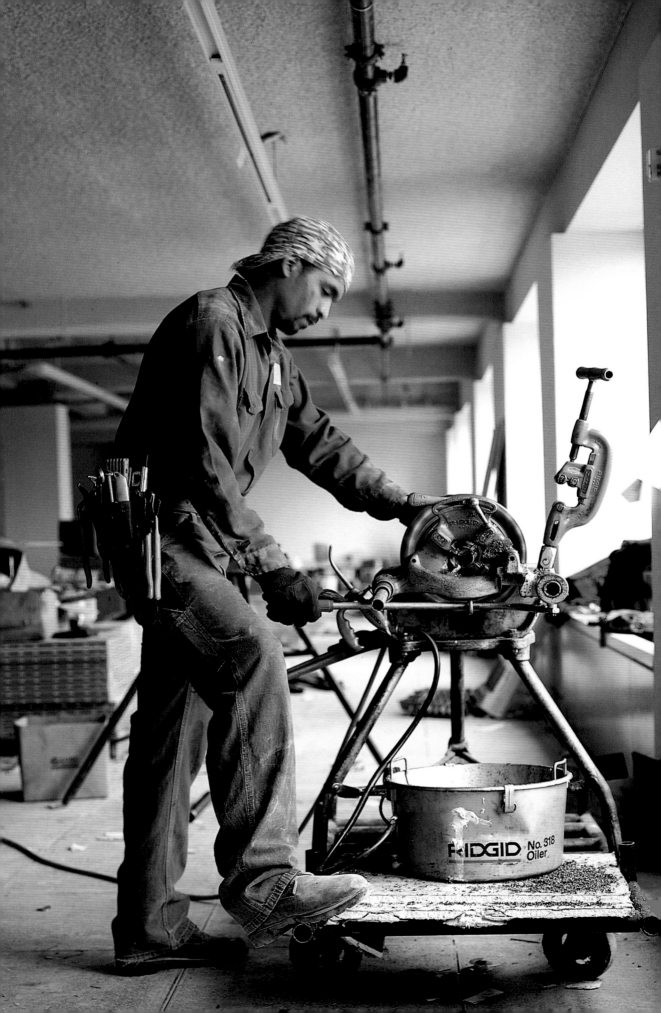

Ramon Candelario
Steam Fitter

Ramon Candelario was born in Puerto Rico in 1965. He and his family came to New York when he was four years old. Candelario attended Prospect Heights High School in Brooklyn, NY, and has been a steam fitter at Active Fire Sprinkler for 15 years. He and his wife Evelyn and their three children live in Staten Island, New York.

PIPE THREADER: "The pipe threader simplifies the process and expedites it, eliminating laborious hand process."

The tool I have selected is my Ridgid 300 pipe threader. I selected this tool because it is a crucial part of the trade — a tool I use on and off all day, making and installing sprinkler systems.

The tool cuts the pipe to size and makes a "male" thread for a fitting connection. The machine, which is run by an electric motor, turns the pipe while I bring down the cutter and then bring down the threader in separate motions. It's a pretty simple tool — I can teach someone to use it in a day if they're bright.

I have a hand-threader for smaller jobs and minor repairs, but the electric pipe threader simplifies the process and expedites it, eliminating laborious hand process. It saves a lot of time and effort on the larger jobs that I do most of the day. I can't imagine how I would do my job well without it.

Other companies make pipe threaders, but the Ridgid pipe threader is the one to use in my line of work. My brother-in-law brought me into the business 15 years ago and I have been here since, using this kind of pipe threader to do my job.

TOOL:
Pipe Threader.
A machine used
for cutting pipe
and threading for
connection. The
threader is pow-
ered by electricity.
A pipe inserted into
the machine is rap-
idly rotated so that
"threads" can be
molded into it. The
threads allow one
pipe to be screwed
into another.

67

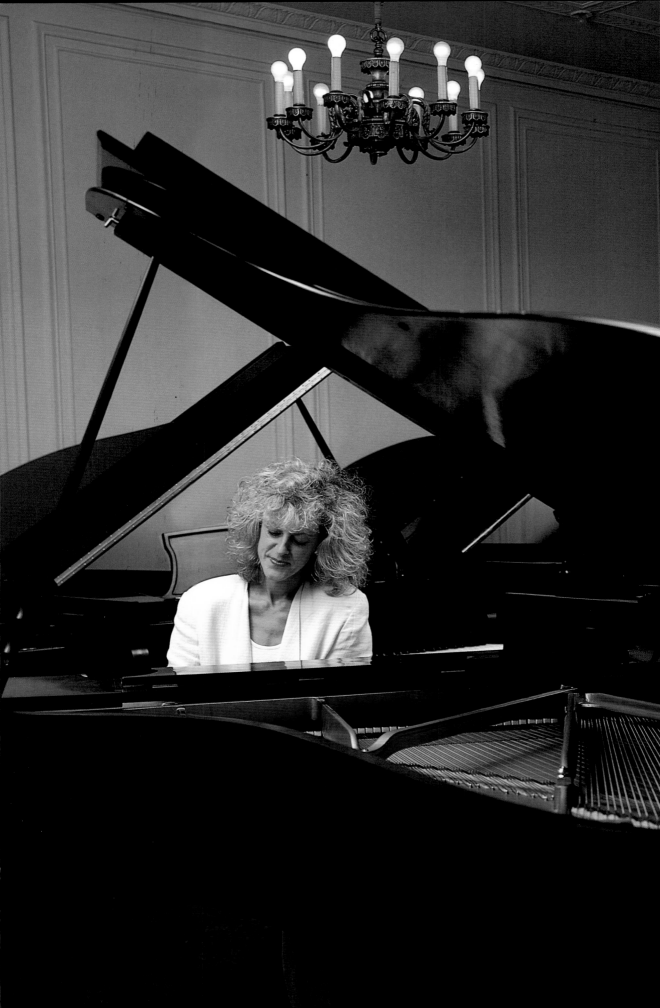

Judy Carmichael
Pianist

Judy Carmichael made her professional debut playing piano at age 16 at UCLA's Royce Hall. The years since have been spent honing the skills required to reach the rank of one of the country's leading interpreters of the early jazz piano forms of stride, boogie, swing, and New Orleans style. This concentration on classic jazz led early supporter Count Basie to nickname her "Stride." A native of California, Carmichael moved to New York twelve years ago and maintains a busy concert schedule throughout the world. In 1992, Carmichael was the first jazz musician sponsored by the United States government to tour China. She has written two books on the musical genre of stride piano as well as numerous articles on the subject of jazz. Carmichael has been featured on National Public Radio's "Morning Edition" and was recently profiled on CBS's "Sunday Morning."

PIANO: "The tone and clarity of each note of my piano, and the feel of it, are an inspiration rather than a limitation."

A Steinway piano is the tool most crucial to my professional life. As a concert pianist, I want a piano with a rich sound and inviting touch. Steinway delivers this more than any piano made today. The tone and clarity of each note, are an inspiration rather than a limitation, as is the case with some other pianos. The dynamic range of a Steinway is great, allowing me a wide emotional range in my playing. I play several different kinds of jazz, which require a versatile piano capable of many moods and sounds.

I started playing piano at a young age on an old, beat-up upright. The Steinway grand I now have at home, reminds me of that first piano the way Pebble Beach might remind Arnold Palmer of a miniature golf course. It definitely had a limited range of expression!

I now play the piano for up to five hours a day to prepare for my performances. And whether I'm playing Carnegie Hall, or an intimate setting like the Peggy Guggenheim Museum in Venice, a Steinway is always my piano of choice. As I continue to grow and develop, the Steinway remains a source of inspiration and a challenge. When your instrument allows no limitations on your creativity, it is left to you to make the most of your gift.

TOOL:

Piano. A stringed musical instrument with a keyboard of 88 ivory and ebony keys. The keys control felt-covered hammers that strike steel strings housed within wooden structures of various shapes and sizes. The nine-foot wing-shaped grand piano is preferred for concert performance due to its tone and full sound.

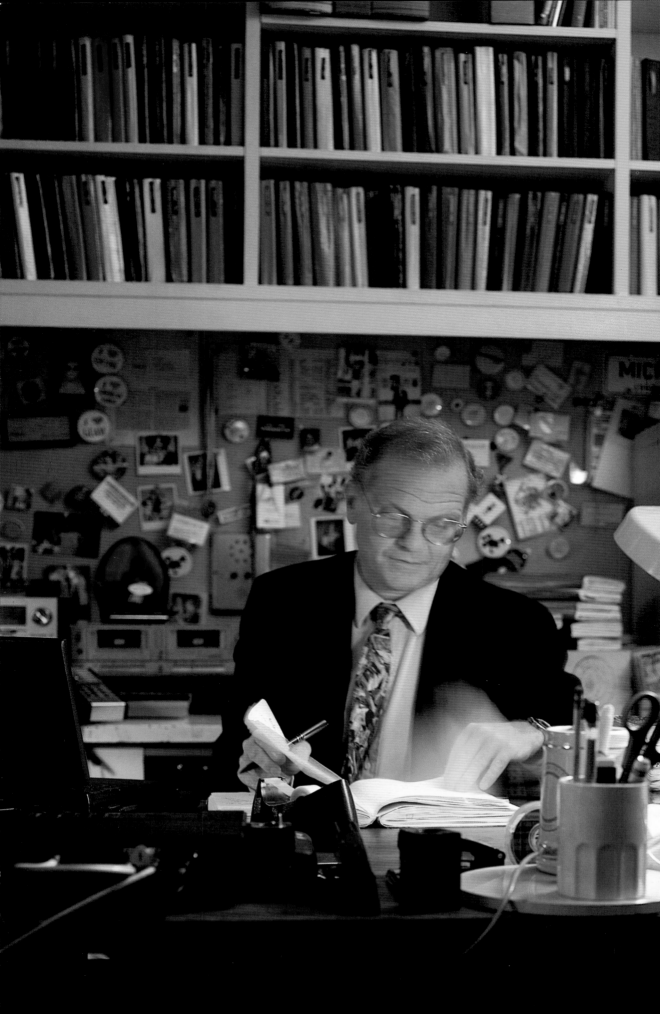

Christopher Cerf
Writer, Composer, President,
Christopher Cerf Associates, Inc.

Christopher Cerf is an author, record and television producer, editor, composer/lyricist, humorist/satirist, educational consultant, computer software designer, and the president of his own company, Christopher Cerf Associates, Inc. As the founding editor-in-chief of the Children's Television Workshop's Products Group, Cerf played a pivotal role in the ongoing funding of the "Sesame Street" television show, through the creation of educational records, toys, and books. Cerf has also composed music for Children's Television Workshop productions, collecting two Grammy awards and back-to-back Emmy Awards for songwriting (1989 and 1990). Other Cerf musical material has appeared on "Saturday Night Live" and in numerous Muppet productions, and has been performed by such recording artists as Harry Belafonte, James Taylor, Paul Simon, and Bonnie Raitt.

COMPOSITION BOOK: "As long as I have my notebook in hand, I have all the data I need for any situation that comes up during the day."

As I pursue my varied professional interests, I'm surrounded by technology — computers, synthesizers, portable phones and digital tape decks are all a part of my work. But my one indispensable tool is an old composition book — the kind that we all used to have back when we were school kids, with the lined pages and black-and-white marble covers.

These composition books are so important to me that I actually use two at once. I tape them together at the start of each month and carry them with me everywhere I go until the books are full or another month arrives, whichever comes first.

I use the books to jot down, in chronological order, all my song and story ideas, notes on every business or creative meeting I attend, and the phone numbers and messages I receive. I even tape my schedule into the front of the book and updated contact lists into the back. The result is that as long as I have my notebook in hand, I have all the data I need for any situation that comes up during the day. I don't lose phone numbers and notes the way I used to when I kept everything on separate scraps of paper. And because I keep track of everything chronologically, in a separate notebook for each month, I can reconstruct everything I need to know about a project or idea. This method works even years after the fact. The old books are fun to look at, too!

18 Sept 1996 — "SLEEPOVER DANCE"
S. St. Song Mtg/lunch w/ Judy Freudberg

Hey it's a sleepover

18 Sept 96 —

CUSTOMER COPY

Judy F. Slopera
Dance
Song

ISLE OF CAPRI
NEW YORK, NY
0000217961739001
APPROVAL CODE
626945

SEP 18, 96

(CCA-S St
SALE Song
619623
FOOD

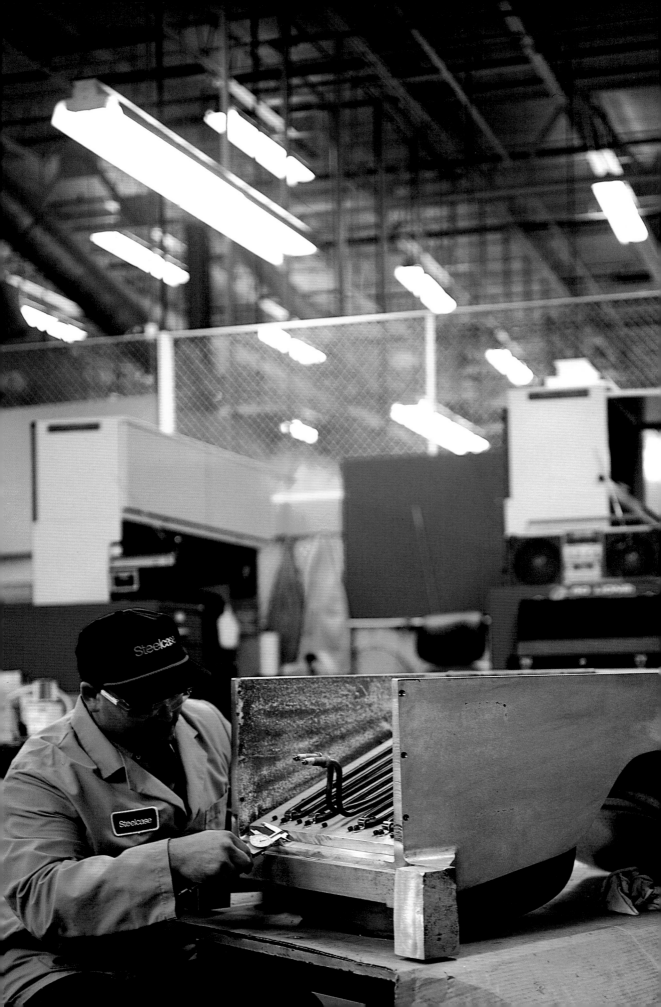

Kelly Coplin
Tooling Expert

Kelly Coplin was born in 1960 in Charlotte, Michigan. After serving in the Marine Corps Reserve from 1980 to 1986, Coplin was an apprentice to a mold maker and was awarded a Journeyman Card in 1986. For the past 18 years he has worked for Steelcase Inc. in shipping, desk welding, chair upholstery, and chair tooling. He and his wife Cheryl Ann, who was his high school sweetheart, have four children.

SIX INCH DIAL CALIPER: "I like this tool so much that I have several of them, including a caliper my father used."

My family has been involved in toolmaking of various kinds for three generations now — my grandfather was a tool-and-die maker, my father was a jig-and-fixture maker, and I am a mold maker, the third generation of Journeyman card-holders in my family.

Calipers have been around for many centuries. Now there are digital electronic calipers that can be coupled to a computer to provide us with printouts and graphs that will show how the measurements are generated. Despite the enthusiasm about new technologies, tool building is still an art that requires craftsmanship.

I use calipers several times a day. The dial caliper, in particular, is a very versatile precision tool because it can measure outside, inside, and depths. I use it to find out just how badly things are wearing out, or to discover just how precisely parts are being made on various machines. The caliper is easy to read, and I can carry it with me wherever I go in the shop.

I like this tool so much that I have several of them. I have one caliper that I use for everyday purposes — it's kind of scratched up but it's still in good working shape. Then I have a new caliper that I use for very close tolerances in nice conditions. And I have one my father used when he was in the trades.

TOOL:

Six Inch Dial Caliper. A stainless steel instrument used to measure thickness and distances with a high degree of accuracy. The caliper has two curved, hinged legs and a dial, which is graduated in increments representing .001 inch and is mounted on the jaw side of the tool.

79

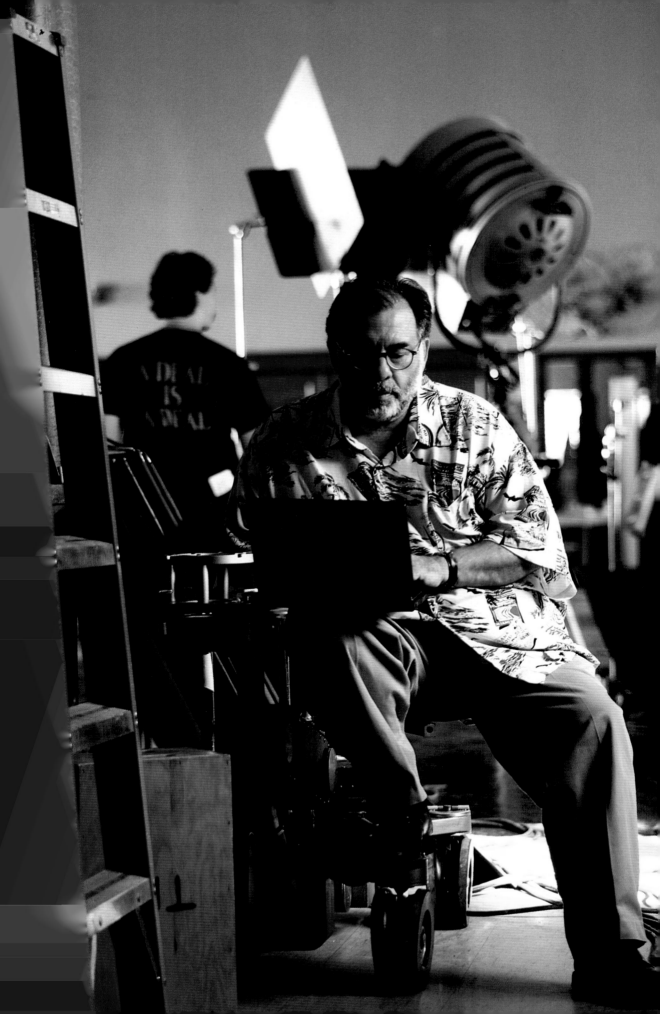

Francis Ford Coppola
Director, Writer

Francis Ford Coppola was born in Detroit in 1939, but grew up in Queens, New York. After earning his bachelor's degree in theater arts in 1959, Coppola enrolled at UCLA for graduate work in film. In 1969 Coppola and George Lucas established American Zoetrope, an independent film production company based in San Francisco. In 1971, Coppola's film *The Godfather* became one of the highest-grossing movies in history. The film received an Academy Award for Best Picture, and a Best Director nomination. In 1974, Coppola wrote the screenplay for *The Great Gatsby,* and *The Godfather, Part II* was released, which won six Academy Awards and Oscars for producer, director, and writer. More recently, Coppola has directed and produced *Bram Stoker's Dracula* and produced *Mary Shelley's Frankenstein.*

PORTABLE COMPUTER: "My computer is the link to all my collaborators."

My IBM ThinkPad 560 computer allows me to do all of the tasks that any computer would, but because it's portable, my efficiency and ability to take care of many different projects are greatly enhanced. The ThinkPad computer has radically changed the way I work.

With the pace of life in the film industry and the kind of schedule I keep, it's crucial that all of the information I might need is right where I can easily access it. My computer allows me to read, write, and edit scripts, send and receive e-mails and faxes, check agreements and schedules, and take notes about various meetings or filmings throughout the day. Everything is in one organized place, rather than scattered about on separate pieces of paper.

Communication is critical in the film business. So many people contribute to the success of a film, and it's hard to know where they are or what they're doing at any given time. They're very difficult to reach by phone. Being able to go on-line makes the computer an important communication tool. My computer is the link to all my collaborators. I can communicate quickly with all the people involved in a certain project, from producers and set designers to cinematographers and script writers. I can also stay in touch with my office when I'm not there, receiving messages and information from my assistants in a timely, convenient way.

TOOL:
Portable Computer.
A portable, pro-
grammable elec-
tronic machine that
assembles, stores,
correlates, or other-
wise processes
information.
(Coppola uses
an IBM ThinkPad
560 computer,
which is 1.2" thick,
weighs just 4.1
pounds, and fea-
tures a fullsized
keyboard. It was
introduced
in 1996.)

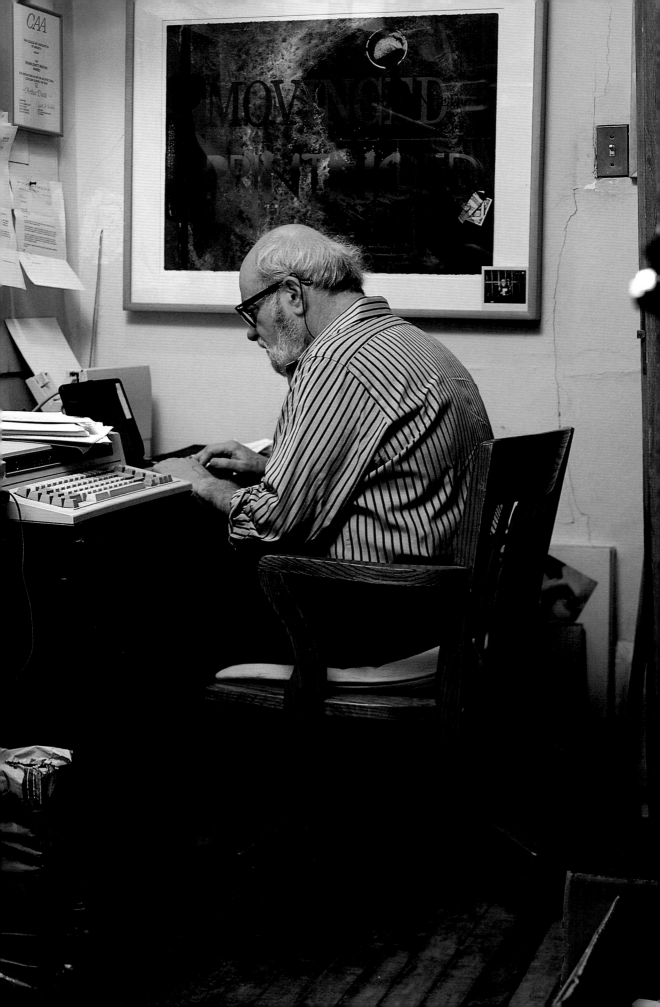

Arthur Danto
Art Critic

Arthur Danto was born on January 1, 1924, in Ann Arbor, Michigan. He holds Master of Arts and Ph.D. degrees from Columbia University, and did postgraduate work at the Université de Paris. For 40 years, Danto taught philosophy at Columbia University. Since 1975 he has been involved with the *Journal of Philosophy,* as editor and president of the publication's board. He currently is art critic at *The Nation.* Danto has written several books, including *Nietzsche as Philosopher* (1965), *The State of Art* (1987), and *After the End of Art* (1996). His honors are numerous, including Guggenheim Fellowships in 1969 and 1982, and honorary doctorates from Parsons School of Design (1990), the School of Visual Arts (1995), and Pennsylvania Academy of Fine Arts (1996). Danto, who has two daughters, married Barbara Westman in 1980.

PORTABLE COMPUTER: "I need the objective presence of words in order to generate more words."

I can't work without my Compaq Aero computer. I used to use yellow pads to write on, but in time composed directly on the typewriter. I used to finish a piece and then rewrite it three or four times, from the beginning. The computer enables me to rewrite as many times as I need, until it is right. I can edit and retain my changes in case I need to go back. Since I made the switch, my writing has gotten denser, clearer, and more poetic. The typewriter feels clumsy and exhausting now.

My Compaq computer enables me to think, by writing. I cannot think in my head, but need the objective presence of words in order to generate more words. My handwriting has become too cryptic for sustained writing — the computer is as fast as my thoughts are and it gives them permanence. That is, until I need to change them. The machine is fast, responsive, and has a memory. And because it is small — only four pounds — working with it has an immediacy no other tool for writing possesses.

The spell-check taught me what a lousy speller I have always been, and the Lotus Organizer feature really does organize my life. The machine is like having a tiny adjunct soul. I use this computer every day for several hours, even when I travel. It has become a part of me — I cannot imagine being without it.

[WARHOL AND THE POLIT

Arthur C. Dar

copyright 199

In the years of revolutionary fervor – in 1968 and 69,

mid-70s – students in American universities felt themselve

a largely corrupt society. So even when their lives were

occupations, with rallies and picketing and confrontations

enhance their understanding of things by participating in t

explained the complexities of their universities as military

TOOL:
Portable Computer.
A portable, pro-
grammable elec-
tronic machine that
assembles, stores,
correlates, or other-
wise processes
information.
(Danto's choice
is the Compaq
Contura Aero com-
puter which is 1.5"
thick and weighs
only 4 pounds.)

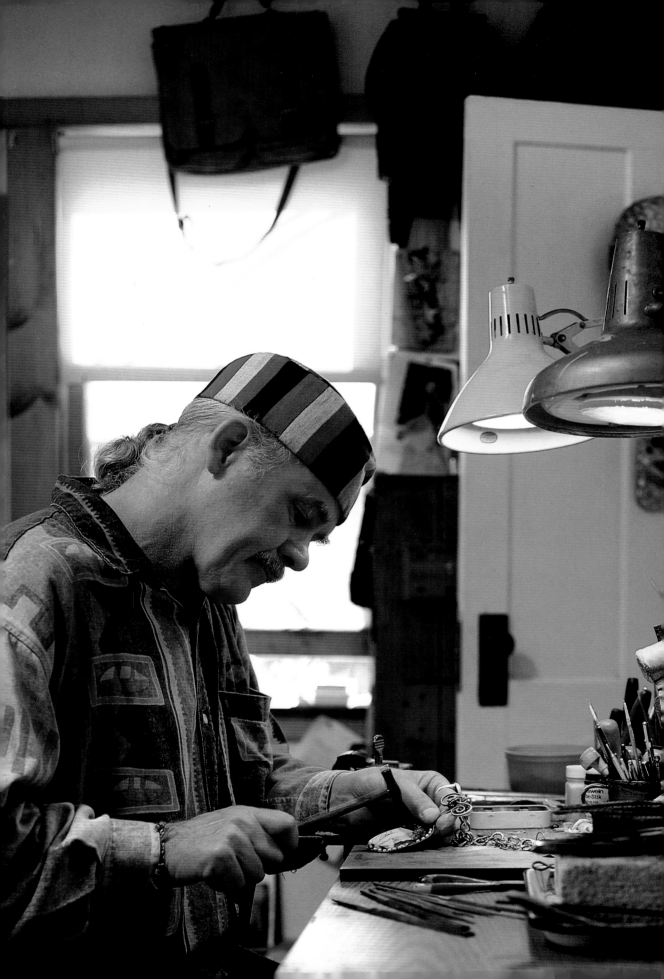

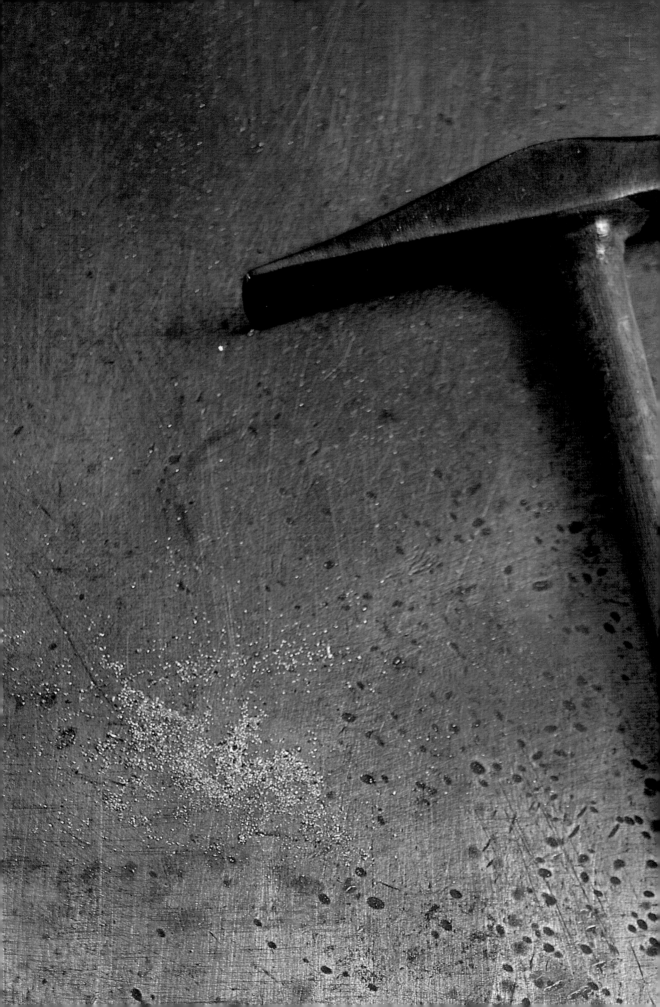

TOOL:

Hammer. A hand tool consisting of a handle with an attached rigid head. The tool is used to exert an impulsive force by striking. The hand-forged goldsmith's hammer comes in a variety of sizes, but its wooden handle is commonly six inches long and its iron head, blunt on one end and tapered on the other, is commonly 2.5 inches long.

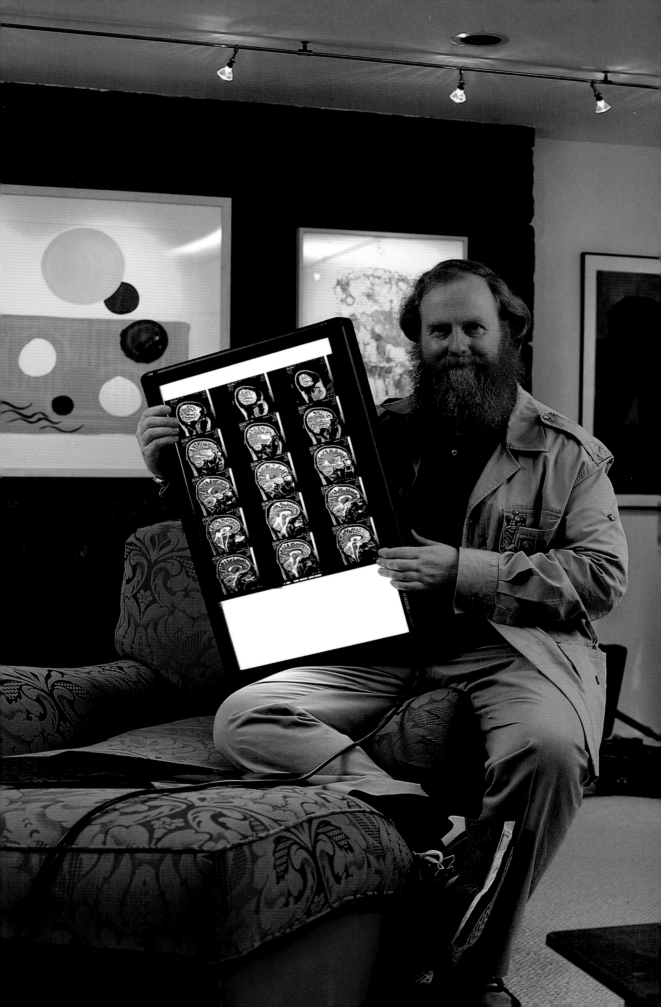

Bran Ferren

Executive V.P., Walt Disney Imagineering

Growing up on the Upper West Side of Manhattan, Bran Ferren traveled extensively with his parents, both artists inspired by exploration. In 1978 Ferren founded his own design firm, Associates & Ferren (now owned by Walt Disney). His work, which has won three Academy Awards for technical achievement, has included design for the Broadway shows *Evita, Cats,* and *Sunday in the Park with George* and for road tours by Pink Floyd, David Bowie, and Paul McCartney. Ferren also directed the special visual effects for the films *Altered States, Little Shop of Horrors,* and *Star Trek V: The Final Frontier,* and he has designed multiple museum and touring exhibitions. Ferren is currently executive vice president of creative technology and research and development for Walt Disney Imagineering.

MY BRAIN: "I use my brain for just about everything and I sedom leave home without it."

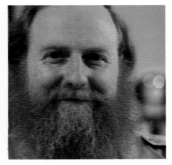

Professionally speaking, my brain is the tool I rely on most. Despite any evidence to the contrary, I use it on just about every project and seldom leave home without it (except, perhaps, that graphics job in Schenectady).

Although not perfect, it usually manages to get the job done. You're often going to be presented with problems and issues that seem intractable, however, the nice thing about the brain is that it adapts and learns by its mistakes. This property of being pretty much self-correcting is unique among tools and makes it so valuable to me.

For most of the brain's useful life, it's constantly learning and improving itself. While it appreciates simplicity, it thrives on making sense out of complexity. It can reflect upon the wonders of a rose while ordering Chinese take out. Try that with a ballpeen hammer or Milton's sketch pad.

I have a reasonably good idea about what the brain is made of, but I don't have a clue how it works. That's the nice thing about tools — we don't have to understand how they work. Most people don't know how computers work; they just use them. Hell, most people don't know how their ballpoint pen works...

TOOL:
My Brain. A key part of the central nervous system that is composed of gray matter, a bunch of neurons, ideas and miscellaneous nonessential information. The brain is the primary center for fusing and interpreting sensory input as well as for consciousness, memory, thought, emotion, inspiration and humor. Size and performance vary.

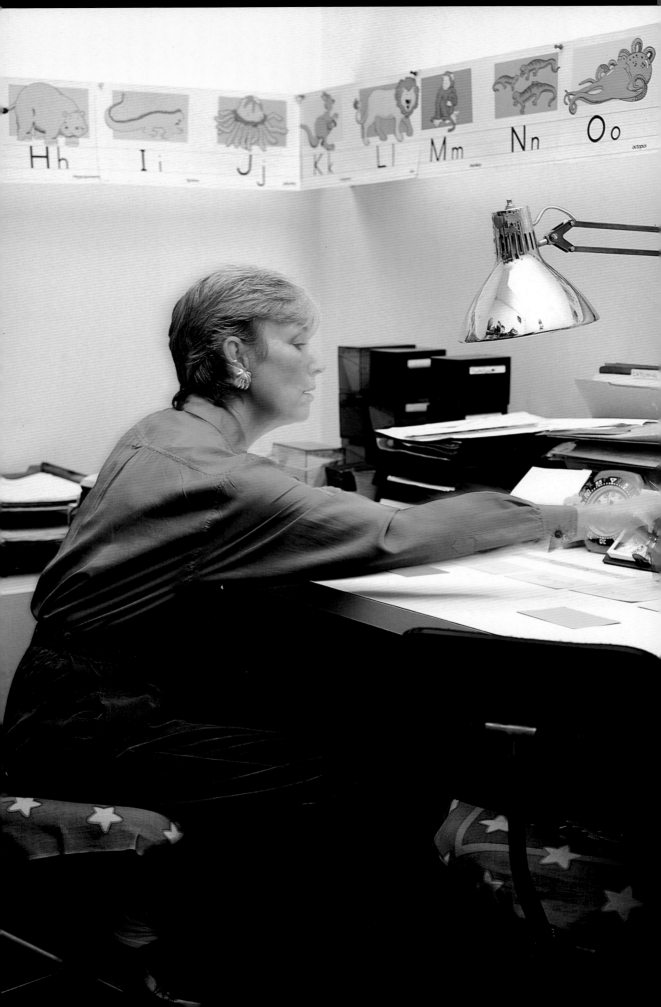

Josephine Franzen
Educational Therapist

Josephine Franzen was born in 1936 in Porthmadog, North Wales, in the U.K. She lived in Coventry and London before coming to the United States in 1962. In 1973 Franzen received an undergraduate degree from Columbia University, and in 1977 she earned a master's degree from Bank Street College of Education. Since then, she has been a learning therapist, first at the Walden School and then in her own practice in New York City, where she lives with her husband Ulrich Franzen, an architect. They also have a home in Santa Fe, New Mexico, which Ulrich designed.

INDEX CARDS: "In my work with learning-disabled children, the index card is the one working tool without which I would be absolutely lost."

In my work with learning-disabled children, the index card is the one working tool without which I would be absolutely lost. I have stacks of white, 3" x 5" index cards in my office, and I reach for more every day.

Learning-impaired children need constant reinforcement and reminders of how words look, sound, and feel. Each of the children with whom I work starts the first session with a collection of his or her own words. Each of those words goes on a 3" x 5" card. These cards become the child's own bank or treasury. Each child also gets a file or word box from me, which is used by the children to store their word cards. New words that present difficulties are added each session.

The cards become the child's own objects to hold, manipulate, play games with, and so on. The physical nature of the cards serves as a constant reminder of the words, ultimately leading to "mastery." When this happens, the child is rewarded with a sticker or a star and the card is then "retired."

I also use the index cards to teach word families, like fat, at, cat, and sat. These cards help me teach children to spell out the days of the week, or the months and the seasons. Index cards provide a wonderful way to involve these children in the world of words and to encourage them as they learn and grow.

throw

thin

theatre

botl

TOOL:
Index Cards.
A piece of stiff paper, usually rectangular, used for recording information. The cards are often organized and stored in a file. The most commonly-used index cards are white, 3" x 5" in size, and ruled in blue ink on one side, but they come in other sizes and colors.

Martin Garbus

Attorney, Frankfurt, Garbus, Klein & Selz

Martin Garbus was born in Brooklyn, New York, in 1934. After receiving his law degree from New York University (J.D. 1959), he was admitted to the New York bar in 1960. In 1962, Garbus was admitted to the U.S. Supreme Court, then to the U.S. Court of Appeals in 1970. Garbus has served on the faculty at Columbia University and Yale Law School, and has authored several books on legal issues, including *Ready for the Defense*. His articles have appeared in numerous publications, including the *New York Times,* the *Washington Post,* the *Boston Globe,* and *Harper's Magazine*.

COURTROOMS: "The courtroom helps me present my visions of a case."

The courtroom is not a static assemblage of tables, chairs, bars, and benches in a fixed space. It is a tool in my work — a place that is elastic and alive, and can be molded, not unlike putty. Presenting a case in a courtroom is like an actor being on stage or a painter painting on a canvas.

I'm sensitive to the space and work to the geography, to the physicality, to movement, and to everything that transpires in that open space. The courtroom helps me present my visions of a case. It helps me communicate to those who listen to juries, judges, spectators in the courtroom, and, on occasion, to the outside world through the media.

A courtroom allows me to address those I want to reach in a number of ways. By my positioning in the room, I can address them intimately or generally, focusing my words on just one person in the room or several at a time. I can use the room to present different visual aids, like movies, charts, and models, or I can use my entire body, as an actor does on the stage, to achieve results. At other times I simply use words to impact and fill the space.

I am in trial, using the courtroom, about a hundred days a year. I also use it on other days, when I argue motions and appeals. I have spent a great deal of time in courtrooms — more than any lawyer I know — and they are the most comfortable rooms I know.

TOOL:
Courtrooms.
Enclosed spaces
in which a judge
and jury convene
to hear cases and
make decisions
based on statutes
or the common law.
The rooms may be
large or small,
ornate or simple.
They are always
housed in spaces
that have been offi-
cially designated by
federal, state, or
municipal govern-
mental agencies.

103

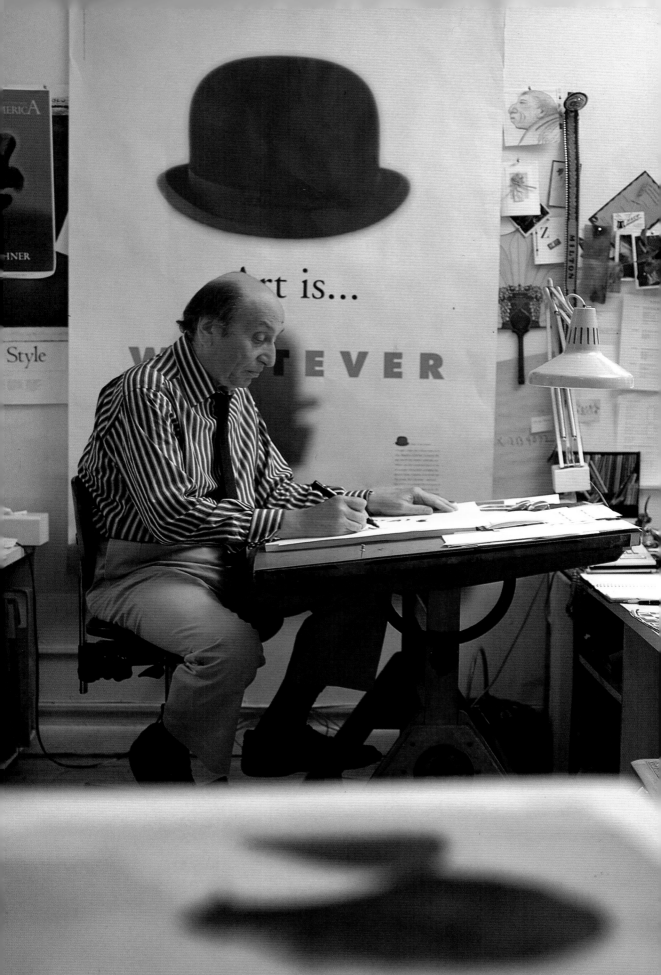

Milton Glaser
Graphic Designer, Milton Glaser, Inc.

Born in New York City in 1929, Milton Glaser was educated there at the High School of Music and Art and The Cooper Union Art School. He later studied, via a Fulbright Scholarship, at the Academy of Fine Arts, Bologna, Italy. He was co-founder of the venerable Push Pin Studios, *New York* magazine, and WBMG, a publication design firm. Milton Glaser, Inc., was established in 1974. Glaser's graphic and architectural commissions include the "I Love NY" logo and the graphic and decorative programs for the restaurants in the World Trade Center. Glaser has created more than 300 posters in areas of publishing, music, theater, and film. His artwork has been exhibited world-wide, including at the Museum of Modern Art, New York, and the Centre Georges Pompidou, Paris. He currently is design consultant to a number of businesses, including Stony Brook University and Land's End Direct Merchants.

DRAWING PAD: "I think better with a large white sheet in front of me to wander across with my ideas."

Large pads of paper are essential in triggering my imagination. I go through two or three Aquabee jumbo pads each month, and each has 100 sheets of paper. I discovered this certain pad more than 30 years ago and since then have not come across many other papers that have the right combination of translucency and durability. Being able to partially see through the paper allows me to slip rough drawings underneath a fresh sheet and make refinements, but if the paper is too thin it doesn't hold up to certain mediums like watercolors and it isn't good for finished drawings.

The most important thing in paper is finding something that can be a vehicle for your imagination — something that doesn't constrict your thinking. The Aquabee pads work that way for me because they are cheap, which diminishes the fear involved in wasting a piece of expensive paper — there's nothing more intimidating than using a twelve-dollar piece of paper. Durability is important because it allows me to use every kind of medium on the paper, including pencils, ink, markers, and watercolors.

The paper's large size is particularly also important. I think better with a large white sheet in front of me to wander across with my ideas — a smaller surface gives me a sense of inhibiting boundaries. These pads of paper have become highly ritualized in their use to me. They've become a mechanism for triggering my imagination.

TOOL:

Drawing Pad. An 18" x 24" pad of white, unruled paper used to mark upon with a pencil or other writing or drawing implement. Sheets of the paper are bound together in such a way that allows them to be easily removed individually from the pad.

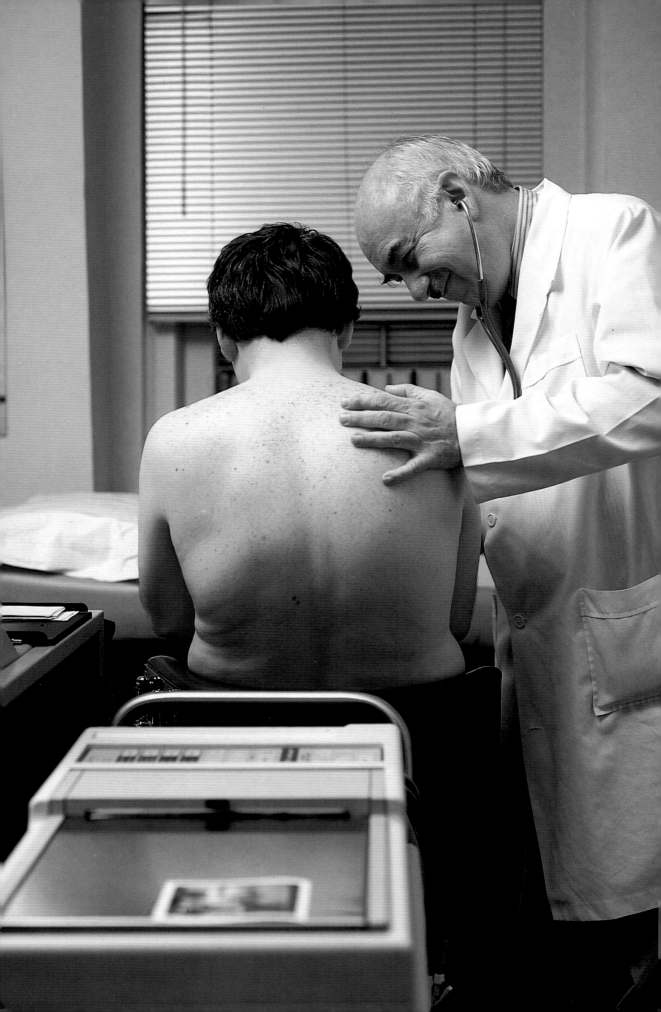

Will Grossman

Cardiologist

Will Grossman was born in 1932 in New York City. He received his degrees at the University of Pennsylvania (B.A., 1953) and the New York University School of Medicine (M.D., 1957). He completed residencies at Cincinnati General Hospital and Henry Ford Hospital in Detroit. In 1963 and 1964, Grossman participated in a cardiology fellowship at Seton Hall College of Medicine. He currently is an attending physician in the Department of Medicine and Division of Cardiology at Beth Israel Hospital in New York City, where he also holds teaching and lecturing positions. He and his wife live in New York City.

STETHOSCOPE: "The stethoscope helps me relate to my patients — the physical bond translates to the entire relationship."

The stethoscope gives me information that I need, quickly and with no expense. In the process, it helps me relate to my patients — the physical bond translates to the entire relationship.

There is something very immediate about the stethoscope, both in the immediacy of information I can obtain and in the hands-on, direct approach of using my ears and hands and a simple tool to detect what's going on inside a patient's body. The stethoscope helps retain the human element of medicine that can be distanced by machines and technology.

When I use the stethoscope, I obtain information for diagnosis. Often, in cardiology, this can help quantitate the severity of the problem, and this information goes a long way in directing the management of the problem. For example, in the evaluation of a heart murmur, the stethoscope will usually tell me which heart valve is involved and often the severity of the valvular disease.

I use a stethoscope at least six to ten times a day. It is a valuable, cost-effective instrument that is still a primary tool in cardiology and medicine. Unfortunately, its usefulness is less emphasized now, in an era of high-tech imaging techniques. The new generation of doctors seems less skilled in the use of the stethoscope, and I think they are passing up an invaluable tool.

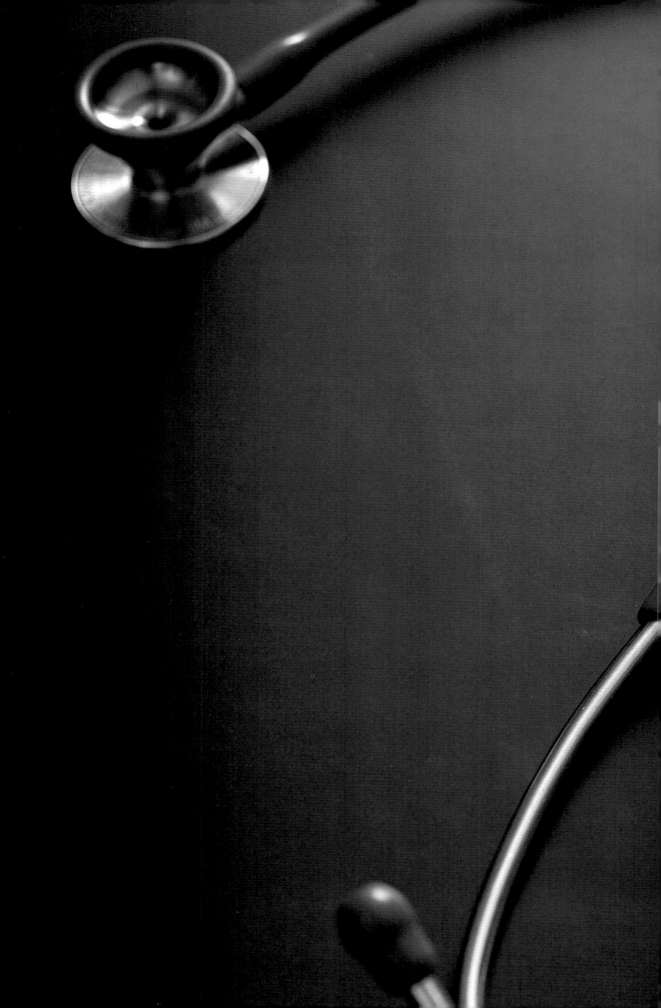

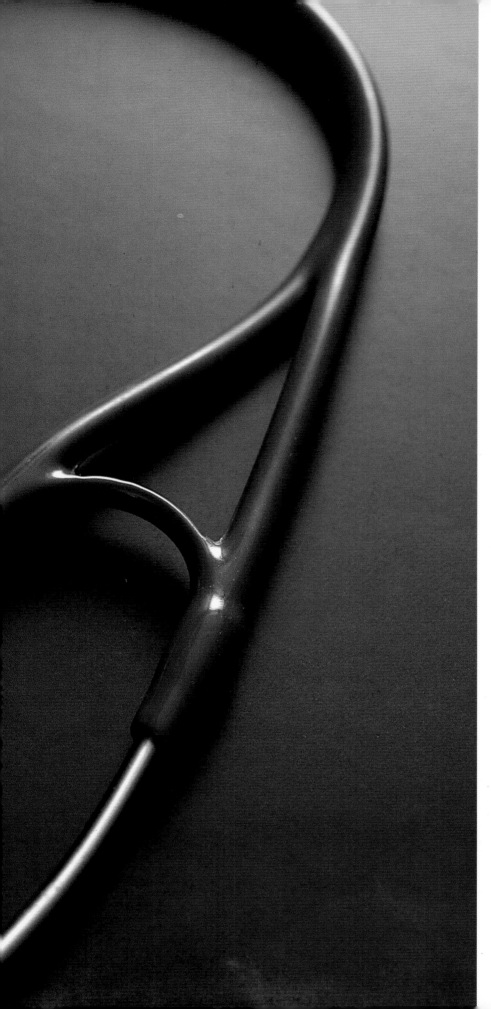

TOOL:
Stethoscope.
An instrument used
for listening to the
heartbeat, lungs,
and other sounds
produced within
the body. French
physician René T. H.
Laënnec invented
the stethoscope in
1819 as an alterna-
tive to the indelica-
cy of placing his
ear to the bosom of
a female patient.

111

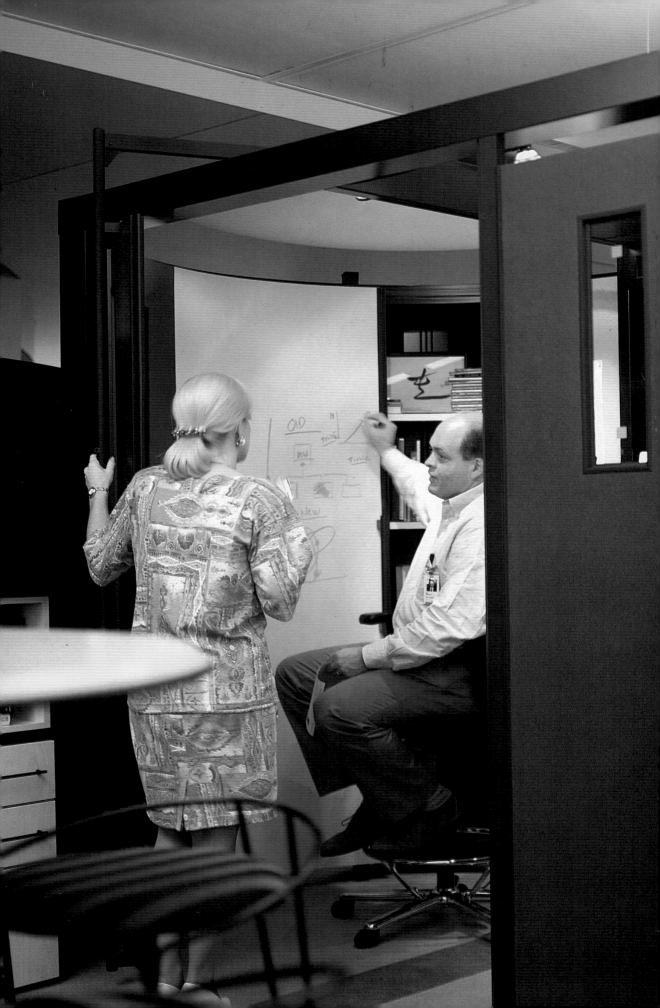

James Hackett
President & CEO, Steelcase, Inc.

James P. Hackett is president and chief executive officer of Steelcase Inc., the world's leading designer and manufacturer of office furniture. Headquartered in Grand Rapids, Michigan, the company has 46 manufacturing facilities in 14 countries and more than 19,000 employees around the world. Hackett oversees the operations of Steelcase Inc., including Steelcase North America, the Steelcase Design Partnership, Steelcase Strafor, and Steelcase International. Hackett, who joined Steelcase in 1981, held a variety of sales and marketing positions in the company prior to being promoted to upper level management positions. He was appointed president and chief executive officer in 1994. Before joining Steelcase, Hackett held sales and management positions at Procter & Gamble in Detroit. He is a graduate of the University of Michigan.

WHITE BOARD: "The white board enables me to get abstract design concepts across quickly and flexibly."

The white board is important in my work because it allows me to be visual in my ideas. Eighty percent of what I put on the white board is drawings and graphics that serve as visual metaphors for whatever idea I'm discussing verbally. The white board enables me to get abstract design concepts across quickly and flexibly. I can use different colored markers to organize my ideas and can quickly erase one concept and draw another to communicate layers of ideas.

The boards are useful when discussing something with one other person in an impromptu setting or when conducting a large meeting. There is something captivating about visual ideas. My father was a veterinarian and also an inventor. He had a blackboard in his office that he utilized to get across process ideas, to draw diagrams, or to work through an equation or calculation so others in his office could follow his train of thought. I often was with him as a boy and was always struck by how captivated people were by what he wrote on the board. After people left, I liked to write on his blackboard and try to imitate his diagrams and equations.

These boards do work well at a visually based corporation like Steelcase, but research shows that everyone who activates the right, visual side of the brain learns more quickly. The white board makes communication more effective.

OLD

T

nw

J.H

New

TOOL:
White Board.
A smooth, hard,
white panel made
of porcelain or a
plastic substance.
The board, which is
generally hung on a
wall, can be written
on with a water-
based marker and
then easily wiped
clean. White boards
have replaced tradi-
tional chalk boards
in many settings.

Sean Hayes

Museum Merchandiser, Liberty Science Center

Sean Hayes is the Director of Retail Operations and Merchandising for the Liberty Science Center in Jersey City, New Jersey. In that position he has developed a retail plan for a 3,000+ square-foot store, is responsible for buying all retail and promotional merchandise, and has established a product development program. He also manages a staff of thirty. In addition, Hayes serves as a consultant for Radio City Productions, where he is responsible for the development and buying of Radio City and Rockettes merchandise. Previously, Hayes did merchandising for NBC, CBS, and Sony Theaters. He earned a bachelor's degree in communications and art history from William Paterson College. He lives in New York City and is the youngest son of seven children.

COMPUTER: "I can't imagine doing my job without a computer — to accomplish all I do now I would have to put in 90-hour weeks."

My computer contains all the information that is important to my job — inventory, cost, sales, e-mail and product development ideas. I use my computer several times a day. It's the first thing I go to in the morning and the last thing I turn off before I leave at night. I guess I'm really attached to my computer but I don't take it home with me.

My computer helps me to know which items of merchandise we sell and our profit margins. It also helps me contact vendors and employees and develop new ideas for merchandise. The Internet is also a valuable resource for finding out about new products and getting ideas for product development.

I've been doing merchandising for eleven years now and have been fortunate enough to work with a computer my entire career. It definitely makes my job much easier and faster. I can't imagine doing my job without a computer — to accomplish all I do now I would have to put in 90-hour weeks.

Occasionally my computer fails me — well, actually, the electricity fails me — and I lose everything I've been working on. In a science museum, we use a lot of electricity, and at times the power goes off on us. Someone needs to figure out how to make computers solar-powered.

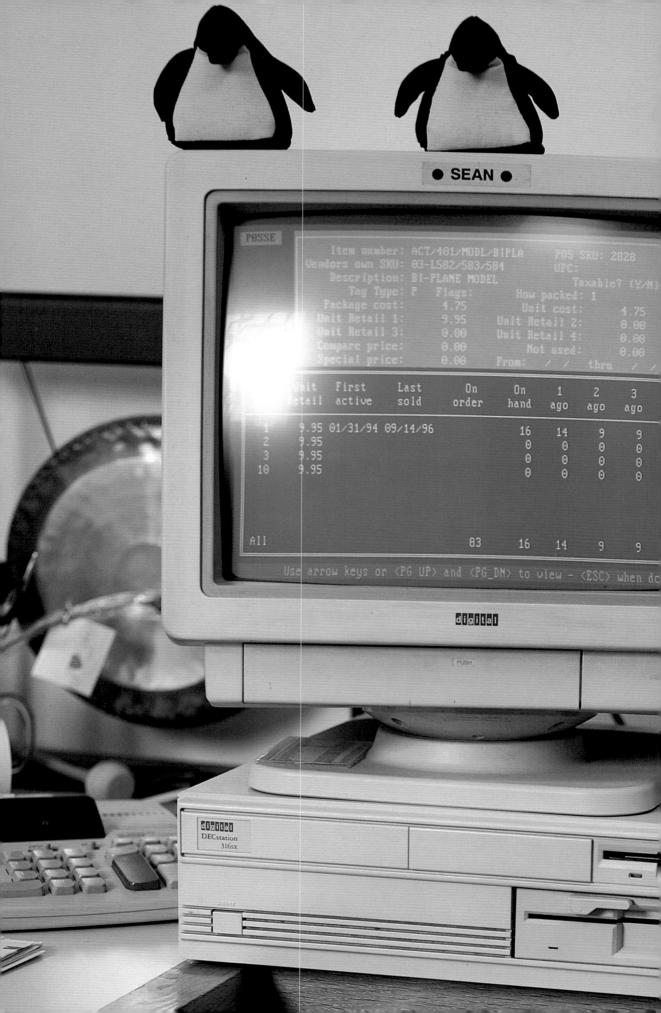

119

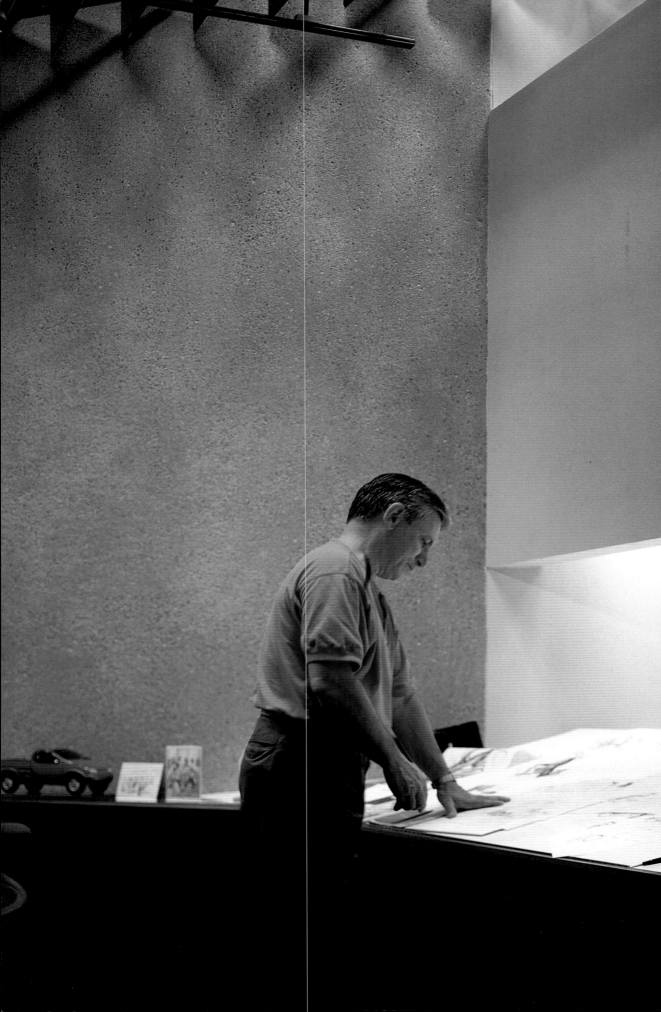

Gerald Hirshberg
Designer

Gerald P. Hirshberg joined Nissan in 1980 and is now president of Nissan Design International, Inc. As a key figure in the management of a select group of designers, engineers, and sculptors for the facility, his primary task is to "internationalize" the design thinking of Nissan. He has overseen the design development of such cars as the Infiniti J30 and Nissan's Altima, Quest, Pulsar NX, Pathfinder, and several pickup trucks. NDI also does a complete line of product design for an international list of clients, from medical instruments to yachts. Hirshberg studied mechanical engineering at Ohio State University and graduated with honors in industrial design from the Cleveland Institute of Art. He is a member of the board of advisors for the Graduate School of Pacific and International Studies as well as for the University of California at San Diego. His book on creativity in business will be released by Harper-Collins in January '98.

KNEADED ERASER: "Unlike a computer, the kneaded eraser edits messily, and I often find ideas and even beauty in the mess."

A kneaded eraser is about visual editing. Unlike a computer, it edits messily, and I often find ideas and even beauty in the mess. With its inability to remove marks completely, my kneaded eraser allows for a finely modulated process of adjustment and refinement. This not only leaves a tracery of the evolutionary thought process that is behind a design, it also leaves a certain level of ambiguity and incompleteness, out of which emerge unexpected connections and creative leaps. Erasing is not so much a process of negation as a process of paring down to the essentials, of getting the most from the least.

My kneaded eraser starts life as a clean, gray rectangular solid, but it becomes gradually molded into an amorphous shape as I worry a design into existence. It can be infinitely modified and shaped to do precision erasures, as well as to make subtle tonal adjustments to my drawings. The eraser yields easily to my hand, adjusts to my body temperature and never seems to wear out.

Along with absorbing miscues and mistakes, the kneaded eraser also absorbs and mollifies some of the stress and tension of the creative process. I first came across a kneaded eraser as a child, at the height of my creative process. I still like it, and I think it likes me.

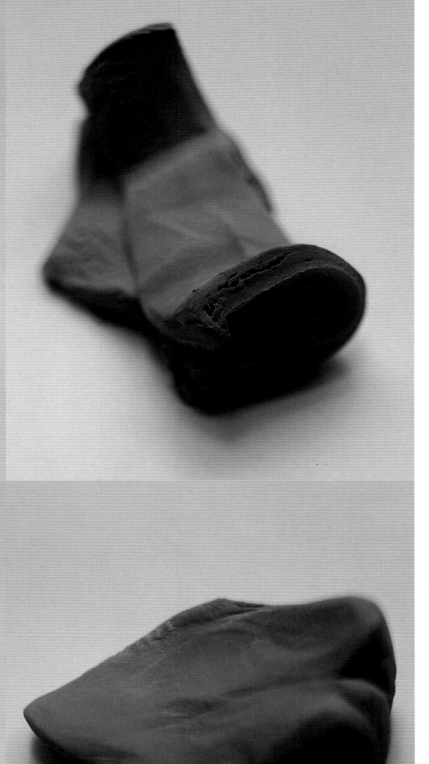

TOOL:
Kneaded Eraser.
A moldable piece of
rubber used for
eliminating graphite,
pastel, and charcoal
marks. The eraser
is packaged as a
rectangle, but does
not retain that
shape once used.
Because it can be
molded, the eraser
can be given an
edge to remove the
finest line, or it can
be rounded to soft-
en a larger area of
markings.

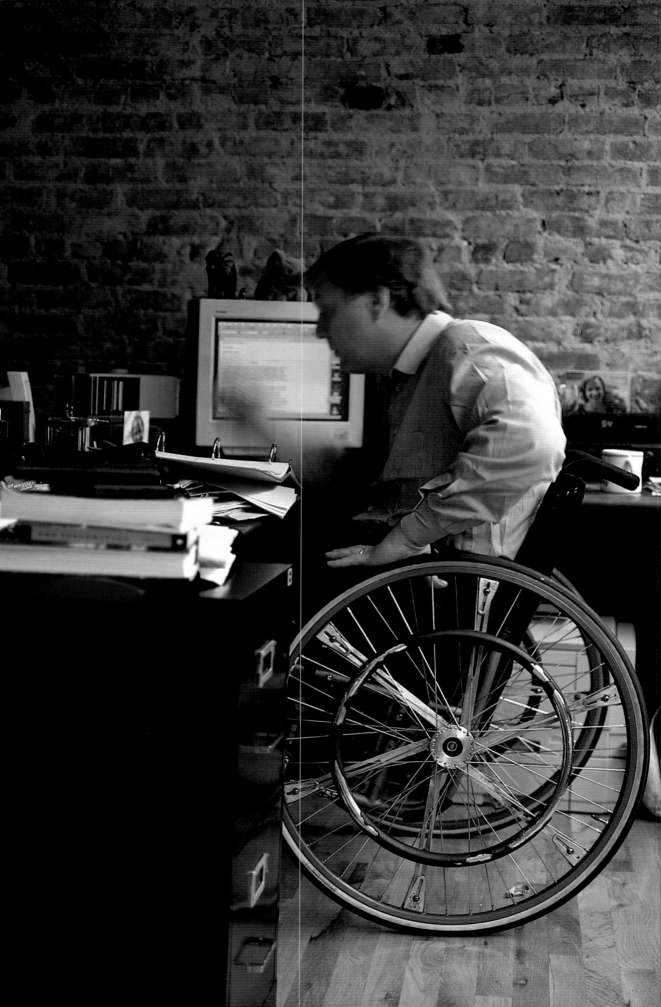

John Hockenberry
News Correspondent, NBC

Veteran newsman John Hockenberry joined NBC as a correspondent for "Dateline NBC" in January 1996 after a fifteen-year career in broadcast news, first at National Public Radio and later at ABC News. While serving as correspondent for the ABC newsmagazine "Day One" (1993 to 1995), Hockenberry contributed a wide range of stories, including an investigation of NASA's plans to build a space station with Russia, and an interview with controversial Russian politician Vladimir Zhirinovsky. For National Public Radio, Hockenberry worked in Seattle, Chicago, and Washington D.C., where he was a reporter for "All Things Considered." Hockenberry is also the author of the memoir *Moving Violations: War Zones, Wheelchairs and Declarations of Independence.*

WHEELCHAIR: "My wheelchair provides me with capabilities for motion beyond normal walking."

The most important tool in my work and life is my Quickie Titanium folding wheelchair. I use it seven days a week for 18 hours a day. It has 28-inch, 48-spoke wheels, kevlar tires and 16-inch handrims. It is a total mobility enhancer. It manages to simulate able-bodied egress for me in a credible fashion, and it provides me with capabilities for motion beyond normal walking. This kind of mobility has been crucial in my work, yet the wheelchair isn't like a tool that one leaves at the office or only associates with work — my wheelchair is fully integrated into professional and private aspects of my life. It is a very physical tool, but it also has qualities that extend broadly into my emotional and mental health.

My wheelchair provides a reliable, structurally sound rolling platform that converts quickly into a portable shape that can be loaded into a variety of spaces for storage or transportation. It permits me swift movement with subtle and fine control, along with the capability of easily using virtually all forms of motorized transportation.

With my wheelchair I can fully compensate for the fact that I cannot walk, and by using the chair I can also inventively redefine mobility. The potential that is inherent in the chair is non-deterministic, thus allowing a relationship with the user that is more like that of a performer with his or her musical instrument.

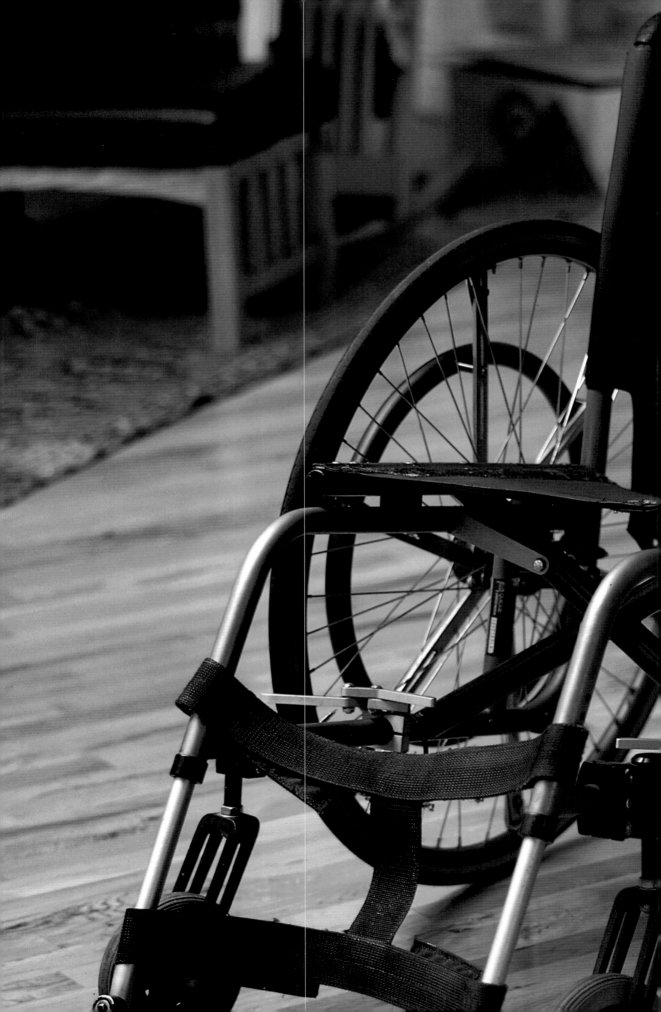

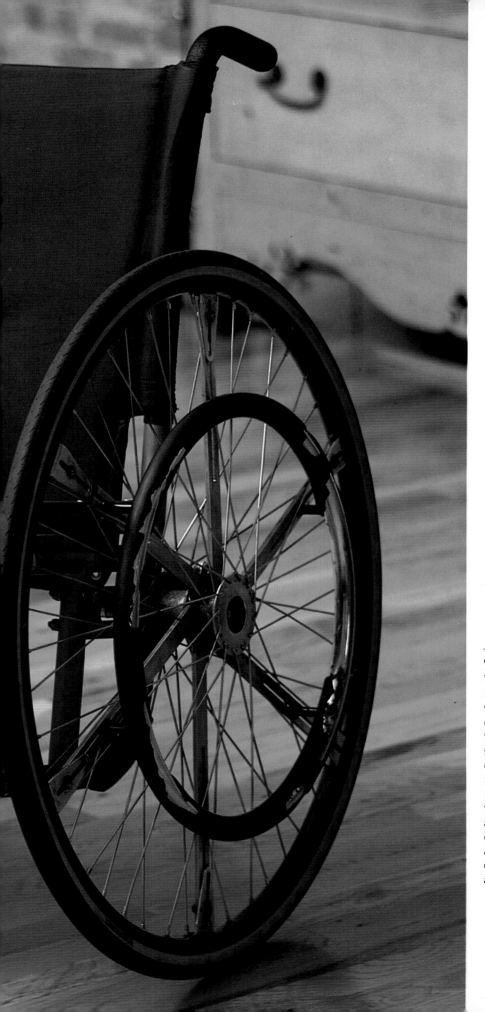

TOOL:

Wheelchair. A chair mounted on large wheels to provide or enhance the mobility of a disabled person. Some wheelchairs are operated manually, by propelling the wheels forward with hands and arms, while other wheelchairs are electric and operated with a control panel.

127

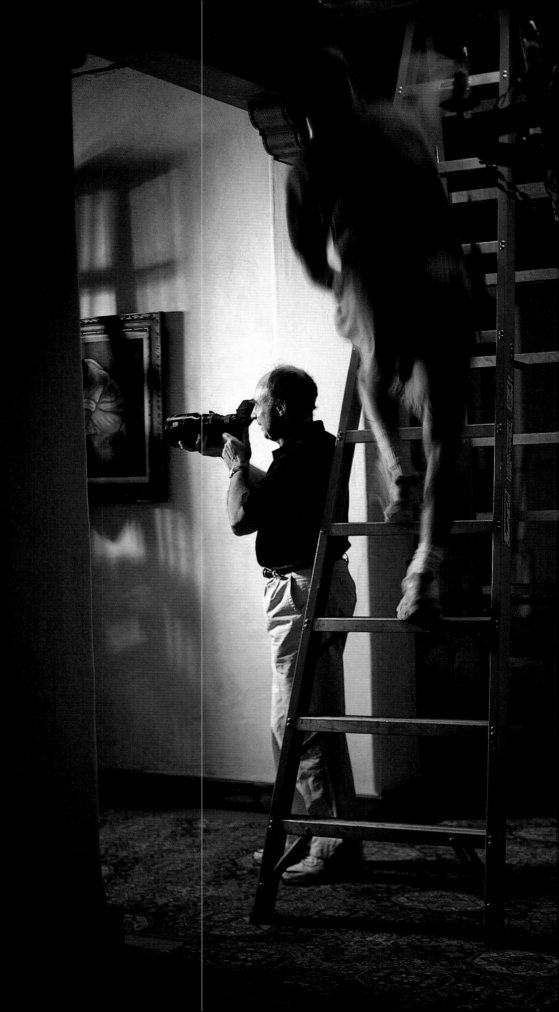

Adam Holender
Cinematographer

Adam Holender was born in Krakow, Poland, in 1937. He has a master's degree in film from the Polish Film Academy in Lodz. Holender is a member of the American Society of Cinematographers. His film credits include *Midnight Cowboy, Panic in Needle Park, The Effect of Gamma Rays on Man-in-the-Moon Marigolds, The Seduction of Joe Tynan, Street Smart, The Dream Team, Fresh, Smoke,* and *I'm Not Rappaport.*

VIEWFINDER: "This is the only type of viewfinder to which an actual motion picture camera lens can be attached, giving me the exact field of vision."

The "tool" I have selected is a particular type of viewfinder — the Penta Finder viewfinder. It is the only type to which I can attach actual motion picture lenses. Most viewfinders only show the parameters of vision, but this type functions along with the lens you select. I can look through it and feel and see what the camera, and eventually the audience, will see. It's an extraordinarily precise tool — it duplicates, not approximates.

This viewfinder is very crucial in helping me precisely and quickly select the specific lens I want for a scene. Each lens has its own characteristics and personality — some are objective while others are expressive. Some lenses flatten things or make the edges fuzzy. If I want to accentuate the hero I would choose one lens, and if I wanted to make him more a part of his environment I would choose another. Looking through this tool, I can feel all the optical characteristics and nuances of the lens I have attached to it, establishing the actual mood and quality of the scene.

I didn't have this tool when I filmed *Midnight Cowboy* — in fact, I didn't discover it until three years ago. Of course, people have been shooting good films for years without this tool, but it helps me do my job more accurately and comfortably. This kind of viewfinder is not widely used now, but I imagine it will be in a few more years. When other cinematographers discover it they will fall in love with it, too.

TOOL:

Viewfinder. A device that allows a cinematographer to determine what will be seen by the viewer after actual filming takes place. Different camera lenses can be attached to the viewfinder to increase accuracy. Viewfinders have an aluminum body, a rubber hand grip, glass optics and mirrors.

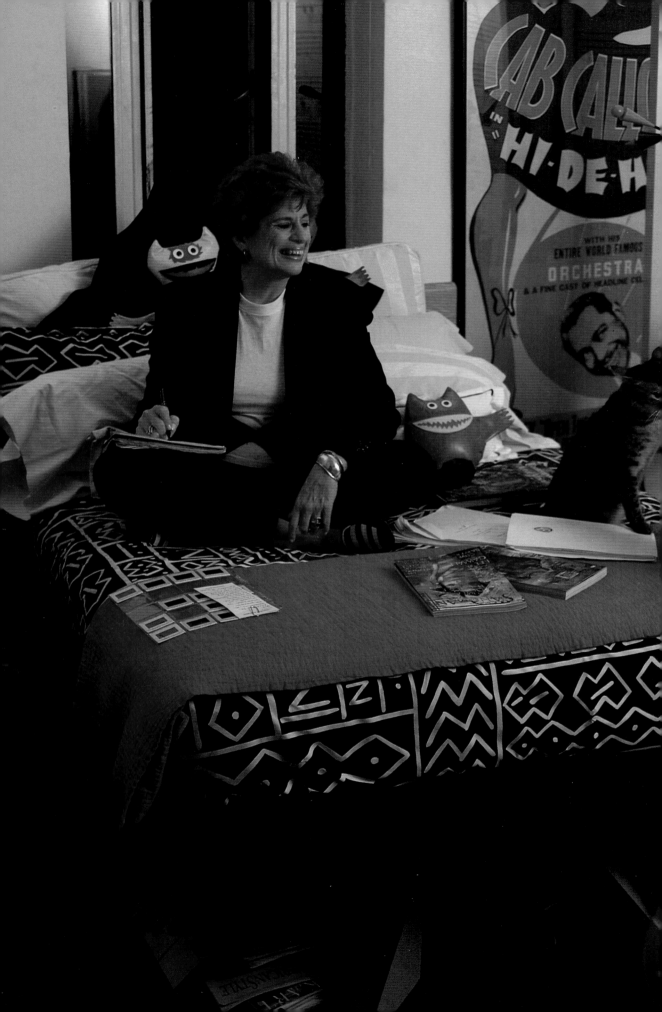

Jenette Kahn

President & Editor-in-Chief,
DC Comics, Mad Magazine

Jenette Kahn, the daughter of Rabbi Benjamin Kahn and Rosalind Aronson Kahn, grew up in State College, Pennsylvania, and later Washington, D.C. She graduated from Harvard, where she majored in art history, and soon after started the first of three magazines for young people: *KIDS, Dynamite* (the best-selling magazine for youth in history), and *SMASH*. When she was 28, Kahn was recruited by Warner Communications (now Time Warner) to become publisher of DC Comics, the owner of over 5,000 characters, including Superman, Batman, and Wonder Woman. Five years later she became president. Today DC Comics publishes close to 1,000 comic books a year for a reader whose average age is 25. In addition to comics, DC is deeply involved in product licensing, live-action television, animation and feature films.

BED: "I think of my bed as a full-service resource center."

My bed is my favorite piece of furniture. It's a prototype piece made for Karl Lagerfeld by Michele de Lucchi, but I would love it even if it didn't have this fine provenance. It's just the place I want to be when I have the choice.

Those who think of a bed as a piece of furniture for sleeping have not taken into account its wonderful and multiple possibilities. I use my bed for eating, for talking on the phone, for putting on make-up (while talking on the phone), for watching television (primarily the Knicks), for thinking, for dreaming, for reading, for writing, and for playing with my cats (all three of them!). I am most creative and most myself when I'm in this environment.

I think of my bed as a full-service resource center. It is large enough for me and for the many things I am working on — all the comics, books, and magazines I'm reading, the notebooks I'm writing in, the portable phone, the food, and the pussy cats and the pillows. Not only do we all fit — we fit quite comfortably, sitting or sprawling whichever way seems best at the time. It is a totally relaxed and reassuring environment, with everything at my fingertips. I use this tool every day — morning and night, on weekends and any time in between.

TOOL:
Bed. A piece of furniture for reclining and sleeping, typically consisting of a flat, rectangular frame and a cushioned mattress resting on springs. While the most basic beds consist only of a metal frame, box spring and mattress, other beds are quite elaborate pieces of furniture that move beyond function to aesthetics, incorporating wood, iron, or other material in headboard and footboard designs.

David Kelley
President & CEO, IDEO Product Development

David M. Kelley is a California-based entrepreneur, educator, engineer, and venture capitalist. He was featured by *Fortune* magazine as one of the "People to Watch" and was selected for the "I.D. 40" list of America's leading design innovators. In that listing he was described as "the most sought-after design engineer this side of Thomas Edison." He is the founder and CEO of IDEO Product Development, America's largest independent product design and development firm. In addition to his work at IDEO Product Development, Kelley is a tenured professor at Stanford University in the school's innovative Product Design program.

CELLULAR PHONE: "My cellular phone makes me feel nostalgic for the old walkie-talkies we had when we were kids."

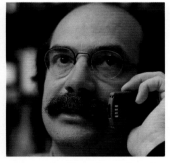

The most important tool in my life and work is a Motorola Star TAC cellular phone. The combination of art and technology makes for a phone that has what Bruce Nussbaum at *Business Week* calls "product lust" — something you just have to have.

This little phone gives me more time in the day. At my company, if you want help on something you can't just assign tasks. It's more like saying "this is your mission, should you decide to accept it." In this process, I have found that talking to people directly or leaving them voice mail is much more effective than memos or e-mail, because it's easier to communicate the nuances of what I am asking them to accomplish. I use the phone like Mr. Phelps uses the little tape recorder, only I hope it will never self-destruct. Because I can carry this phone with me everywhere, I can check messages — or hand out missions — any time of the day or night. Voice mail never sleeps.

I first encountered portable, cellular phones when they were the size of cinder blocks and almost as heavy. They were too bulky to carry around, so I would typically leave mine in my car. Then I heard that the Star TAC cellular phone model was coming. When I first saw it in a full-page newspaper ad, it was love at first sight. It makes me feel nostalgic for the old walkie-talkies that we had when we were kids, when we'd stand 50 feet away from each other, and then try to think of something to say.

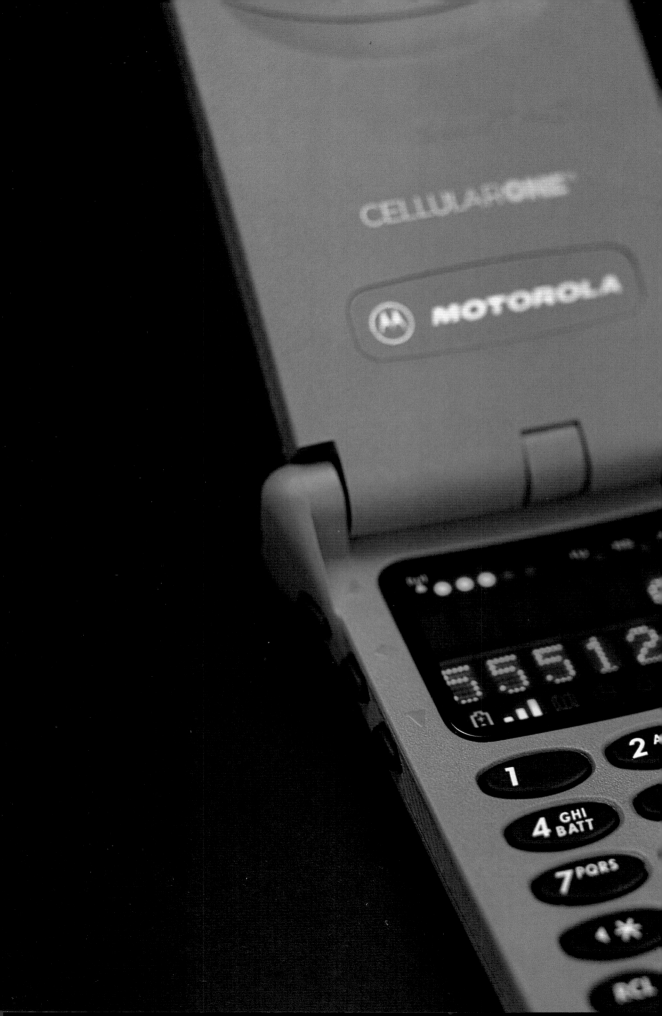

TOOL:
Cellular Phone.
A mobile radio telephone that uses a network of short-range transmitters located in overlapping cells throughout a region, with calls automatically switched from one transmitter to the next as the caller enters an adjoining cell. Widespread use of the cellular phone began in the late 1980s.

James Kiberd

Actor, Artist, National Ambassador for UNICEF

At age four, James Kiberd began drawing portraits. Later he studied at the Rhode Island School of Design, the School of Fine Arts at the University of Pennsylvania, and many of Europe's museums. His work has been recognized by the New York State Council on the Arts, the National Endowment for the Arts, and the America the Beautiful Fund. In 1996, his art was featured in six exhibitions, including his New York City debut at M.B. Modern on 57th Street. As an actor, in another New York City debut, Kiberd played Ty Cobb in Lee Blessing's *Stealing Home.* On television, he appears on ABC's "All My Children." Kiberd has also received a number of humanitarian awards, including the 1994 Danny Kaye Award at the National Convention of the U.S. Committee for UNICEF.

SCRIPT AND SCREEN: "My tool tells me what to say — almost when to breathe."

As a needle and thread or hammer and nail are united in their function, so are script and screen. In a sense, I as an actor am a piece of the cloth or lumber that becomes part of the garment, the structure, the story. At times, however, this cloth wants to be the whole garment, this lumber wants to be the structure, this actor wants to be the story. What the script and screen do is provide design, placement, focus, direction, limitation, context, and broadcast of this actor's energy. The synergy of script and screen is total. Though they may exist apart, they could not survive apart.

Not only does my tool, script and screen, create my work, acting, it creates the very life I live. Each day, as part of a story being told, I am given character, emotions, state of mind, physical state, purpose, and movement. My tool tells me what to say, almost when to breathe.

Because the screen is available to many viewers and what I am doing must be appropriate and appealing to those viewers, movement, appearance, physique, and vocal quality are modulated for the screen. Should all the factors fall into place and the actor be "appealing" to the viewers, a public knowing of the actor's image is created. However, the public knows the actor not as the person, but as the character the script and screen have created. Consequently, the danger of my coexistence with my tool is that I can be shaped by it.

TOOL:

Script and Screen.
Script: Copy of a text used by a director or performer. It sets the context, establishes relationships between characters, and provides the performer with words to speak.
Screen: The surface onto which a picture is projected for viewing. The screen displays the visual narrative that accompanies the sound.

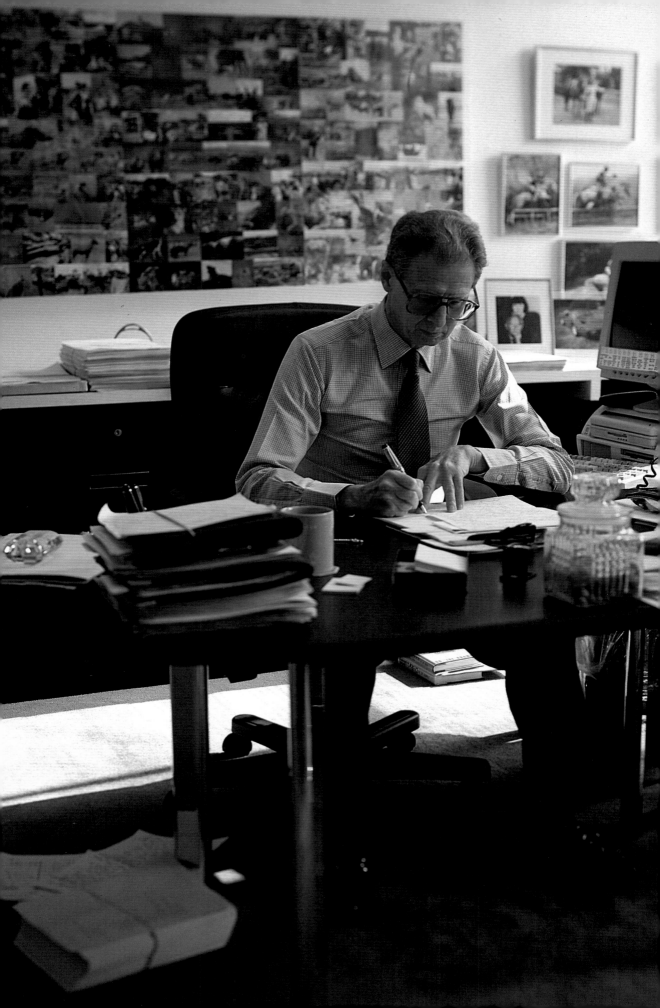

Michael Korda
Writer, Editor-in-Chief and Corporate V.P.,
Simon & Schuster

Michael Korda is a best-selling writer of both fiction and non-fiction, with #1 bestsellers in both categories. He is the author of *Male Chauvinism: How It Works; Power: How to Get It, How to Use It; Success; Charmed Lives, a memoir;* and the novels *Worldly Goods; Queenie; The Fortune; Curtain;* and *The Immortals.* His latest book, entitled *Man To Man: Surviving Prostate Cancer,* was published by Random House in the spring of 1996. Korda is also the editor-in-chief and corporate vice president of Simon & Schuster. Korda was born in London in 1933 and educated in Beverly Hills, New York, and Switzerland. He served two years in the Royal Air Force then attended Magdalen College, Oxford.

FOUNTAIN PEN: "A good pen like this one makes writing a pleasure and handwriting an art."

The tool that I use constantly is an Aurora fountain pen. This particular pen is very much mine, like a good pocket knife or a beloved fishing rod or shotgun. Nobody else uses it.

I use my fountain pen for every kind of writing and practically everything I do as a writer and editor. I write both fiction and non-fiction and have edited and published such writers as Graham Greene, Joan Didion, Tennessee Williams, Nick Pileggi, Joseph Heller, and many others. My Aurora fountain pen has been an essential tool in all of this.

A good pen like this one makes writing a pleasure and handwriting an art.

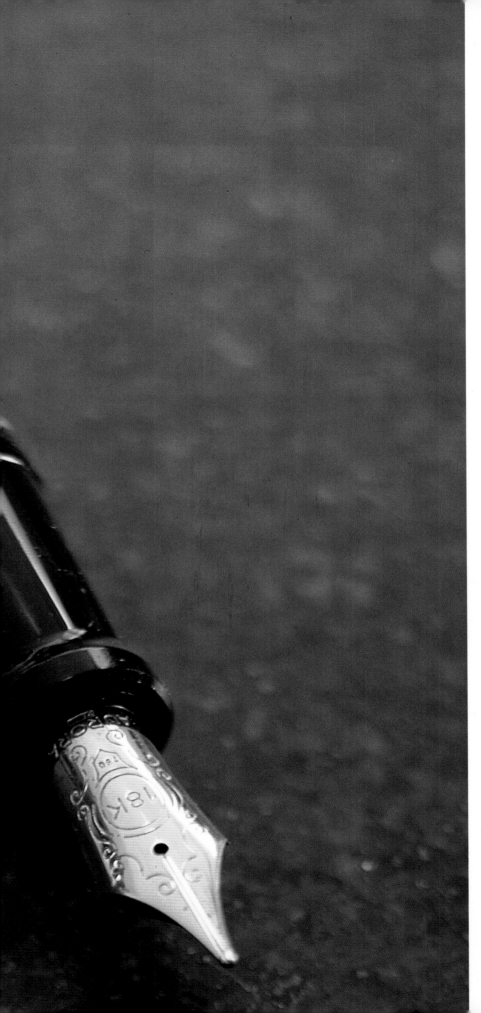

TOOL:

Fountain Pen.
A writing instrument invented by American Lewis E. Waterman in 1884, replacing the quill pen. Fountain pens incorporate their own ink reservoirs, encased by a body made of plastic or other material, and writing points made of stainless steel, gold, or nickel. A variety of ink filling methods were employed before ink-filled cartridges were developed.

147

Thomas Krens
Director & Trustee, Solomon R. Guggenheim Museum

Thomas Krens earned his undergraduate degree at Williams College in Massachusetts, a master's degree in art at State University of New York at Albany, and a master's degree in public and private management at Yale University. He has served as chairman of the Massachusetts Museum of Contemporary Art Commission and as an adjunct art history professor at Williams College. Currently, Krens is the director of the Solomon R. Guggenheim Foundation and Museum in New York City as well as the Peggy Guggenheim Collection in Venice, Italy. He is also an adjunct art history professor at the University of Karlsruhe in Germany, and serves on a number of art and foreign relations boards in the United States, Italy, France, and Germany.

BINDER CLIP: "The design of the binder clip is somehow satisfying: it's functional yet elegant."

The tool that I find invaluable is a binder clip — I use several every day. At the Guggenheim, we are involved in numerous complex projects, including organizing exhibitions at our two museums in New York, at the Peggy Guggenheim Collection in Venice, and at the Guggenheim Museum Bilbao which is opening in Spain in 1997. We also arrange for many traveling shows in the United States and abroad, so there are always several things going on at once in different parts of the world.

All of these projects involve a lot of paperwork and organization. The binder clip is perfect for assembling multi-part documents because it contains related documents and allows items to be added and removed easily. It comes in several sizes — there is a clip for every need — and is strong enough to hold together unruly sets of papers, including very large sets of documents. Binder clips help me stay organized as I keep track of many projects in the United States and Europe.

Also, the design of the binder clip is somehow satisfying: it's functional yet elegant. There is something pleasing about not only how it holds documents together but also how it looks while doing its job — the design is simple and efficient, and the lines are clean.

TOOL:
Binder Clip.
An implement of
tempered steel,
nickel, and plated
wire used to hold
together sheets of
paper. The clips,
which are manu-
factured in several
sizes to accommo-
date stacks of doc-
uments up to an
inch thick, have
handles that can
be flipped upright
for hanging or
folded flat.

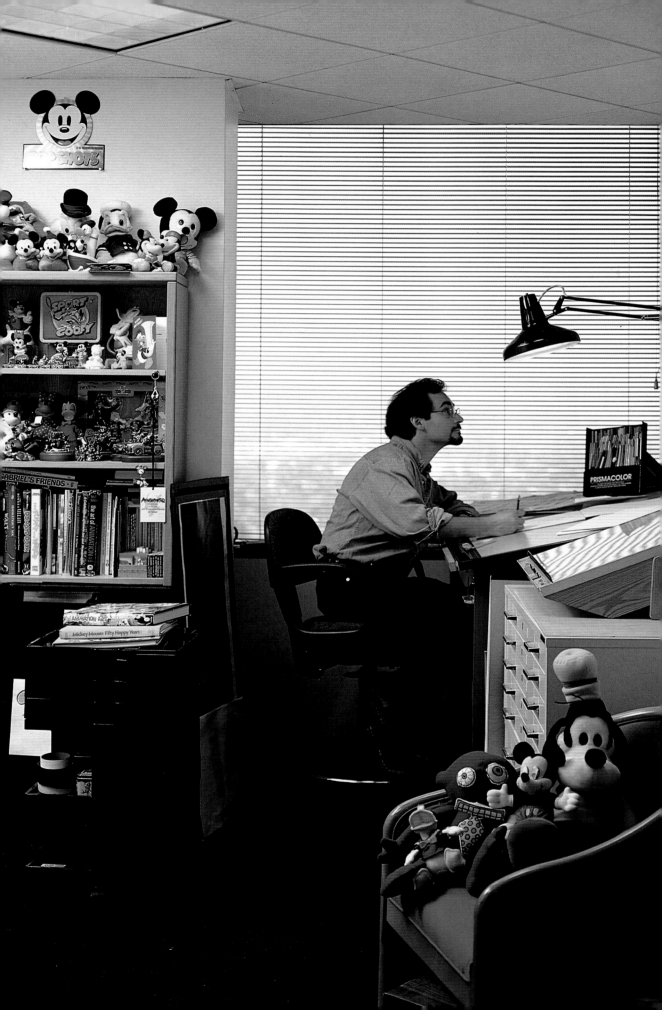

John Loter
Character Art Director, Disney Consumer Products

John Loter went to the School of Visual Arts in New York City to train for a career in animation, graduating in 1986. In 1985, Loter began working in the New York office of Disney Consumer Products (DCP). As an in-house freelance character artist, Loter drew Disney characters for a variety of merchandise and was hired on staff in 1987. In 1994, his office was relocated in California. Loter is now character art director for the standard character group of DCP. He heads up a team of artists working on an array of licensed products featuring Mickey Mouse and friends, ensuring consistent appearances and personalities. Loter initiates concepts for entertaining products, and creates new ideas and design approaches to keep the characters current and appealing.

OFFICE WALLS: "My office walls provide me with a creatively stimulating environment in which to do my work."

The tool I use the most in my work is utilized by my eyes, not my hands. Throughout the day I look at the walls of my office, particularly the wall in front of my drawing table. My walls are nearly covered with reference and inspirational material. They provide me with a creatively stimulating environment in which to do my work.

Artwork and ideas are accomplished through the use of the material on my office walls. With references pinned up all over the wall, I don't have to constantly pull materials out of files and set them up on my desk. It is all there at a glance, leaving my work space clear.

On the wall, the character model sheets are close enough for me to see but not so close that I would be inhibited by them. Model sheets are necessary for me to refer to so that my drawings don't stray off-model. However, if I focus on them too heavily, I may wind up merely duplicating those drawings instead of freely creating my own. At the distance from my eyes to the wall, I am guided more by the overall feeling and energy of the reference, not its detail. Also, a wall full of fun visuals immediately inspires and motivates me to work the moment I step into the room.

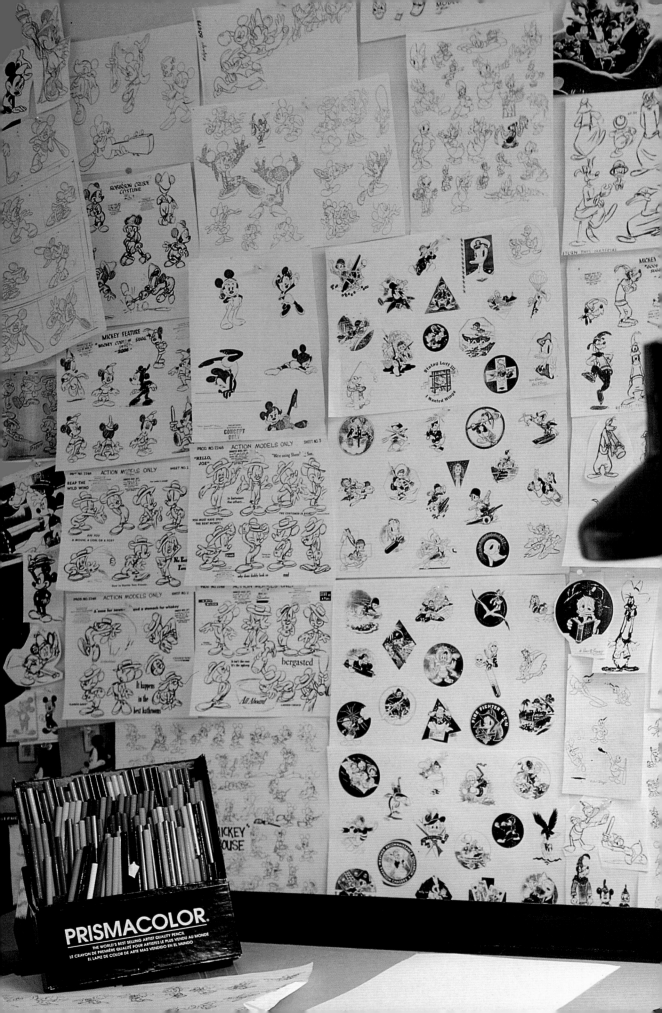

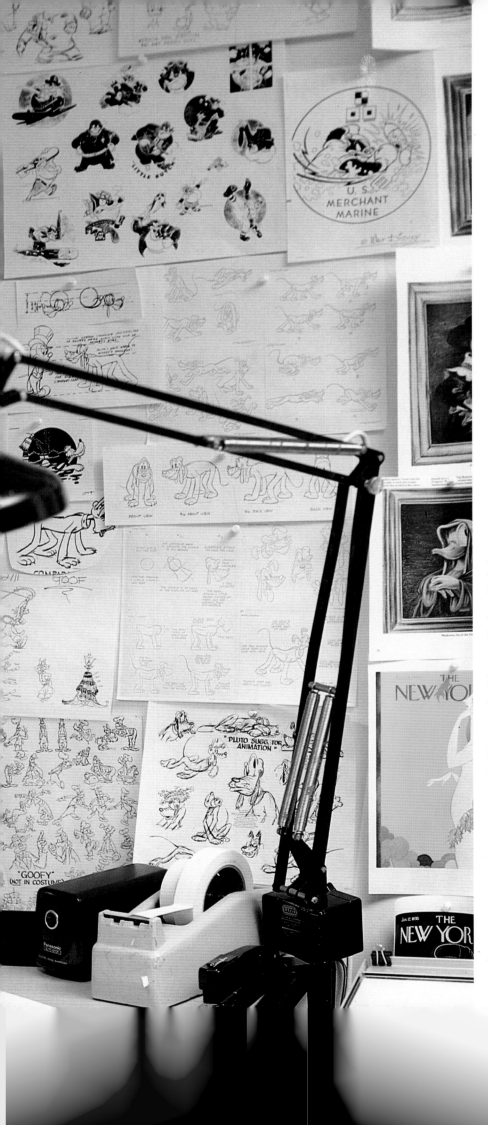

TOOL:

Office Walls.
Flat, upright structures made of a solid building material such as masonry, wood, drywall, or plaster. Walls are erected to enclose an area or divide a space into various rooms and hallways. While many office walls are white or other neutral color, they are often painted, papered, or decorated with art or other images to create a certain mood or effect.

155

William McDonough
Principal, William McDonough + Partners,
McDonough Braungart Design Chemistry

William McDonough was born in 1951 in Tokyo, Japan. He received degrees from Dartmouth College and Yale University in 1973 and 1976, respectively. Since 1994, he has been dean of the School of Architecture at the University of Virginia. He is also a practicing architect, designer, environmentalist, and planner with firms in Charlottesville, where he resides with his wife, Michelle and son, Drew. In addition to his design work, which can be seen all over the world, McDonough advises major corporations on sustainable industrial protocols and environmental ethics. In 1996, he became the only individual to win the U.S. highest environmental honor when he received the Presidential Award for Sustainable Development from President Clinton.

FOUNTAIN PEN: "The service of this product is transcendent. I only hope I never lose it — I want to pass it on to my son."

Without my Montegrappa fountain pen I feel uncomfortable, like something is missing. I employ this pen to satisfy an endless array of needs and desires, from the prosaic to the sublime. With it, I sketch ideas, script notes, doodle, point at things, and sign with a flourish. My pen also soothes me and helps me think.

The pen is very beautifully designed and made. I enjoy every aspect of using it, from sliding it out of my pocket to unscrewing the cap and then screwing it to the other end. I love to roll the pen around in my hand and between my fingers to enjoy its planes and texture.

I feel like the pen was waiting for me in a shop window in Vicenza, where I discovered it. It was expensive, so I passed it up at first, but during the course of the day it kept calling me back for another look. In the end, I gave in and bought it.

Now I don't go for five minutes without using it. Almost everyone who sees the pen compliments its qualities and enjoys my obvious enjoyment of it. Few tools I know become so personal.

I have worked to develop a protocol which defines the nature of artifact and artifice, in terms of products of consumption and service. The service of this product is transcendent. I only hope I never lose it — I want to pass it on to my son.

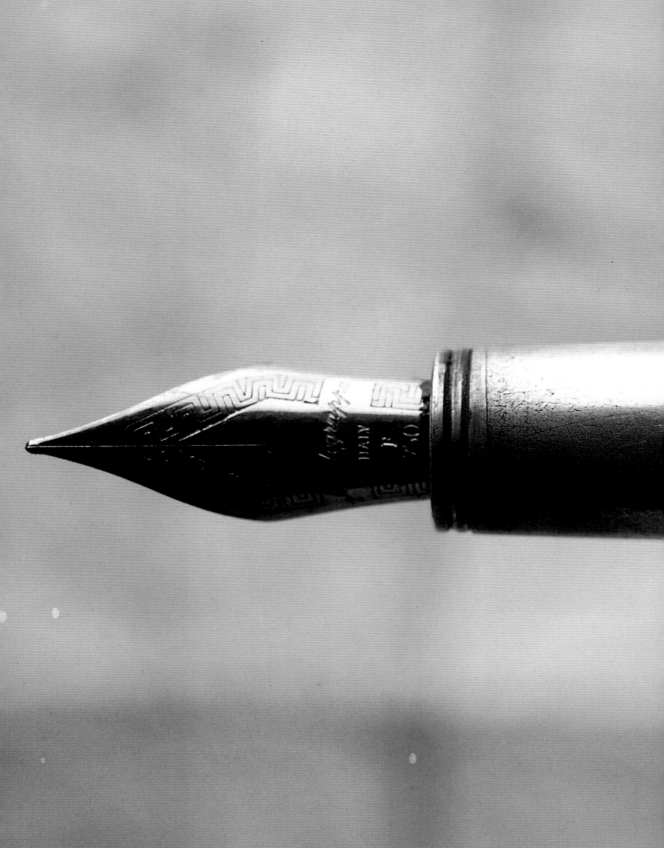

TOOL:
Fountain Pen.
A writing instrument invented by American Lewis E. Waterman in 1884, replacing the quill pen. Fountain pens have their own ink reservoirs. (McDonough's choice, the Montegrappa pen, is made in Italy and has an engraved sterling silver body and an 18k gold nib.)

159

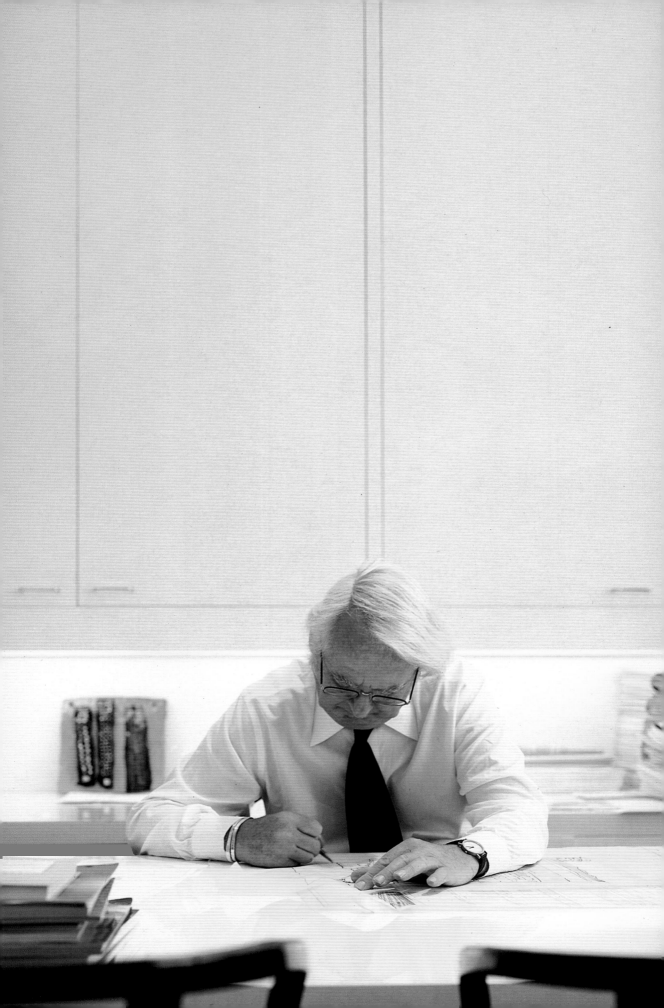

Richard Meier
Architect, Richard Meier & Partners

Richard Meier received his architectural training at Cornell University. His practice has included housing and private residences, museums, medical facilities, commercial buildings, and major civic commissions such as courthouses and city halls in the United States and Europe. Among his most well-known projects are the Getty Center in Los Angeles, the High Museum in Atlanta, and the Frankfurt Museum for Decorative Arts in Germany. In 1984, Meier was awarded the Pritzker Prize for Architecture, which is considered the field's highest honor, and in 1989 he received the Royal Gold Medal from the Royal Institute of British Architects.

DRAFTING PENCIL: "I have used the same type of pencil for more than 30 years now, so I'm quite attached to it."

If the Berol drafting pencil #314 did not exist, I don't know what I would use. I use the pencil more than any other single instrument for drawing. I have used the same type of pencil for more than thirty years now, so I'm quite attached to it.

The graphite has just the right density for me, and the overall weight of the pencil is comfortable in my hand. It has a large, soft lead with a strong black line that marks easily and helps me to articulate design concepts and ideas visually. The marks made by this pencil have a definite presence that commands attention.

I use the pencil all the time, on many different types of paper. I don't use it for taking notes or for writing letters, because it is so soft, but I use it for everything else. I first came across this pencil in high school, and I have been using it ever since. It would be difficult to find another pencil that I like as much — I don't think one exists. The only way that it could possibly be improved is if someone could find a way to keep it sharp and to keep it from getting smaller than about half its full size. Once they're smaller than that, I pull out a new one.

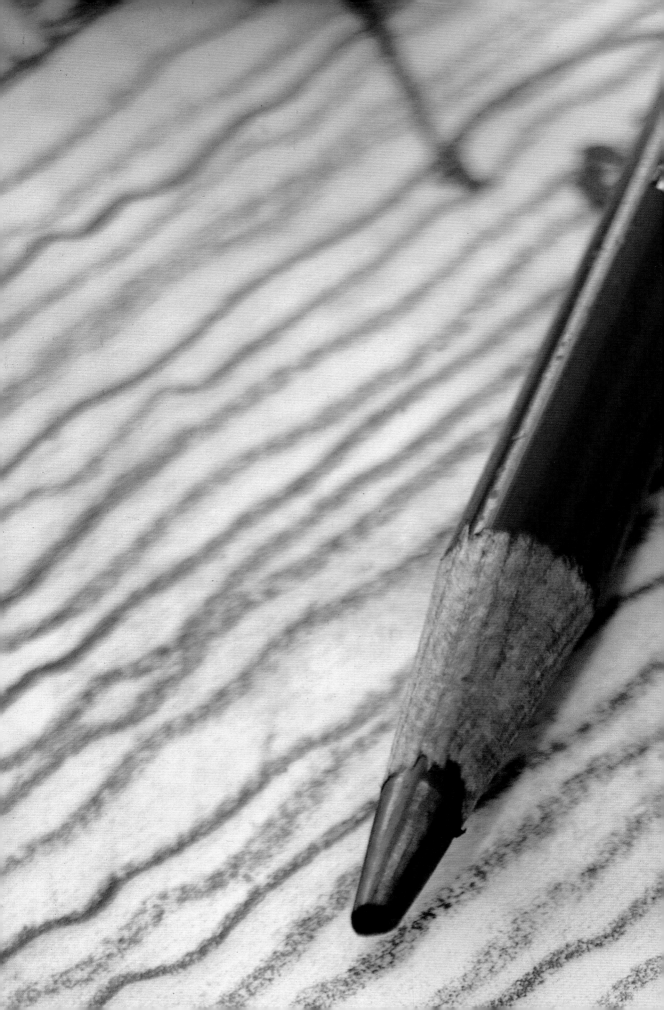

TOOL:
Drafting Pencil.
A narrow, cylindri-
cal implement for
writing, drawing,
or marking. The
"lead" in pencils is
actually a mixture
of powdered
graphite, clay, and
water, which is
extruded into thin
rods then kiln-fired
at almost 2,000°
Fahrenheit. Wax is
then injected into
the porous rods
to impart smooth-
ness. The wood
encasements are
generally cedar.

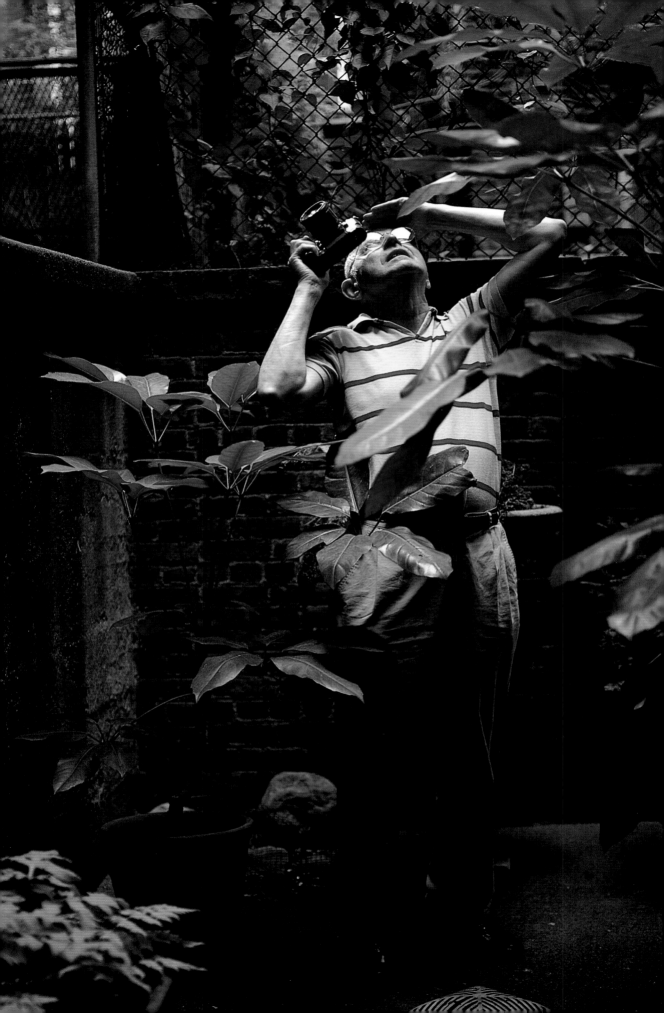

Duane Michals
Photographer

Duane Michals dwells on the invisible: dream, loss, death, myth, and spirit. His work combines photography with writing, drawing, and painting. Born in McKeesport, Pennsylvania in 1932, Michals studied art at the University of Denver and Parsons School of Design, New York. He is self-taught in photography, taking his first photographs at the age of 26 with a camera borrowed for a trip to Russia. Soon after, he moved into commercial photography and in 1964 began a personal project of photographing empty places around New York City, such as launderettes, buses, and coffee shops. In 1966 Michals began the narrative sequences of photographs for which he is well-known. His work has been exhibited in the United States and Europe, and is in many important collections. He is represented in New York by the Sidney Janis Gallery.

CAMERA: "My camera helps me investigate my own experiences and life."

The most important tool in my work as a photographer is, obviously, a camera. Although I use this tool all the time, I don't have lots of fancy new cameras. I'm not an equipment freak who is constantly upgrading and looking out for the latest advancement to come along. Right now I have only two cameras — they're both Nikon 35 mm and about ten years old. My big technological breakthrough was getting a motor drive about eight or ten years ago.

I don't need all the new equipment because I've been taking photographs pretty much the same way my whole career. The camera is essential as a tool, but the creativity for me is in deciding what to see through the lens. My camera helps me investigate my own experiences and life.

The world has seen an age of great music and an age of great painting, but this is the age of film. The camera is sort of like a computer — something that just about everyone today can use. A person who doesn't use a camera is, in a way, illiterate — it's the medium of the age. Everyone is a photographer in some sense, but it's similar to how everyone can write a letter but not everyone can write a great poem or piece of literature. The camera is an accessible tool that allows for many levels of use.

TOOL:
Camera. A device
that directs an
image focused by
a lens or other opti-
cal system onto a
light-sensitive film
housed in a light-
proof enclosure.
When the shutter
release is pressed,
a mirror flips up and
light strikes the film,
allowing a photo-
graph to be made.
Cameras come in
simple or more
complicated ver-
sions and in vari-
ous sizes.

167

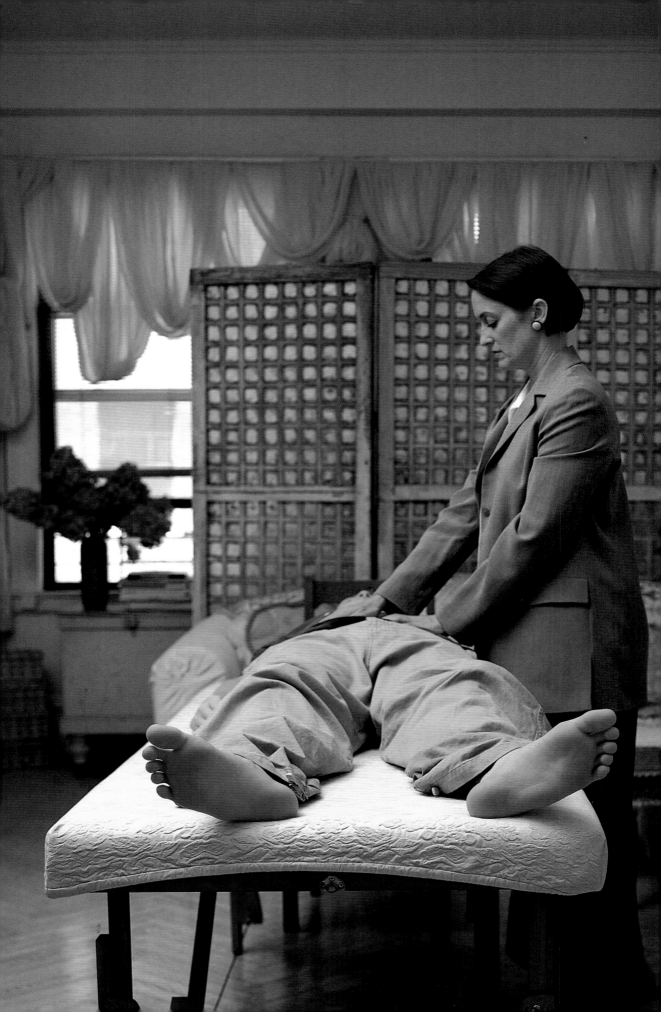

Pamela Miles

Reiki Master/Researcher/Consultant
for Complementary Therapies

Pamela Miles is a Reiki Master with 30 years of experience in yoga, meditation, and complementary therapies. Miles teaches Reiki self-treatment to people living with HIV/AIDS at New York City's Beth Israel Medical Center and the Gay Men's Health Crisis Center, where she is conducting a preliminary research study to document Reiki's impact on her students' health and well-being. Miles also has a research project at Kessler Institute for Rehabilitation in New Jersey to study the effects of Reiki on stabilized stroke patients. Additionally, she works with patients who have cancer, lyme disease, chronic fatigue syndrome, crohn's disease, heart disease, migraines, back pain, and emotional instability. The mother of two, Miles serves as discussion group director for New York City Parents in Action, Inc., a non-profit organization which seeks to prevent adolescent substance abuse by promoting effective parenting.

BREATH: "The breath helps me maintain my center, or to regain or deepen it."

The breath is by far the most useful tool in my life and work, both in terms of what it facilitates, and in its sheer accessibility.

The technique of Reiki healing is very simple. I connect my client with the flow of life force, called Reiki, and then I watch. What I can contribute personally to this process is the quality of my presence, the ability to remain a quiet support. Obviously it's hard to accomplish that with a chattering mind! Letting the awareness rest in the breath settles the mind and leaves it open to intuition. It enables me to stay connected to my heart, giving my client a sense of being profoundly cared for. As I'm listening to my clients, as I'm touching them, as I'm training them in their self-care, the breath holds the connection between the inner and the outer realities that enables me to respond to their needs respectfully, without intruding.

Healing is more than a technique. It's a way of being that can be learned. Breathing with awareness can make a noticeable difference in one's state. Conscious breathing offers a priceless opportunity for self-healing that is available to everyone, everywhere.

TOOL:
Breath. The air inhaled and exhaled through the nose or mouth in respiration. Breathing energizes the blood by bringing in oxygen and expelling carbon dioxide. The word "breath" is also used to refer to spirit or vitality.

171

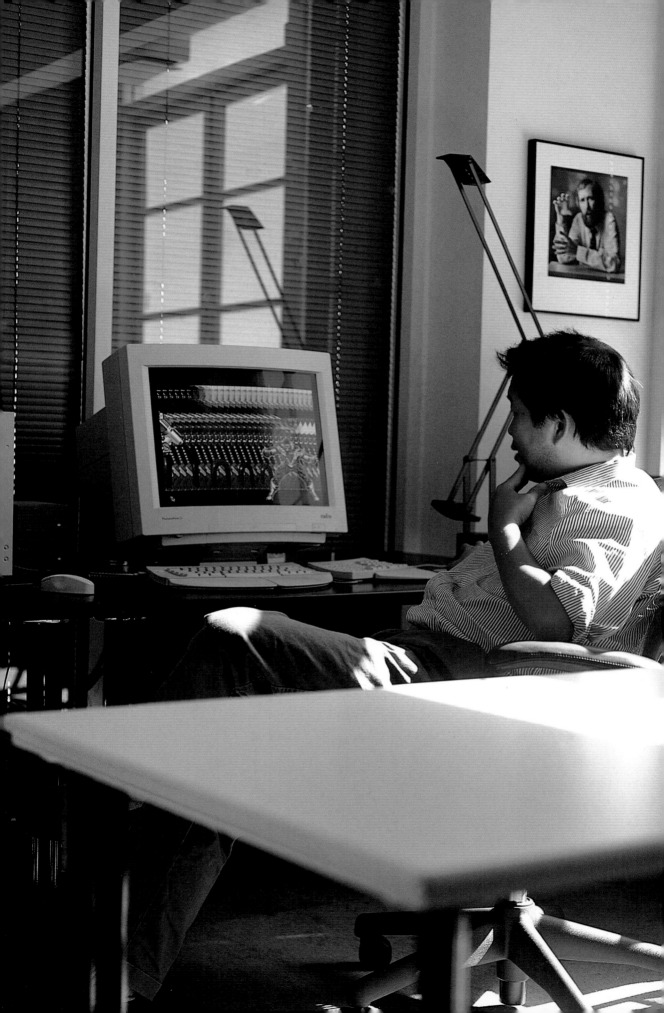

Clement Mok
Web Designer, Founder of Studio Archetype, and
NetObjects

Creating meaningful connections between people, ideas, art, and
technology is the focus of many design and consultative projects with
which Clement Mok is involved — from cyberspace theme parks to
expert publishing systems to major identity programs. Mok, with help
from his 80-plus person studio, has done work for clients such as the
Microsoft Network, CBS Sports, and the Mirage Hotel in Las Vegas.
Mok is also the founder of two products companies, CMCD and
NetObjects. NetObjects was cited by *Fortune* magazine as one
of the "25 Coolest Technology Companies in 1996." Mok has been
published internationally and has received hundreds of awards from
many industry categories. His designs have been exhibited in muse-
ums and galleries in Europe and Asia.

COMPUTING: "Computing allows me to be powerful and efficient
when this is called for, and it allows me to keep in touch."

Although the obvious choice of tool for me in my work
and life is the computer, the truth is that the tool I
use most is "computing." The difference between a
computer and computing is the difference between form and
function. A computer is about form, computing is about func-
tion. In my work and thought process I rely on function.

What really interests me is not what a computer is but
how computing transforms, mediates, and processes ideas. It's
not just the computer hardware, but the software and the net-
working capabilities that have made computing the quintessential tool for my purposes.

Computing, when used appropriately, allows me to be in control — in control of the
gazillion things that compete for my attention, my time, and my expectations. It facili-
tates all aspects of my work/design, day/life activities — writing, doodling, editing, illus-
trating, designing, sending e-mail, ordering gifts, and even ordering meals. It allows me
to be powerful and efficient when this is called for, and it allows me to keep in touch,
metaphorically as well as physically, with people and ideas.

Computing is, in fact, a tool that can be what you make it to be. I use this tool at
work and at home — whenever and wherever there is a need. My design and my com-
puting are intricately linked. They are inseparable.

TOOL:
Computing.
A variety of functions and calculation that are determined by programs and commands. Computing is defined by computer hardware and software and the user of those tools.

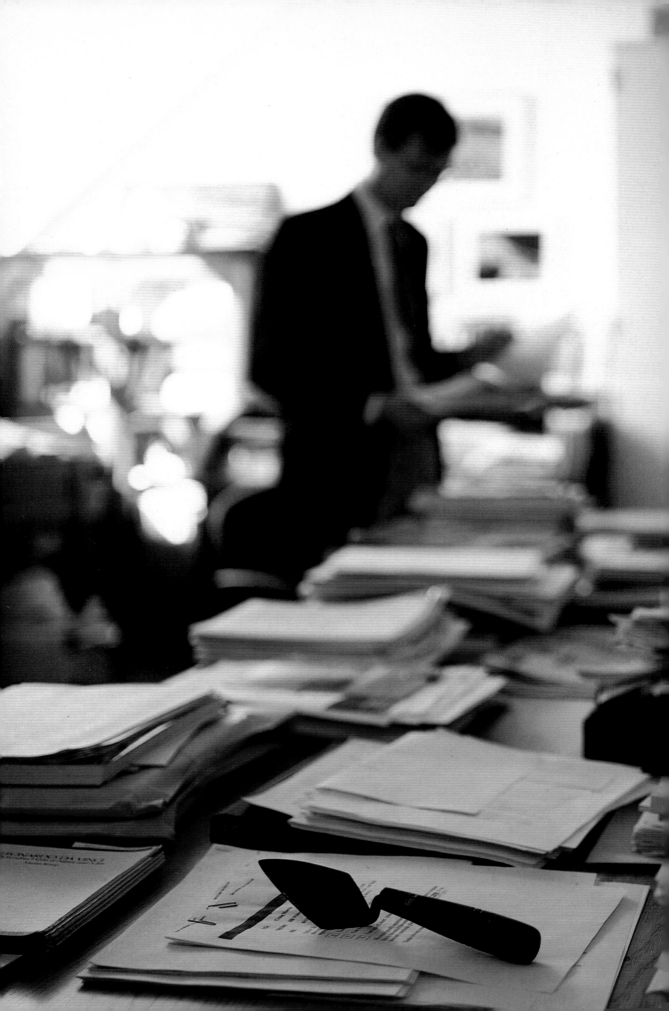

Craig Morris

Dean of Science, Curator of Anthropology,
American Museum of Natural History

Craig Morris, dean of science and curator of anthropology
at the American Museum of Natural History, has done field research
in South American archaeology for more than 30 years. A well-known
expert on the archaeology of the Inka empire, Morris excavated the
Inka provincial capital of Huanuco Pampa in the Peruvian central
highlands. Currently he is conducting archaeological studies on the
Inka expansion into the Chinca and Cochabamba valleys. Morris has
written numerous articles and is senior author of two books about his
studies of the Inka empire. He received a bachelor's degree from
Vanderbilt University and graduate degrees in anthropology from the
University of Chicago. (Note: The spelling of Inka with a "k" is in
keeping with the way it is written in modern Quechua, the language
of the descendants of the Inka.)

TROWEL: "The trowel, a delicate and controllable tool, allows us to recover the remains of lost cultures with great care and respect."

Growing up on a farm in Kentucky, I often used a gardener's trowel as a child, helping in my father's tobacco fields and garden. My first professional use of a trowel was in 1962 while in archaeological field school in Utah. Since then, the trowel has been the single most important tool in my work, as it is for any archaeologist. It is the icon of my profession.

During an excavation, archeologists generally use three different-sized trowels: the smallest one helps uncover delicate objects like bones or ceramic pieces; a mid-sized trowel is used for moving earth in small, controlled quantities; and large trowels can be used for cutting the earth and examining its different levels. The design for the trowels I use has remained the same since the last century, and is based on the trowels masons used.

I use a trowel every day during an excavation. I always carry one in my back pocket so it's right there when we come across something interesting. The trowel is my contact with the earth — it allows an intimacy with the earth. I am so attached to the tool that I have saved some trowels from my earliest days as an excavator, although they are so worn down that they are useless now. They are like souvenirs of places I've worked and the earth the trowels have moved.

TOOL:

Trowel. A hand tool used for digging, leveling, or spreading dirt, cement or mortar. The tool consists of a flat, steel blade attached to a treated wood handle. Trowels have been used by masons for centuries. The current design has remained essentially the same for more than 100 years.

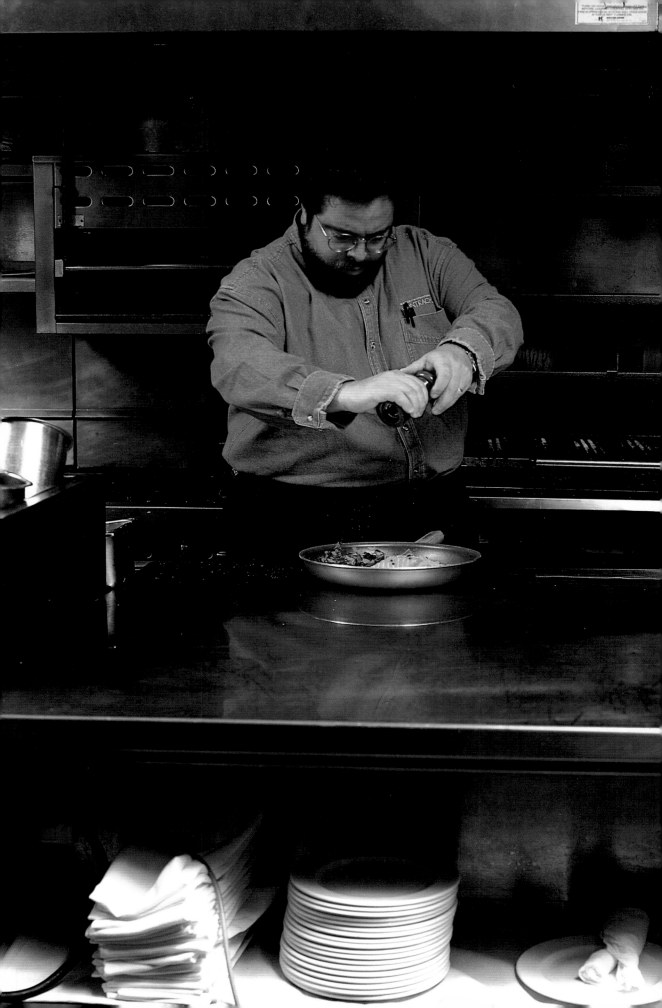

Drew Nieporent
Restaurant Entrepreneur

After working in restaurant management, Drew Nieporent struck out on his own. He has been solely or partially responsible for the open-ing of six restaurants including the Tribeca Grill, which he opened with Robert DeNiro, and Montrachet, which has received several *New York Times'* three-star ratings. In 1994, Nieporent opened Rubicon in San Francisco with partners DeNiro, Francis Ford Coppola, and Robin Williams. He also owns Nobu, Zeppole, TriBakery, and Layla. His restaurants have won prestigious James Beard Foundation Awards. Nieporent is also involved in a number of activities, including service as director of the American Institute of Wine and Food, partic-ipation in the "Chefs for Peace" initiative to Israel, the Starfish Foundation for Children with AIDS, City Meals-On-Wheels, City Harvest and Share Our Strength (S.O.S.).

TEFLON: "Teflon offers great utility and flexibility, allowing me to be creative with a variety of foods rather than confined by my tools."

Cooking and the enjoyment of food is one of the most important elements in my life. Anything that can increase my enjoyment of cooking, like a Teflon pan, is an essential tool. Cooking creativity is an extension of my personality, and a Teflon pan provides many culinary options. I didn't learn to cook with Teflon, so it was a wonderful dis-covery when it became more widely available and used.

It is extremely useful and utilitarian, and very versatile. I can cook fish, meat, vegetables, eggs, and even pasta with it, as well as many low-fat preparations because less oil is necessary. It also makes for easier cleanup, which has never been an enjoyable aspect of cooking. With Teflon, I'm more likely to clean the pan right away and have it ready for the next use.

I'm not attached to a certain pan. It's the versatility of Teflon that's important to me. It offers great utility and flexibility, allowing me to be creative with a variety of foods rather than confined by my tools. Variety is very important to me — I own a variety of restaurants with a wide variety of dishes on the menus. Having tools that expand rather than limit your possibilities is an important part of success.

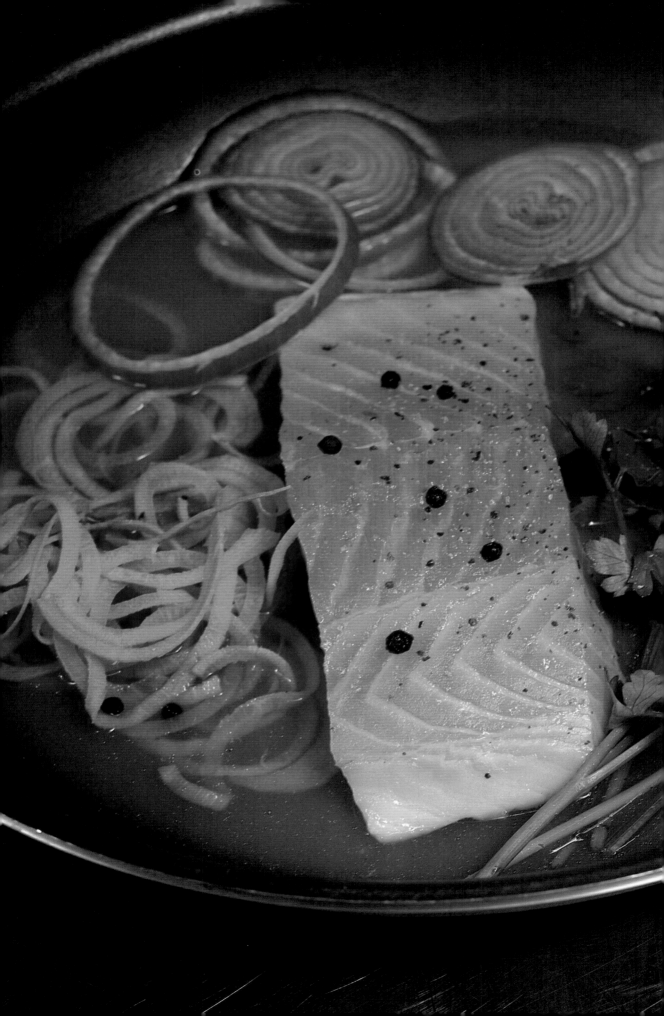

TOOL:
Teflon. A trade-marked substance used for, among other things, coating the inside surfaces of cooking pans to prevent food from sticking. Teflon, comprised of polytetra-fluoroethylene plastic, was discovered accidentally in 1938 by Du Pont chemist Roy Joseph Plunkett while working on refrigerants. It is also an excellent electrical insulation material.

183

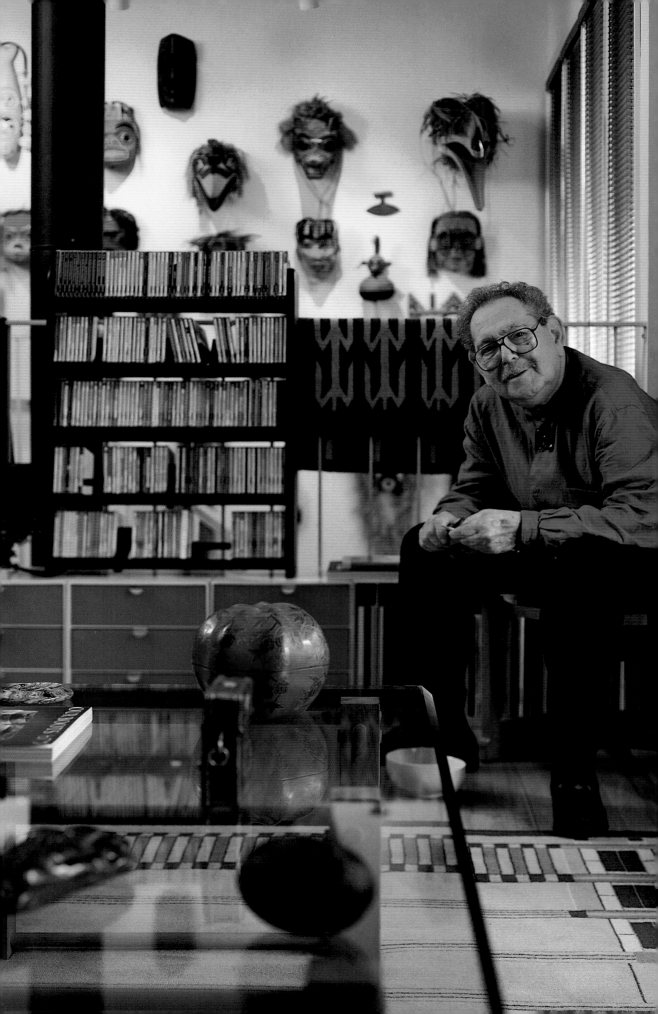

Victor Papanek

Professor of Architecture and Design,
Design Consultant

Victor Papanek was born in 1926 in Vienna, Austria. He attended secondary schools in England then came to the United States for advanced studies in architecture and anthropology at Cooper Union and the Massachusetts Institute of Technology. He has been a professor of design in 14 countries and is the author of several books on design, including his most recent: *The Green Imperative: Ecology and Ethics in Design and Architecture.* He serves as the permanent senior design consultant to the World Health Organization and as a consultant to several corporations, as well as to the government of Papua, New Guinea. Currently, Papanek is the J. L. Constant Distinguished Professor of Architecture at the University of Kansas.

NORWEGIAN WOOD WHITTLING KNIFE: "It is good to touch wood — on a spiritual level it has great beauty."

I use a Norwegian wood-whittling knife several times a day. I have owned one since 1960, when I took a wood-carving course in Norway and had to make my own whittling knife. In fact, I made six until I had one that satisfied me. That knife was stolen some 20 years later, and a Norwegian craftsman made me a new one, which is better than the original one.

With the increasing use of computers, this knife is one of the very few hand tools that I use daily. It is "handgo" — that is, it feels good in the hand. Consequently it satisfies ergonomic, haptic, and ludic requirements, in addition to providing sensuous pleasure. It is good to touch wood — on a spiritual level it has great beauty.

Every morning I start my day by using my knife to sharpen six old-fashioned wooden pencils. I also like to take my knife with me on nature walks to acquire plant samples and branches, and to dig out rocks. The knife helps me in model building and it works well for cutting mats. It's even hard enough to cut aluminum. In a pinch I can use it to fix and eat my lunch.

There are a few designed objects that come close to true elegance and timelessness: Shaker furniture, the whisk made of bamboo for the Japanese tea ceremony, an American racing sulky, and some surgeons' scalpels. This whittling knife belongs in that group.

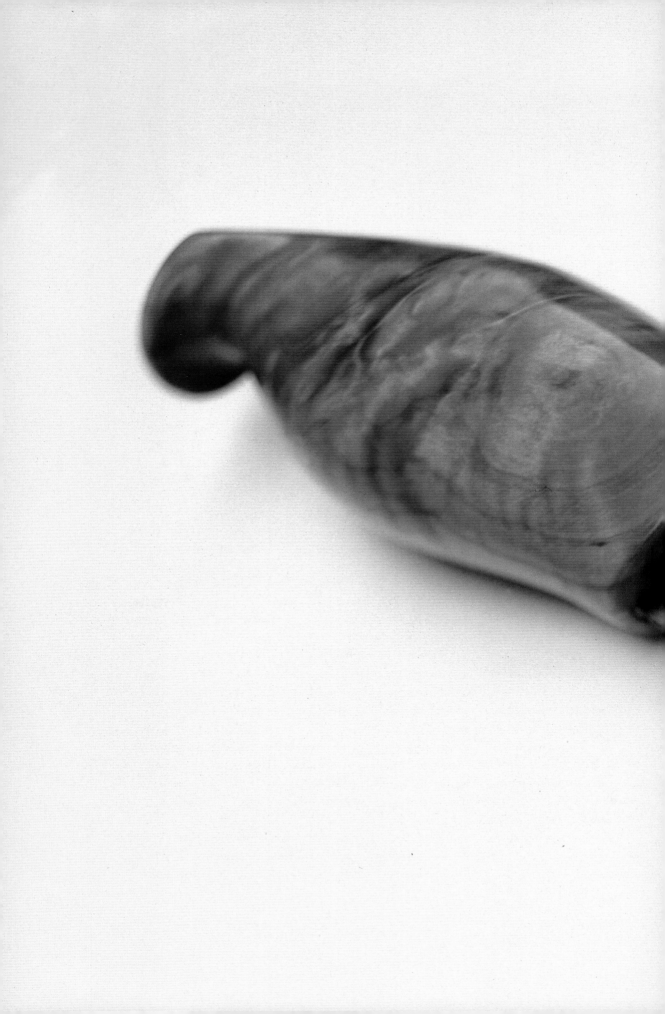

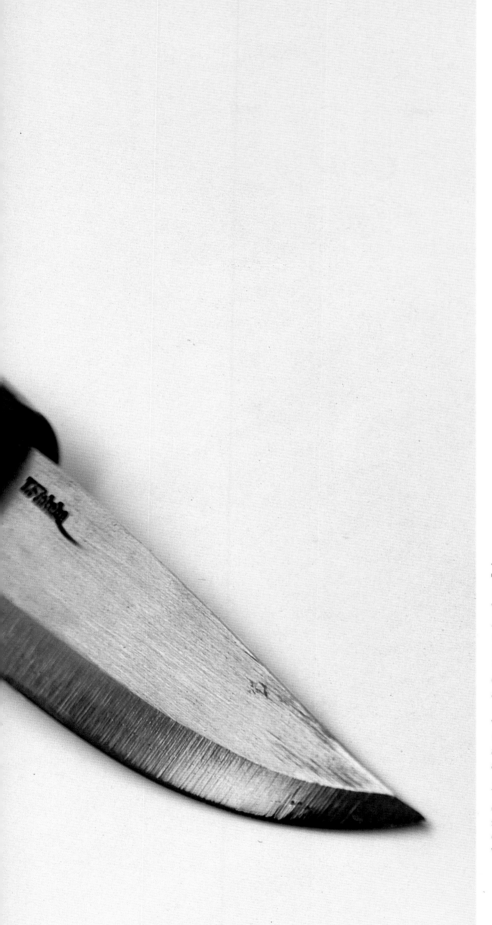

TOOL:
Norwegian Wood
Whittling Knife.
A traditional knife
used to cut small
bits or pare shav-
ings from a piece
of wood, fashioning
and shaping it.
Most Norwegian
whittling knifes are
made by hand, with
a wooden handle
and a highly tem-
pered steel blade.
The knives are
often made by, or
specifically for, the
craftsperson who
will be using them.

187

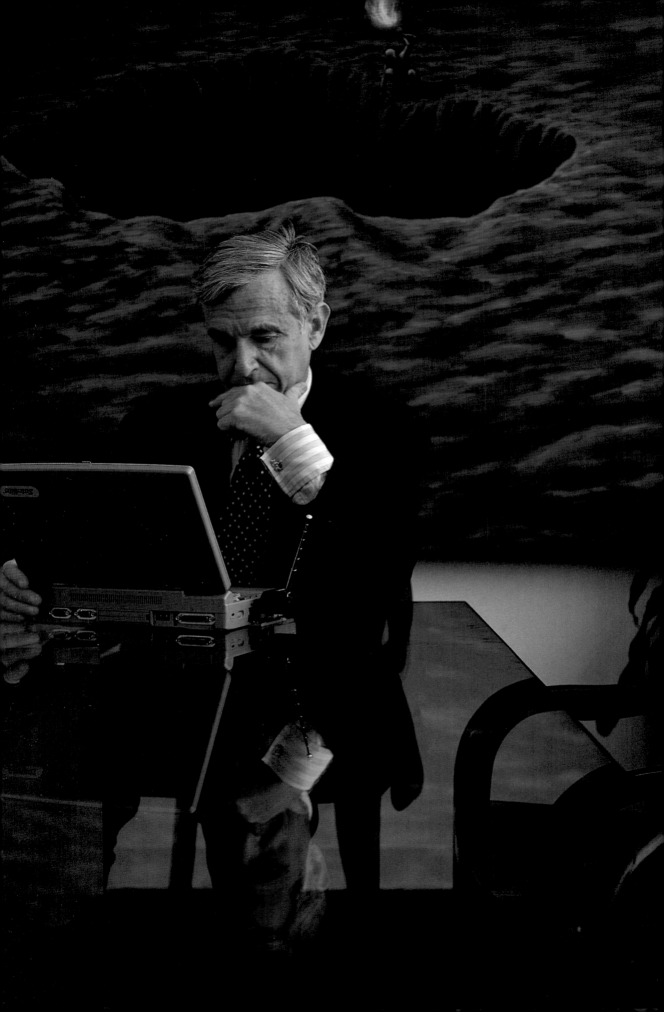

Alan Patricof

Venture Capitalist, Chairman,
Patricof & Co. Ventures, Inc.

Alan Patricof is chairman of Patricof & Co. Ventures, Inc., a U.S.
member of Apax Partners, one of the world's leading venture capital
firms with operations in seven countries and $2 billion under manage-
ment. From 1960 to 1968 he was assistant vice president and then
vice president of Central National Corp., a private family investment
management organization. During that time, Patricof became a
founder and chairman of the board of *New York Magazine,* which later
acquired the *Village Voice* and started *New West Magazine.* During the
past 26 years, Patricof has participated in the financing and develop-
ment of a large number of both public and private companies includ-
ing Office Depot, Apple Computer and Cellular Communications, Inc.
During the 1992 presidential election campaign, he served as chair-
man of entrepreneurs for Clinton-Gore. In 1995 he served as chair-
man of the White House Conference on Small Business.

WIRELESS COMMUNICATIONS SERVICE: "WyndMail wireless commu-
nication keeps me in constant touch."

WyndMail wireless communication is very impor-
tant in my business because it allows me to
send and receive e-mail and faxes even when
I'm away from the office or nowhere near a phone line. For
this reason, I particularly rely on it when I'm traveling or out
of the office at a meeting.

My work relies on staying on top of things in a quickly
changing world. Each day there is an extraordinary amount of
information to deal with and respond to. I have to keep up with
it. In addition to my work at the firm, I am a member of several boards, committees, and
foundations. Information comes at me from many different directions from all over the world,
and with my WyndMail service, I am always connected, using my palm-tops or my lap-top
computer with my wireless modem.

With wireless communications, I can stay in touch with what's going on — someone
at the office can e-mail all my messages and stock prices throughout the day, as well as
fax important statements. I also receive numerous e-mail messages from many other peo-
ple. They know they can reach me wherever I am. It keeps me in constant touch.

TOOL:
Wireless Communi-
nications Service.
A service that
allows easy access
to e-mail, faxing,
alpha paging, and
text-to-voice mes-
saging via comput-
er. Through this
program, users can
send and receive
e-mail to anyone
on the worldwide
Internet, send
faxes, and send
e-mail to telephones
(the program can
convert written text
to speech and read
e-mail aloud to
recipients).

191

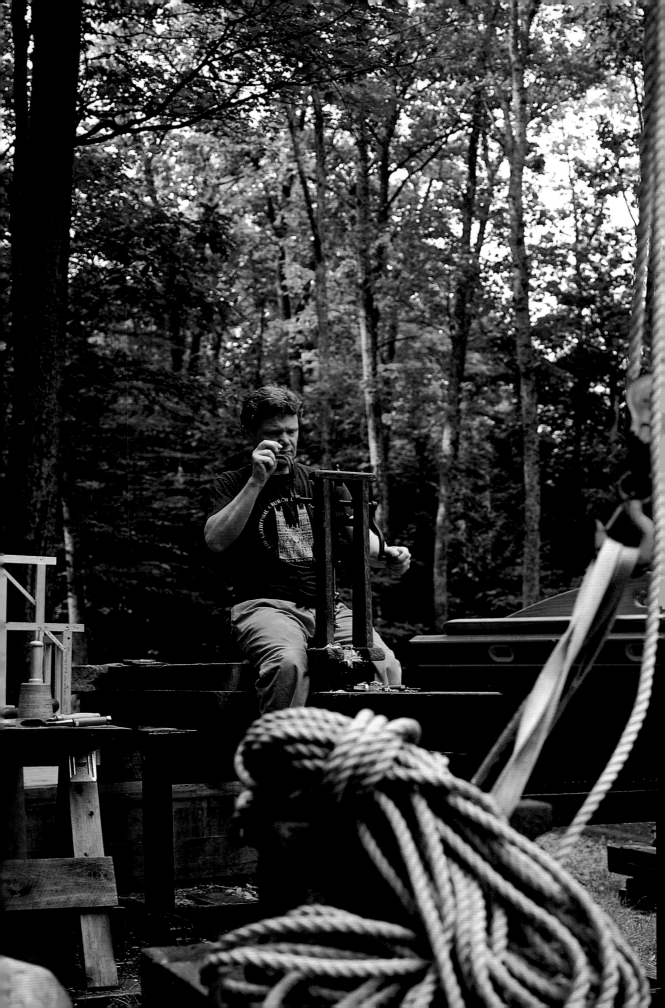

Philippe Petit
High-Wire Artist, Street Juggler,
Writer, Timber Frame Builder

Philippe Petit was born in 1949 in Nemours, France. After being expelled from five different schools, he conducted independent studies in fencing, horseback riding, printmaking, and drawing. He is best known for his famous high-wire performances, including a crossing between the twin towers of the World Trade Center, one quarter of a mile above the streets of New York City. His other skills and pastimes include carpentry, engineering, lock-picking, chess, bullfighting, writing, and street juggling, for which he has been arrested more than 500 times. Petit has traveled all over the world, speaks several languages, and is an artist-in-residence at the Cathedral of St. John the Divine in New York.

BORING MACHINE: "The boring machine is pleasing to the eye — no part of it is useless. Even something that looks like an embellishment is dictated by functional concerns."

Since I started building a small barn with the methods and tools of 18th-century timber framers, the boring machine has become an indispensable tool. It helps framers of timber structures bore holes more accurately, easily, and quickly than the T-auger.

I take great pleasure in using this tool. It is an object from the past that I find superior to modern tools in many respects. It is silent — one can hear the cutting of a beam's fibers and judge the degree of dryness and the quality of the wood. It is a very clever tool — the frame assures that the auger bores at right angles to the wood, and it uses the force of gravity to draw the bit downward. It is also pleasing to the eye — no part of the boring machine is useless. Even something that looks like an embellishment is dictated by functional concerns.

To use the boring machine, you sit or kneel on its wooden base, using both hands to turn the two cranks that continuously turn the auger bit. The boring machine is not an obstacle or an unconnected link between the worker and the work itself, as an electric drill is. Instead, it becomes a part of the carpenter who is riding it. The slightest motion of the body is transmitted to the beam, and the most minute turning of the auger is dictated directly by the finger tips that hold the handles. It is a great example of simple yet complete communication between the craftsman and his craft.

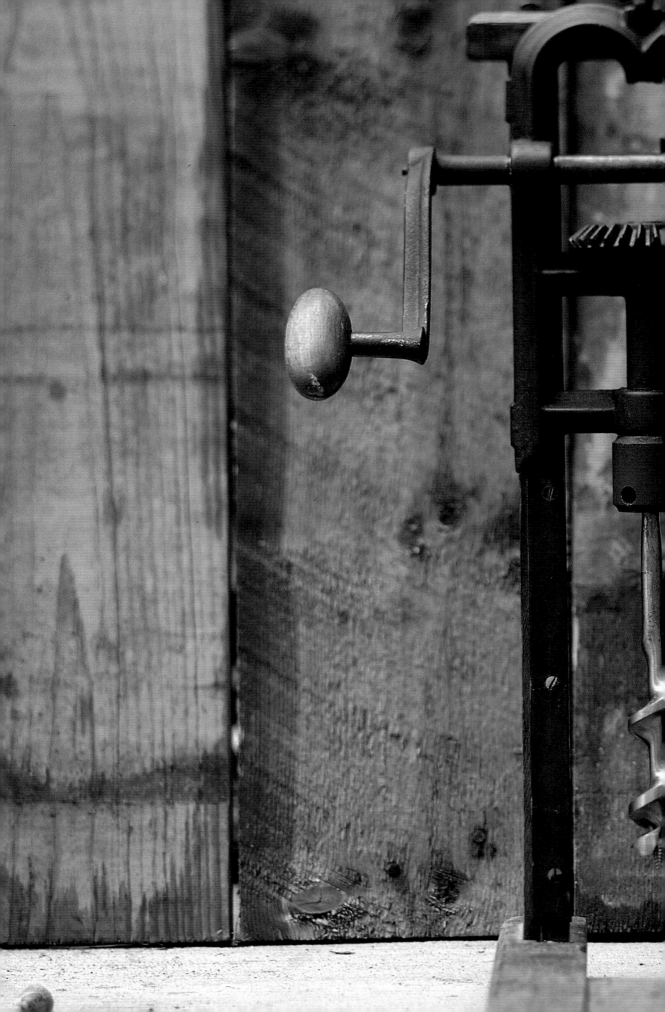

TOOL:
Boring Machine. An 18th-century tool used to make a hole in or through wood, as if with a drill. This tool was traditionally used while building structures, such as barns. The weight of the person using the tool forces the bit downward, and the tool's frame assures the holes are cut at right angles to the wood.

195

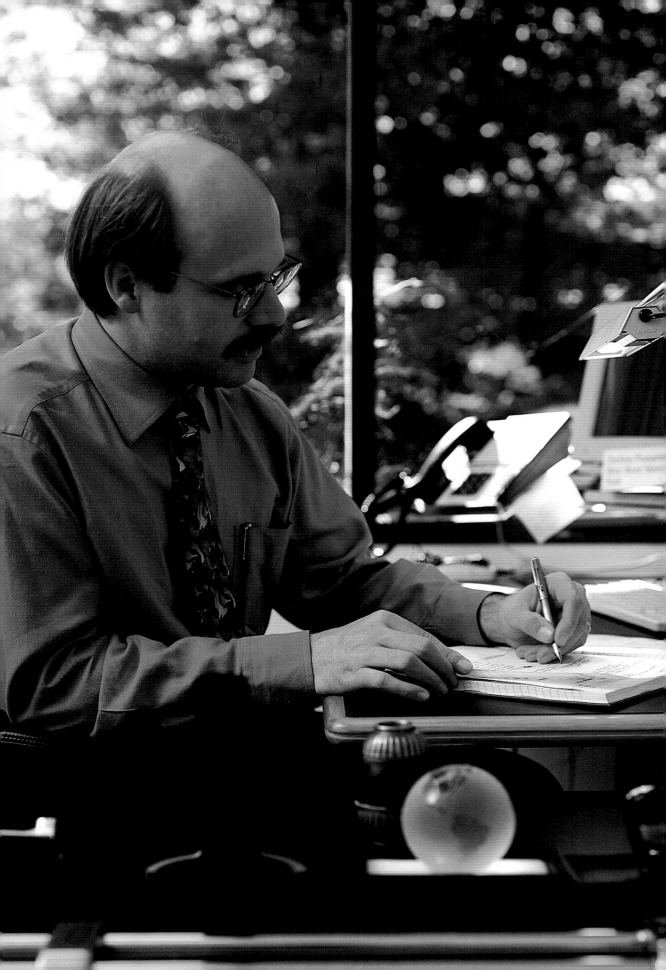

Paul Saffo

Forecaster, Director, Institute for the Future

Paul Saffo is a director at the Institute for the Future, a 26-year-old management consulting foundation that provides long-range planning and forecasting services to Fortune 100 companies and government agencies. A specialist in the long-term social and commercial impacts of new information technologies, Saffo's clients include major computer, telecommunications, and media companies. He also contributes an occasional column to *Wired,* and his essays on information and media trends have appeared in a variety of publications, including *PC Computing Magazine, Infoworld Magazine, MacWeek,* the *Los Angeles Times,* the *New York Times,* and *Fortune* magazine. A book of Saffo's essays, *Dreams in Silicon Valley,* was recently published in Japan. He holds degrees from Harvard College, Cambridge University, and Stanford Law School.

ANTIQUE FOUNTAIN PEN: "My fountain pens are really true, flexible 'multi-media' tools, vastly superior to today's computers."

Oddly enough, my favorite tool is an antique fountain pen. I rotate through a collection of some 40-odd pens, using one or another to keep a daily record of notes and diagrams in a bound journal that's always with me.

It may seem a bit odd that a technology forecaster like myself would use something so old-fashioned as a pen and use it several times a day, every day. I do actually make extensive use of computers and other advanced communication tools in my work, but these advanced tools are constantly changing, whereas my pens and my journal have been constants for over a decade. With my pens, I record key ideas, drawings, diagrams, and references and make notes that are the foundation for my work. The pages in my journal are free-form, with notes in the margins and arrows connecting ideas. Using pens to record information frees me up to express myself in whatever way works best for the idea.

The pens are, themselves, object lessons in the evolution of technology — each is exquisitely tuned to the specific needs of its particular time. As a result, using these pens helps me to establish context. And writing, of course, is a measured process that encourages reflection. The pens are really true, flexible "multi-media" tools, vastly superior to today's computers. Thus, they are very effective means to capture ideas for future reference.

TOOL:

Antique Fountain Pen. A writing instrument invented by American Lewis E. Waterman in 1884, replacing the quill pen. Fountain pens incorporate their own ink reservoirs, encased by a body made of plastic or other material. (Saffo's favorite is the 1956 Parker 61 first edition, which was the first self-filling fountain pen. It has a gold-filled rainbow cap.)

Gordon Segal
Founder and CEO, Crate & Barrel

Gordon Segal is founder and CEO of Crate & Barrel, a chain of retail home furnishings and accessory stores. Segal and his wife, Carole, opened their first store in 1962 in the Old Town district of Chicago, stocking it with the kind of well-designed, everyday, useful products that they had seen in Europe. With no retail experience, they rented a 1,700-square-foot former elevator factory and used the crates and barrels in which their first merchandise arrived for displays. Many factors contributed to their success — the ease of importing products through the newly opened St. Lawrence Seaway, the value-oriented, well-designed merchandise, and Carole's display techniques. Currently there are 69 Crate and Barrel stores in 15 markets in the United States, as well as a catalog business. The Segals have three children and reside in a northern Chicago suburb.

CELLULAR/CAR PHONES: "My cellular and car phones are so much a part of my day that they are almost invisible to me."

The most important tools in my work and life are my car phone and my cellular phone because they make my days more productive. These instant communication tools are so important in our work. They symbolize the present and the future of business communication.

I use the phones every time I am in the car and when I travel, I can't imagine doing business without them. Because of them, my time in the car or otherwise out of the office is not necessarily "down time." Even when I am not in my office, I am able to stay in touch with our stores and with business contacts all over the world. When I'm in the car, having a phone makes time fly and takes away my frustration at being stuck in traffic.

I was lucky enough to be one of the first 100 people chosen to beta-test cellular phones in Chicago. Soon after they became available on the market I bought a car phone. Cellular phones are constantly being improved — the designers always seem to be one step ahead of what the consumers are looking for, designing smaller, lighter, and easier-to-use products. Now they are so much part of my day that they are almost invisible to me.

TOOL:

Cellular/Car Phones. A mobile radio telephone that uses a network of short-range transmitters located in overlapping cells throughout a region, with calls automatically switched from one transmitter to the next as the caller enters an adjoining cell. The cellular phone became popular in the 1980s.

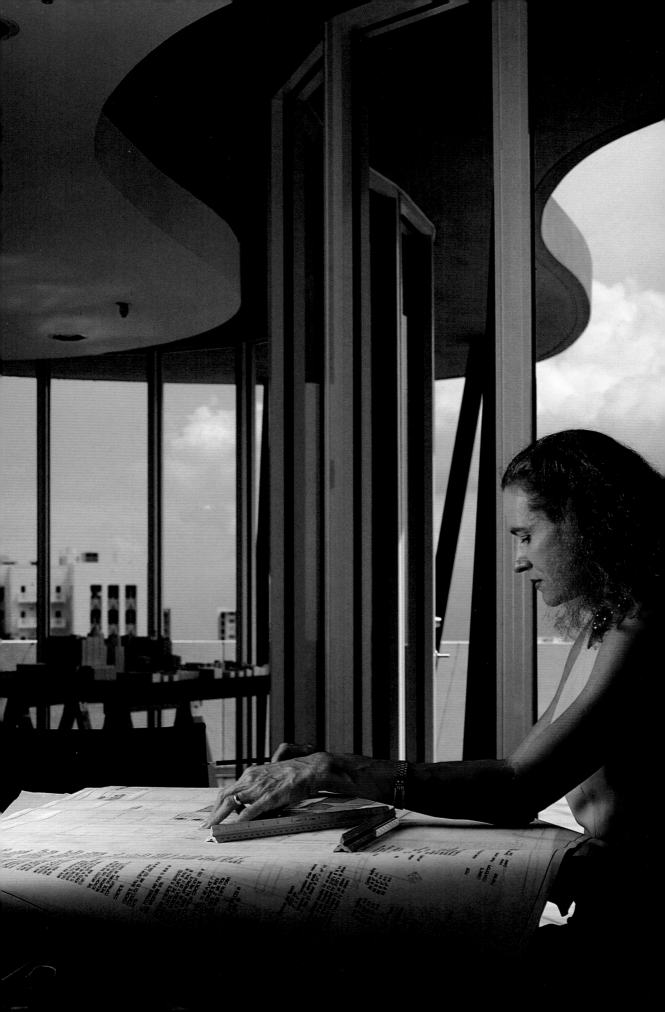

Laurinda Spear
Principal Architect & Co-Founder, Arquitectonica

As founding principal of Arquitectonica, Laurinda Spear has been involved in the design of all projects undertaken by the firm. Her projects range from low-income housing, high-rise condominiums, and single-family housing to office towers, corporate headquarters, medical office buildings, retail complexes, and hotels. Spear's projects have been featured in numerous prominent magazines and professional journals such as *Time, Newsweek, Esquire, Life, Art in America, Progressive Architecture,* and *Architectural Digest.* Her designs have won several awards from the American Institute of Architects and *Progressive Architecture.* She has lectured around the world and her work has been exhibited in numerous prominent museums throughout the United States and Europe.

SCALES: "Without a scale, it's difficult to discover exactly what size certain spaces are on a drawing."

The most important tool for me as an architect is the scale. I have a scale that measures in metric and another that measures in feet and inches. I use an engineering scale as well. They are made out of wood, plastic, or metal but all serve the same function.

Without a scale, it is difficult to guess exactly what size certain spaces are in a plan — especially since not all dimensions are always noted on all drawings that I work with. I rely on a scale several times a day.

The scale has been around forever — architects have always used them. And it hasn't really evolved since it was developed, perhaps because there's really no way to improve the design or utility. There is something nice about the simplicity of the design and function. Even though computers can serve the same function, I like the convenience and availability of the scale. It's always right there on my desk and it's easy to use. Reaching for it is second nature to me.

TOOL:
Scales. Long, triangular instruments bearing marks at fixed intervals. The marks are standardized from instrument to instrument so they can be used as common measurement references. Scales come in many sizes and are used most commonly by architects and engineers.

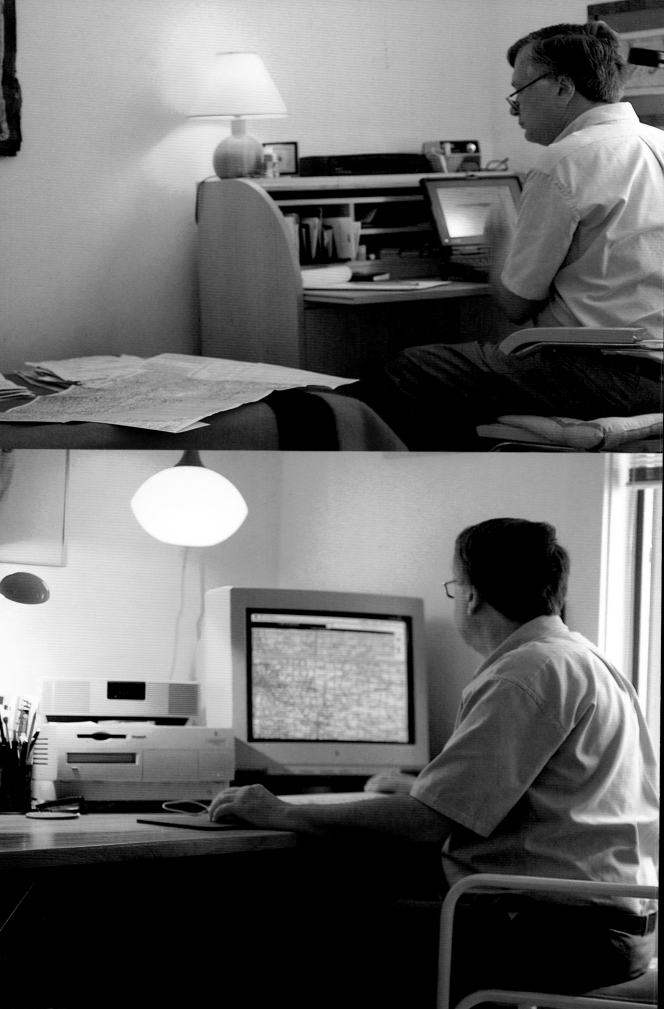

Philip Stone

Professor of Psychology, Harvard University

Philip Stone is professor of psychology at Harvard University and a senior scientist with the Gallup Organization. His research has included detailed multi-national surveys of how people use their time, as well as studies of how office environments can be more effective in supporting work. He created "envisioning" tools Steelcase uses to help organizations identify their evolving organizational cultures and how they can be best matched with supportive office environments. An author, co-author, and/or editor of seven books, his work on office environments has appeared in the *Harvard Business Review* and been featured in cover stories of facility management trade magazines.

WORK SURFACES OF VARIOUS HEIGHTS: "Having work surfaces of various heights gives me a sense of unhampered freedom and energizing empowerment."

The most important tool for my work is a series of four work surfaces at four different heights: 27 inches, 28 inches, 30 inches and 42 inches high. Each setting is outfitted with appropriate seating and standing areas and equipped with various task lighting combined with natural light sources.

As a highly kinesthetic person, I find that my thinking is greatly helped when I change positions often. To work at one desk and in one chair all day would be torture for me. I am six-feet two-inches tall, and two of the work settings were especially constructed for my height from butcher block.

The great flexibility of my work and seating arrangements gives me a chance to change posture, to improve blood circulation, to type while sitting or standing, to walk about while thinking, and to have varying amounts of physical closeness to the information that I deal with. It seems to give me greater productivity in writing computer programs, and producing reports. According to research surveys by the Gallup Organization, there are quite a few kinesthetic people like myself who need motion and changes in position to keep their minds functioning at their best. The arrangement gives me a sense of unhampered freedom and energizing empowerment.

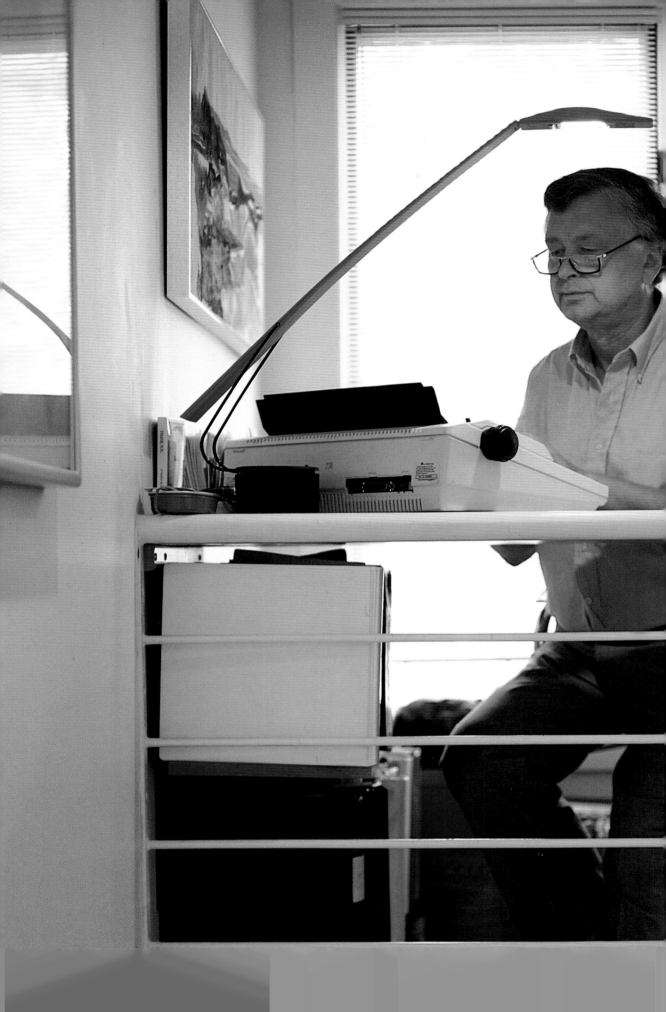

TOOL:
Work Surfaces of
Various Heights.
Hard surfaces,
made of wood or
metal, that are par-
allel to the floor.
The surfaces often
hold a variety of
equipment, such
as computers and
telephones, as well
as evidence of
work, such as files,
papers, calendars,
pens, and docu-
ments. Most sur-
faces are of a
height suitable
 for sitting, but
others are higher,
for standing.

211

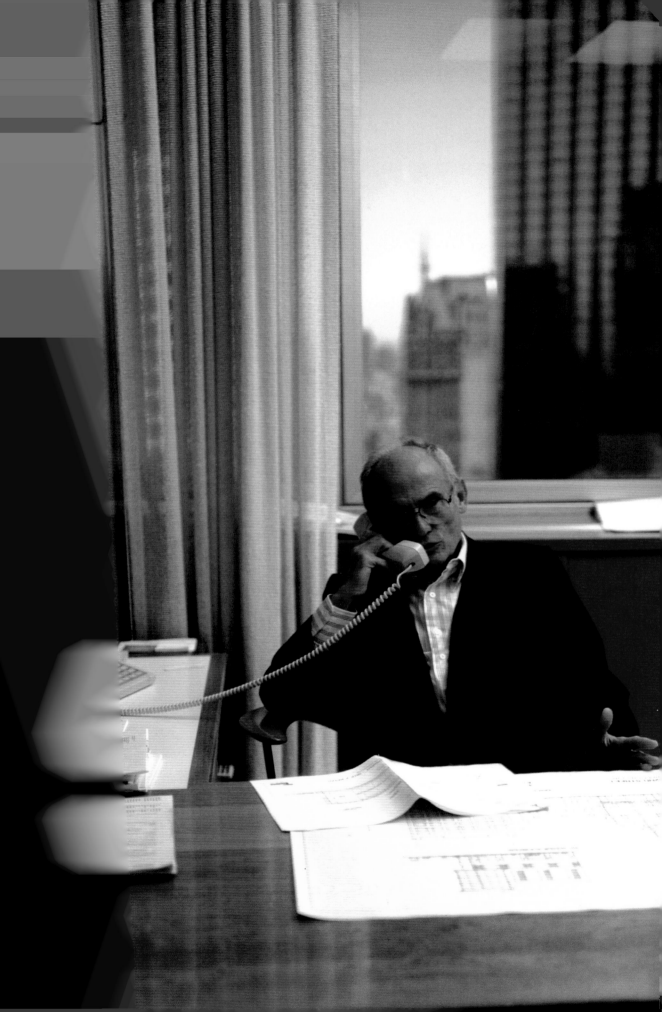

John Tishman
Chairman & CEO, Tishman Realty &
Construction Co., Inc.

John L. Tishman is chairman and CEO of Tishman Realty &
Construction Co., Inc., and of all its operating units worldwide. In
1948 he joined the company, which was founded by his grandfather
in 1898. Tishman is recognized as an expert in the development and
construction of complex, large-scale projects, particularly those incor-
porating state-of-the-art systems or requiring the application of new
construction techniques. Landmark Tishman projects include the
World Trade Center in New York, the John Hancock Center in
Chicago, the Renaissance Center in Detroit, Walt Disney's EPCOT
Center in Florida, and the renovation and restoration of Carnegie Hall.
Tishman graduated from the University of Michigan in 1946 with a
degree in electrical engineering.

TELEPHONE: "The telephone gives me more freedom and allows
more communication and life is about communication."

The telephone is the single tool that I use most often in
my work. It's indispensable to me. I have a phone with
me 24 hours a day, one way or another. If I'm not at
my office or at home, I have my voice-activated car phone or
my cellular phone with me. When I travel, I always have my
cellular phone, and all I need in my hotel room to keep me
happy is a shower and a phone.

The fact that I can always have a phone with me gives
me more freedom to move about yet stay in touch with peo-
ple and projects. For instance, I can talk to the West Coast during my ride home. The
telephone makes good use of my "down time," therefore expanding my time, so to speak.

Phones are so important to my work because they allow me to be face-to-face,
metaphorically speaking, with people I need to communicate with. Always having up-to-
date and immediate communication is essential, because life is about communication.
Things really start to fall apart and break down when people aren't communicating
actively, and the telephone is the perfect way to stay in touch since we can't all be in the
same room at the same time.

TOOL:

Telephone.
An instrument that converts voice and other sound signals into a form that can be transmitted to remote locations, and that also receives and reconverts waves into sound signals. Alexander Graham Bell was granted a patent for the telephone in 1876. By 1887 there were more than 150,000 telephones in the United States; in 1990 there were about 181 million.

Sara Little Turnbull

Director, Process of Change Laboratory,
Stanford University

Sara Little Turnbull is the director of The Process of Change/Innovation and Design Laboratory at Stanford University's Graduate School of Business. She also is a consulting professor at Stanford's School of Engineering. Turnbull has served as a design development consultant at several corporations internationally, including Corning Glass Works, Proctor and Gamble, Scott Paper, Ford Motor Co., DuPont, Volvo, and Columbia Broadcasting. She serves on the boards and advisory councils for several art schools and museums, and has lectured on design issues across the United States and in France, Korea, and Denmark. In 1988, Turnbull received a Distinguished Designer Fellowship from the National Endowment for the Arts.

RESTING AREA: "My resting area provides a change of pace, from intense concentration to serenity, to objectivity, and to re-examination."

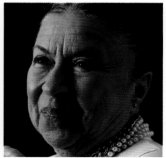

In my professional experience of some 60 years, an indispensable tool for conceptualizing, visualizing, imagining, and always worrying has been a place to rest. It can be a chair, a settee, a sofa, or a bed — very often it's all of them at different times during the day, depending on where I am and on my mood. Such a resting area is a sanctuary that must be visually and purposefully integrated in my space and in various activities.

When I leave my desk or a meeting and enter my resting area, something happens to the way I think and feel. The resting area helps me distance myself mentally, and allows me to lower my stress level and to see the world with a fresh eye and in new ways. It's actually more a mental respite than a physical one. For me to be able to conceive of the whole picture and to delineate, comfort is an important functional phenomenon. My resting area also provides a change of pace from intense concentration to serenity, to objectivity, and to re-examination. It is a place in which to think, imagine, and plan.

I use my resting area whenever I reach a seminal moment in the decision-making process. While resting, I am able to listen to my inner self and explore new directions that allow my mind's eye to see patterns and ideas from a refreshed perspective.

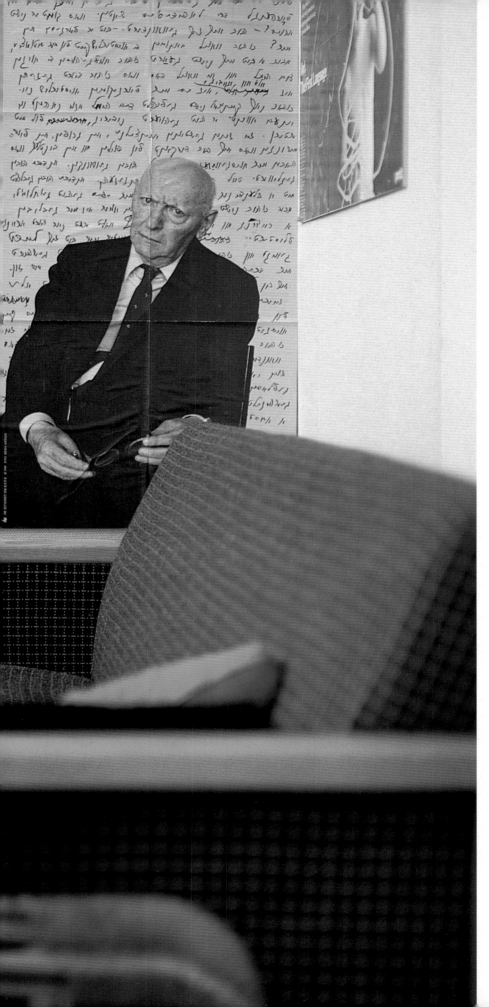

TOOL:
Resting Area.
An environment
that is conducive
to quiet contempla-
tion and does not
distract from a
serene mood. The
area generally
includes a comfort-
able piece of furni-
ture on which to sit
or recline, such as
a chair or sofa,
and other pleasing
objects, such as art
or plants.

219

Constance van Rhyn
Manager of Design, PepsiCo, Inc.

Constance van Rhyn is the manager of design at PepsiCo, Inc. where she is responsible for the space planning and interior design for the head-quarters building and adjacent sites. Van Rhyn was previously a designer at GTE's World Headquarters in Stamford, Connecticut, and held staff positions at The Space Design Group, Inc. and Sherburne/Hurst, Inc. in New York City. She is a professional member of ASIC and IFMA and received NCIDQ certification in 1988. Van Rhyn has served on the board of the Connecticut Chapter of ASID, the Stamford Art Assoc-iation, and the Art Society of Old Greenwich. She is a recipient of ASID Chapter Presidential Citations in 1987 and 1989. She holds a Bachelor of Fine Arts in interior design from Syracuse University and a master's degree in facilities management from Pratt Institute.

25-FOOT TAPE MEASURE: "A tape measure isn't high-tech, but I can use it for so many tasks."

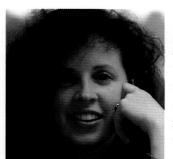

My 25-foot Lufkin tape measure gets a lot of use. The Lufkin has a slim profile compared to other models. It's small enough to fit in my purse, so it's very portable — I can carry it with me everywhere. This gives me the flexibility of having a tool to accurately dimension or scale an item or concept at any time. Also, because of its 25-foot length, it permits measurements in long increments — the 10-foot tape measures are too small for my purposes.

A tape measure isn't high-tech, but I can use it for so many tasks, like verifying the accuracy of measurements, comparing the relationships of ideas or items, and determining scale. It's useful in the field when discussing designs or reviewing design issues. I also use it to determine if something I designed was con-structed as specified, and if my ideas will actually work in a space. When I travel, I take it along so that if I find something interesting I can enhance my sketches with actual dimensions, creating a more accurate illustration of what I saw.

I use my tape measure almost every day, sometimes all day long. I bought a great Lufkin model in 1982, but I lost it last year. I'm still looking for another in the same model — it was a great one. In the meantime, the new model meets many needs.

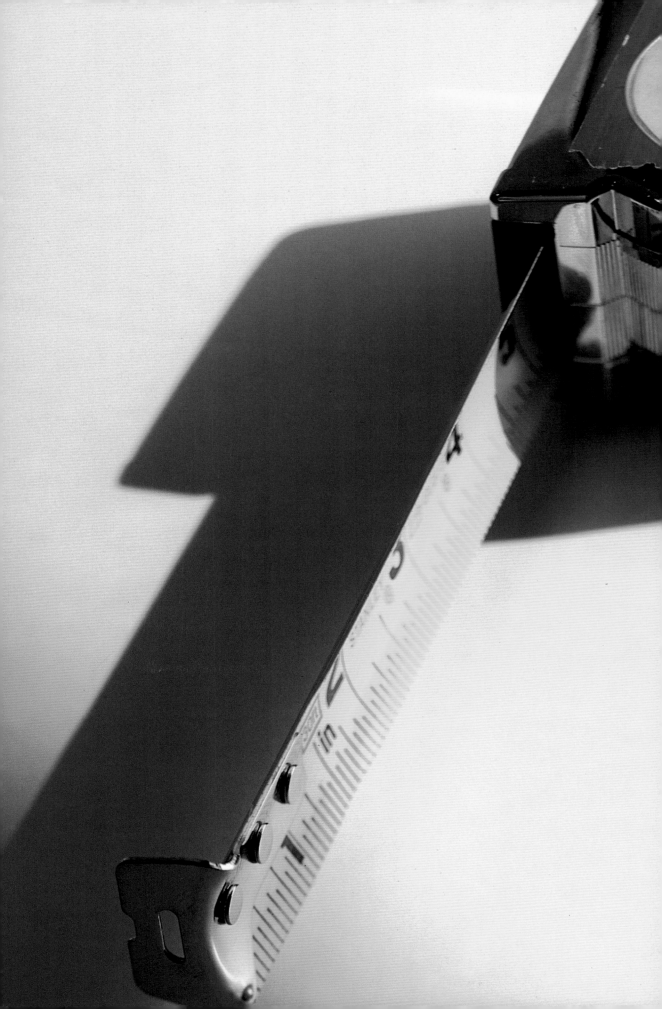

TOOL:
25-foot Tape Measure. A strip of steel marked off in a linear scale, with inches and centimeters, used for taking measurements. The tape is rolled inside a metal or plastic casing, from which it is pulled to the desired length and stopped with a brake. A spring retracts the tape into the casing.

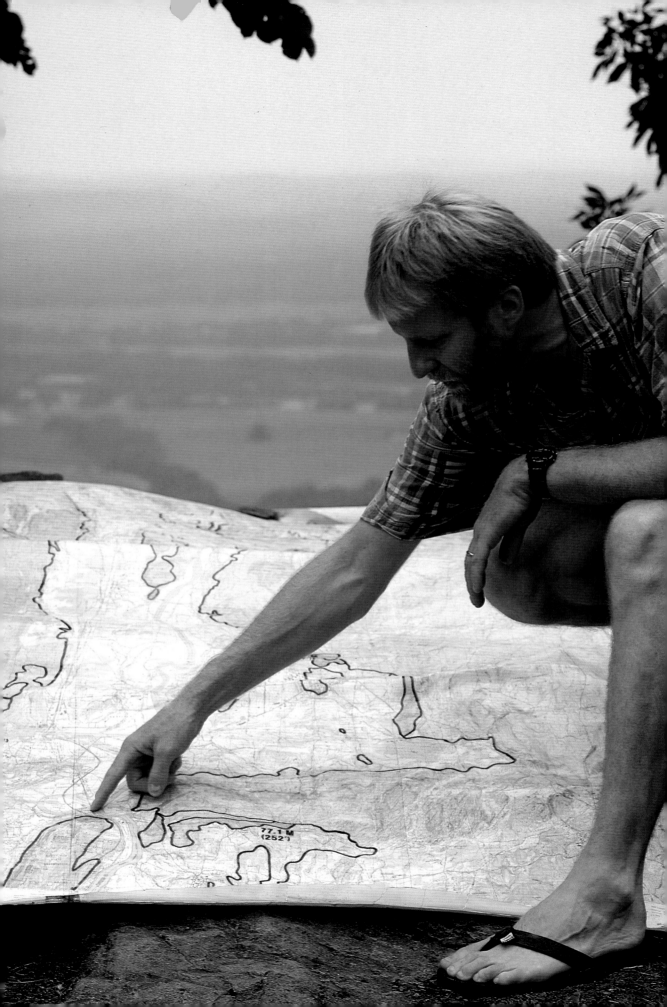

Al Werner
Geologist, Associate Professor/Chair,
Mount Holyoke College

Al Werner is an associate professor of geology and chair of that depart-
ment at Mount Holyoke College in South Hadley, Massachusetts.
Werner joined the faculty at Mount Holyoke in 1988, after completing
his doctoral degree at the University of Colorado that year. He has
received several research grants from the National Science Foundation
and has conducted extensive research in primarily Alaska and the
Canadian Arctic. His papers have been published in a number of pro-
fessional journals, including the *Journal of Geological Education*.

TOPOGRAPHICAL MAPS: "Topographical maps contain an amazing
amount of information about the earth's surface."

The most useful tools in my work are topographical
maps, especially those published by the U.S.
Geological Survey and sold for a few bucks each — a
tremendous bargain, even for weekend hikers. Topographical
maps are more than just road maps. They contain an amaz-
ing amount of information about the shape of the landscape,
the occurrence of rivers, lakes, and swamps, and the loca-
tion of roads and buildings.

These "topo" maps are invaluable research tools. You can
get a sense of accessibility, vegetation cover, development, potential hiking routes, and the
overall lay of the land. A comparison of old and new maps often allows geologists to deter-
mine how fast rivers or coast lines are eroding, therefore determining rates of change.

All geologists who conduct field work and collect samples use topo maps extensively. I
use them daily in the classroom as well as for my research. I even teach a course that specif-
ically shows students how to recognize geological features on maps and aerial photographs.

Gradually, paper topo maps are being replaced by electronic (digital) maps. These
provide the same information as paper maps, but allow greater manipulation of the map
and give us the opportunity to put interpretations and sample sites into digital format.

TOOL:
Topographical Map. A paper or digital map with detailed graphic representation of the surface features of a place or region. Positions and elevations are indicated, showing the relations among various components of the land. While used most by scientists, topographical maps are also useful to hikers and people involved in other wilderness sports.

227

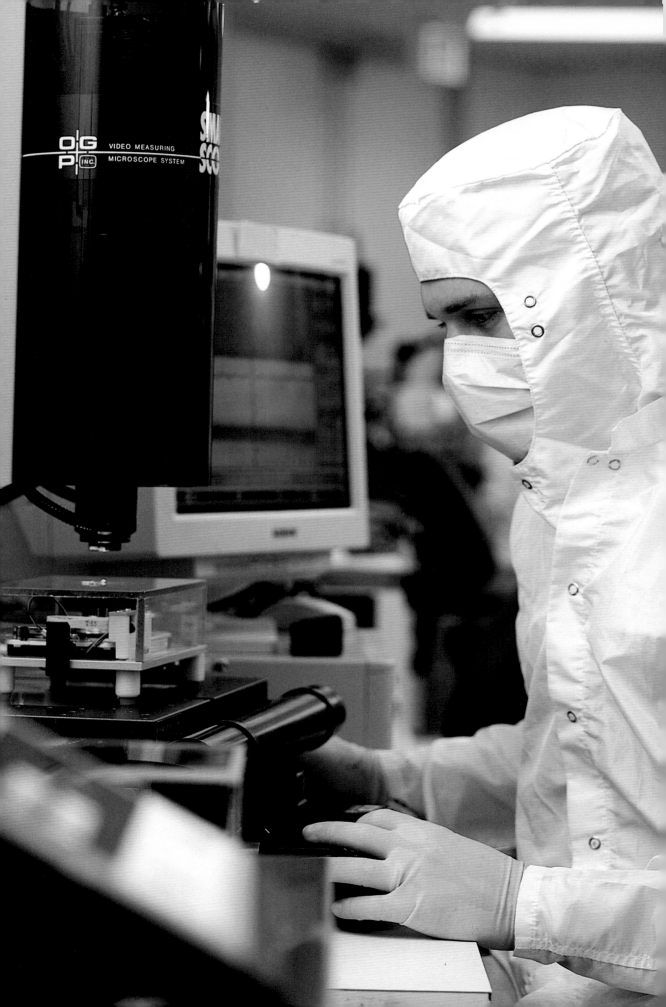

Blake Westman
Reliability Engineer, Seagate Recording Media

Blake Westman is a reliability engineer at Seagate Technology's Media Division in Milpitas, California. In that position, he helps run the lab that monitors the quality of the disks that go into various Seagate hard disk drives. Westman is 28 years old and has been in the computer drive manufacturing industry for 5 years. In 1992, he graduated from California Polytechnic University in San Luis Obispo, California, with a bachelor's degree in aeronautical engineering.

OPTICAL GAGING MICROSCOPE: "An optical gaging microscope keeps me in touch with our new miniature world."

I help run the lab that monitors the quality of the disks that go into various Seagate hard disk drives. In other words, I make sure that our customers' hard drives don't crash.

To do this, I rely on an optical gaging microscope (or video measuring microscope). It's important for the tools in my line of work to be able to perform one or more duties quickly, automatically, and accurately. Not only does such a tool free up my time for other projects, but it also makes me more effective in an important area of this fast-paced industry — quality assurance.

My video measuring microscope helps provide quality assurance not only in testing samples, but also in testing equipment. Unless quality and consistency of equipment are maintained, it is hard to justify calling my lab a "reliability lab." And unless we monitor the quality of samples, we cannot assure the quality of our products.

We use the latest video imaging technology and automation software to provide a quick, accurate, three-dimensional analysis of the physical dimensions of one or more objects, as well as their relative positions to each other. These analyses can no longer be done with one's own eyes, or with a pair of calipers — they require an optical gaging microscope, which keeps me in touch with our new miniature world.

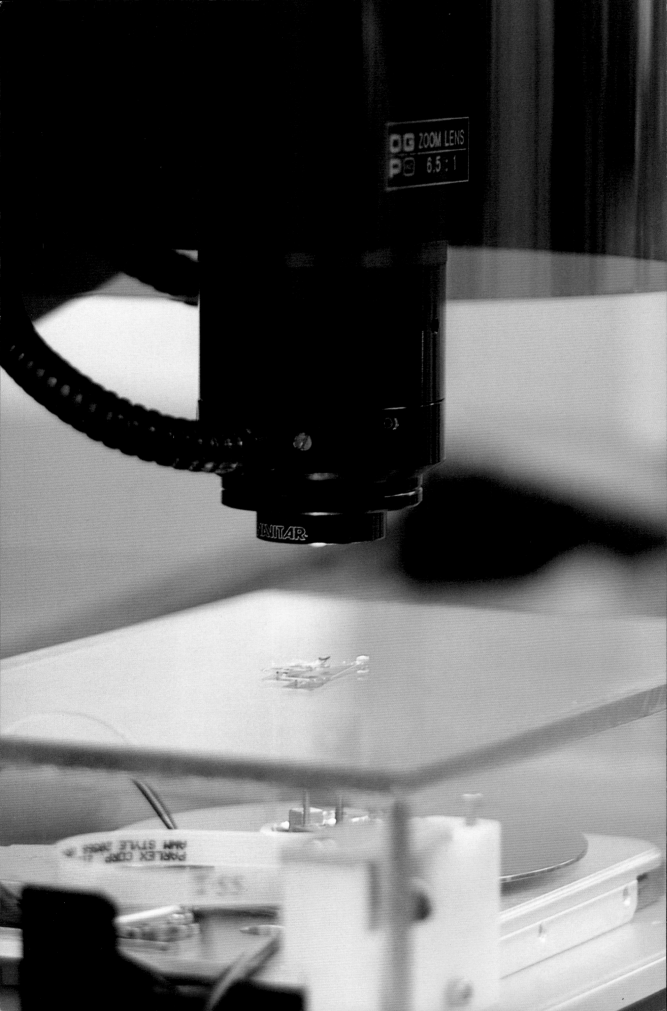

TOOL:
Optical Gaging
Microscope. A
video inspection
device, created in
1993, that utilizes
PC-based technol-
ogy. The apparatus
consists of a micro-
scope stage, video
monitor, computer,
and video printer. It
is capable of char-
acterizing objects
as large as eight
inches square or
detail as small as
half a thousandth
of an inch.

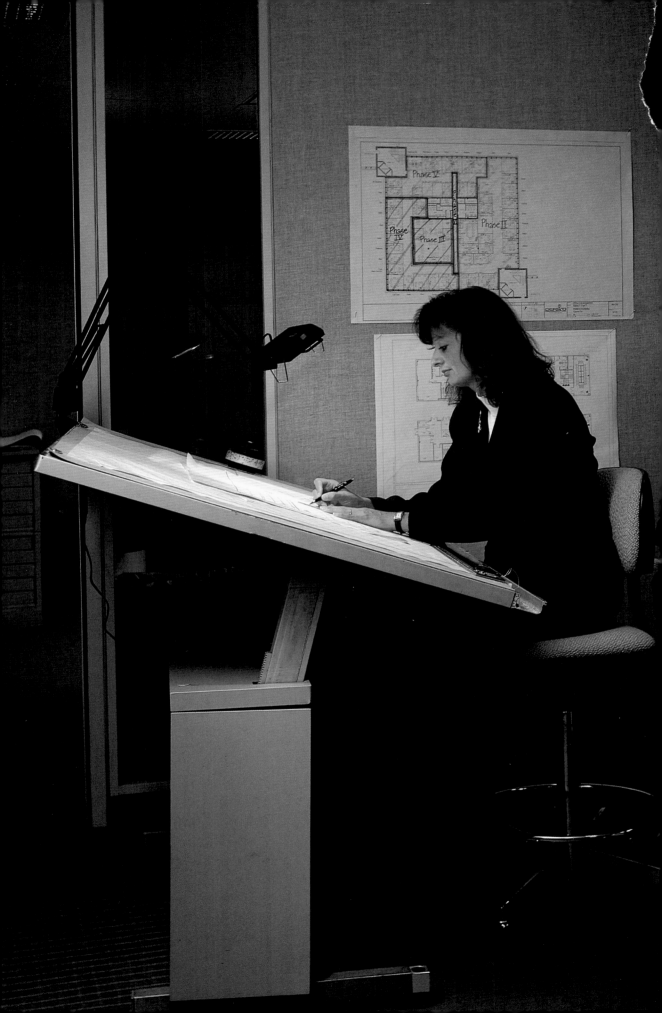

Brenda Williamson

Interior Designer, Project Coordinator, PepsiCo, Inc.

Brenda Williamson's interest in space planning took root at a young age — by age eight she was constantly rearranging the furniture in her family's home, looking for more functional and interesting ways to configure the rooms. In 1990 Williamson received a bachelor's degree in interior design from Kansas State University. After working as an interior designer for Pizza Hut Corporation, she moved to Purchase, New York, to work as a designer at the PepsiCo World Headquarters. Williamson is also working toward a master's degree in facility management from the Pratt Institute.

MECHANICAL PENCIL: "This pencil never needs sharpening, unlike other drafting pencils."

I use a Pentel P205 mechanical pencil with 0.5 mm HB lead and an eraser every day — for creating design sketches, planning space, drafting, recording appointments, and doodling ideas. The impermanence of pencil marks allows me to erase mistakes, and cancel appointments when I need to, without making a mess. A regular pencil needs to be sharpened (and replaced) all the time, but mechanical pencils never need sharpening.

I use my pencil so often that I have one at my desk, one at my drafting board, and one in my planner. The pencil has a pocket clip on it, so it gets clipped to graph paper pads and taken along on appointments.

My father, who was an engineer for the State of Kansas until he retired, always carried one of these pencils with him — clipped in his pocket, of course, as all engineers seem to do. When we were kids, my brothers and sisters and I always tried to sneak it from him to use for our homework. (He wasn't too happy if we failed to return the pencil to him!) My father had a special talent for writing poems to his children, which were usually written with his Pentel P205 pencil. The poems meant a lot to us. He was able to express himself with those pencils in ways he couldn't with words.

TOOL:
Mechanical Pencil. A long, slender, plastic-barreled pencil with riveted finger grips, refillable lead and a chrome clip, cap and tip. The lead, rather than being fixed, is refillable, and can be manually extended from the tip or pushed into the barrel. Erasers are also replaceable, giving these pencils a long life.

235

References and Bibliography

Arendt, Hannah. *The Human Condition.* Chicago: University of Chicago Press, 1958.

Colquhoun, Alan. "Centraal Beheer." *Architecture Plus* 2, no. 5, (September/October 1974).

De Zurko, Edward Robert. *Origins of Functionalist Theory.* New York: Columbia University Press, 1957.

Duffy, Francis. *The Changing Workplace.* London: Phaidon, 1992.

Duffy, Francis, and Jack Tanis. "A Vision of the New Workplace." *Site Selection and Industrial Development,* March/April 1993, Atlanta: Conway Data, Inc.

Handy, Bruce. "Arnold Neustadter, Big Wheel." *New York Times Magazine,* December 29, 1966.

Hodges, Henry. *Technology in the Ancient World.* New York: Barnes & Noble, 1992 (first published 1970).

Johnson, George. "Quantum Theorists Trying to Surpass Digital Computing." *New York Times Magazine,* February 18, 1977.

Kouwenhoven, John A. *Made in America: The Arts in Modern Civilization.* Garden City, N.Y.: Doubleday, 1962 (first published 1948).

Langer, Suzanne. *Problems of Art.* New York: Scribner's, 1957.

Lewis, Arthur O., Jr., ed. *Of Men and Machines.* New York: E. P. Dutton, 1963.

Lieux? De Travail. Exhibition catalog, Paris: Centre Georges Pompidou, 1986.

Marx, Leo. *The Machine in the Garden: Technology and the Pastoral Ideal.* London: Oxford University Press, 1964.

Mumford, Lewis. *Art and Technics.* New York: Columbia University Press, 1952.

———. *Technics and Civilization.* New York: Harcourt, Brace, 1934.

"New Work Options Increase Flexibility." *Business Insurance,* July 25, 1994, quoted in "Work Expectations," Grand Rapids: Steelcase, 1997.

Papanek, Victor. *Design for the Real World: Human Ecology and Social Change.* New York: Van Nostrand Reinhold, 1984.

Pérez-Gómez, Alberto. *Architecture and the Crisis of Modern Science.* Cambridge, Mass.: MIT Press, 1983

Petroski, Henry. *The Evolution of Useful Things.* New York: Knopf, 1992; New York: Random House, 1994.

Read, Herbert. *Art and Industry.* New York: Horizon Press, 1954.

Rybczynski, Witold. *Waiting for the Weekend.* New York: Penguin, 1991.

Sale, Kirkpatrick. "Ban Cloning? Not a Chance." *New York Times,* March 7, 1997.

Small, Harold A., ed. *Form and Function, Remarks on Art by Horatio Greenough.* Berkeley and Los Angeles: University of California Press, 1947.

Steelcase Workplace Performance papers, Grand Rapids, Mich.: Steelcase, Inc., 1995ff, including: "Learning Opportunity Kit #1," "Learning Opportunity Kit #2," "Learning Opportunity Kit #4," "Workplace Factor Overview: Measurement," "Workplace Factor Overview: Utilities Management," "Workplace Factor Overview: Financing Alternatives," "Workplace Factor Overview: Cost of Ownership," "Workplace Factor Overview: Communication Linkages," "Workplace Factor Overview: Health and Safety," "Workplace Factor Overview: Organizational Shape," "Workplace Factor Overview: Electronic Tools," and "Workplace Factor Overview: Work Expectations."

Stewart, Thomas A. "The Search for the Organization of Tomorrow." *Fortune,* 1992, reprinted by Steelcase, Inc., as S2592, June 1995.

Tynan, Kenneth. *Curtains.* New York: Atheneum, 1961.

White, Lynn. "Dynamo and Virgin Reconsidered." *American Scholar* 27, no. 2 (Spring, 1958).

Williams, Cecil, David Armstrong, and Clark Malcolm. *The Negotiable Environment: People, White-Collar Work, and the Office.* Ann Arbor: Facility Management Institute, 1985.

Wright, Frank Lloyd. "The Art and Craft of the Machine." In Bruce Brooks Pfeiffer, ed. *Frank Lloyd Wright: Collected Writings, Volume I,* 61–62, 64. New York: Rizzoli/Frank Lloyd Wright Foundation, 1992.

First published in the United States of America in 1997 by
The Monacelli Press, Inc.
10 East 92nd Street, New York, New York 10128.

Library of Congress Cataloging-in-Publication Data
Work, life, tools : the things we use to do the things we do / based on an exhibition
created by Milton Glaser and the Steelcase Design Partnership ; foreword by George
Beylerian ; introduction by Stanley Abercrombie ; photography by Matthew Klein.
p. cm.
Book to accompany an exhibition scheduled to tour the U.S. through the year 2000.
Includes bibliographical references.
ISBN 1-885254-83-0
1. Technology and civilization. 2. Work environment. 3. Tools—Design and construc-
tion. 4. Office equipment and supplies—Design and construction. I. Glaser, Milton. II.
Steelcase Design Partnership (New York, N.Y.).
HM221.W67 1997
303.48'3—dc21 97-29447

Printed and bound in Italy